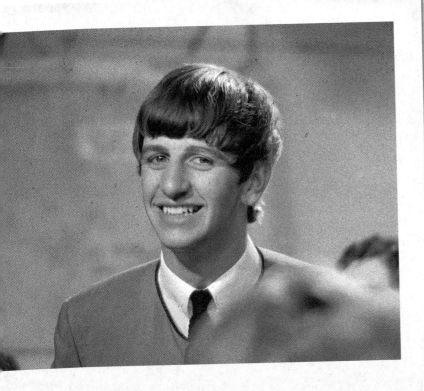

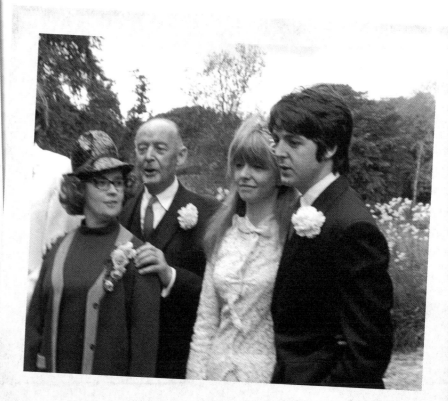

THE BEATLES
ON CAMERA, off guard 1963–69

MARK HAYWARD WITH MIKE EVANS

THE BEATLES
ON CAMERA, off guard 1963–69

PAVILION

CONTENTS

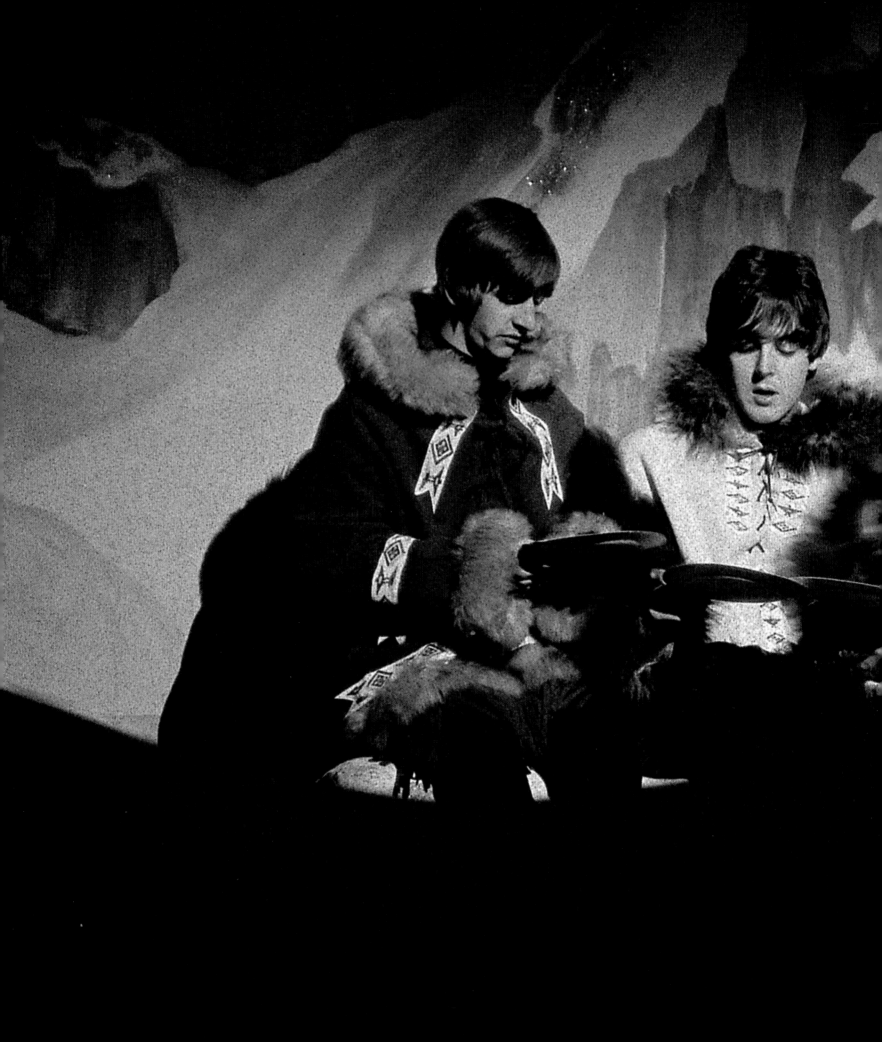

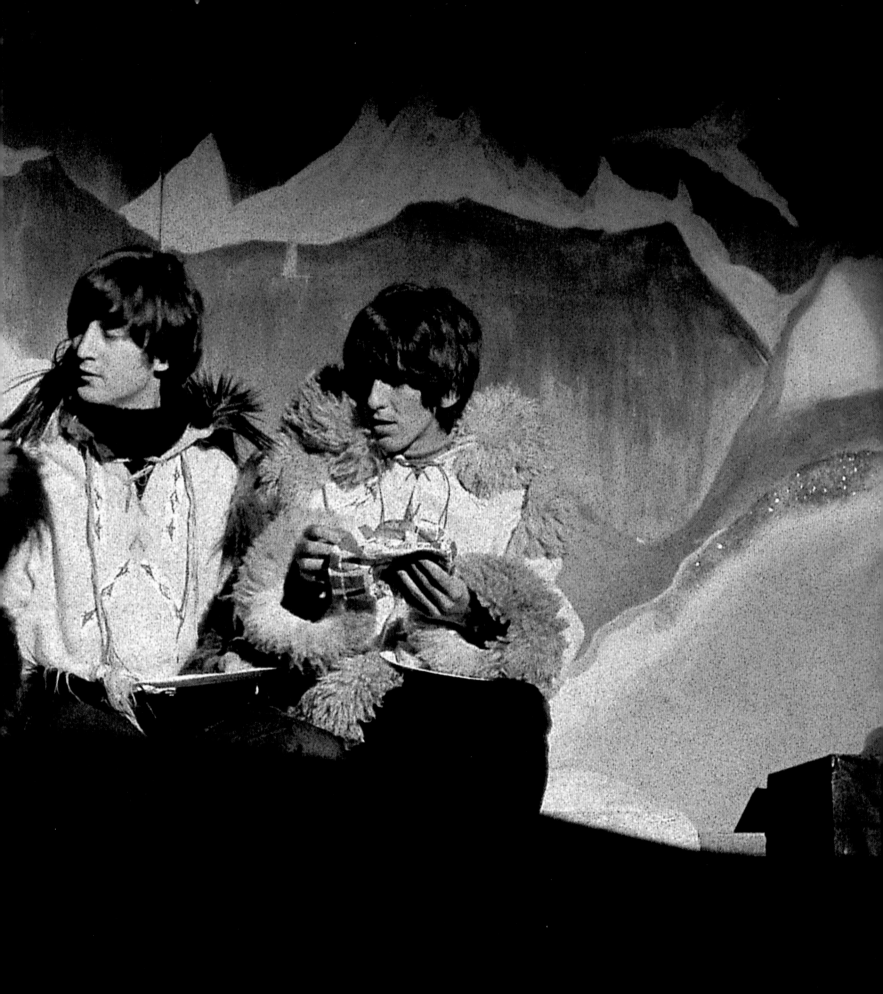

INTRODUCTION

ALONG WITH A FEW SELECT MOVIE STARS, such as Marilyn Monroe and James Dean, since the mid 1950s rock 'n' roll has produced a handful of true modern-day icons. Of these, the most genuinely 'iconic' have undoubtedly been Elvis Presley and the Beatles. During the 1960s the four Liverpudlians were simply the most famous band in the world, and as a 'brand' image are still universally recognised today.

Over the past quarter century I have been fortunate enough to acquire some amazing pictures of the 'Fab Four', and with the addition of various fascinating items of memorabilia have compiled a unique visual record of their career as it spanned the 1960s – from their first chart success in 1963 to their final disbandment as the decade came to a close.

This book features many images that have never been published before, supported by text drawn from various sources including newspapers and magazines, books, fan club material, auction catalogues, and interviews with many of the photographers themselves.

For the first half of their eight years at the top, the Beatles' visual trademark was dominated by the 'mop tops' stereotype beloved of the world's press; through the latter half of the decade, particularly after they had finished their final live tour in August 1966, they were able to dictate their visual representation themselves – hence projects like *Magical Mystery Tour* and 'A Mad Day Out'.

Some of the Beatles' most potent iconography is found on the five album covers created by their 'house photographer' Robert Freeman, from 1963's *With The Beatles* to *Rubber Soul* in 1965, while other images familiar worldwide featured the work of eminent cameramen such as Angus McBean, Robert Whitaker, and Richard Avedon.

But the intimate pictures here reveal the Beatles beyond iconography – snapped backstage as they line up for another press call, in screen grabs from home movies taken as they filmed on location, Paul's holiday footage, the band busy in the TV studio. In these exclusive images, we see the Beatles on camera – but often off guard.

Mark Hayward

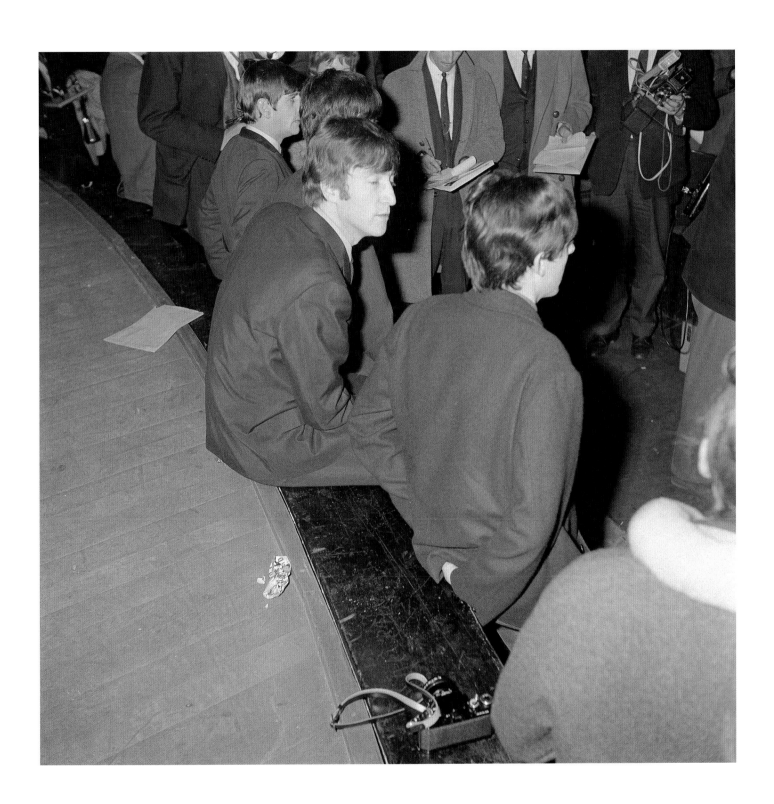

THE EARLY YEARS

IN THE 1940S AND 1950S, WHEN THE BEATLES WERE GROWING UP, having your photograph taken was a much rarer experience than it is today. Now every schoolkid seems to have a mobile phone which takes instant pictures, but back then an average family might have just one camera which was only brought out on special occasions and holidays. Often the only other pictorial record of childhood years was a costly 'sitting' at a professional photographer's studio, and the obligatory school photograph taken once a year. Pictures of the Beatles as children are, therefore, much-sought-after rarities, original snaps of John, Paul, George, and Ringo in their back gardens with family members, or on a holiday beach somewhere, bringing high prices at sales of pop memorabilia. But these four individuals would gradually find the camera omnipresent as they became, in the space of a couple of years during their early twenties, the four most famous faces on the planet.

Even when they were making their first forays into the world of music, no one imagined that their amateur skiffle group strummings would represent something historic. Pictures of John Lennon's group the Quarrymen, for instance, are extremely thin on the ground, and consequently highly prized by collectors, as are photographs of Ringo playing at Butlin's holiday camp with Rory Storm and the Hurricanes.

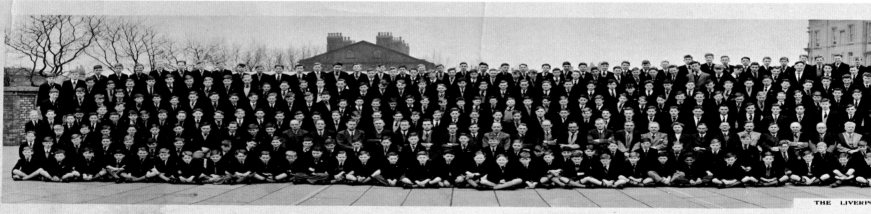

THE LIVERP
Lower School.

BELOW: Dovedale Primary School photograph, 1947–48, back row 8th from left is John Lennon aged 7.

BOTTOM: A traditional panoramic school photo, of the Lower School at Liverpool Institute High School in 1956, when pupils included Paul McCartney, George Harrison, future Beatles road manager Neil Aspinall, and *Mersey Beat* photographer Les Chadwick.

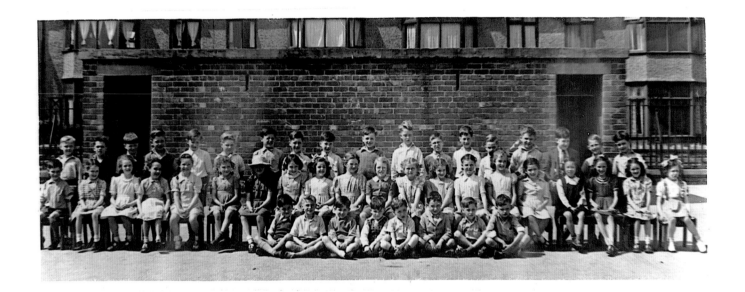

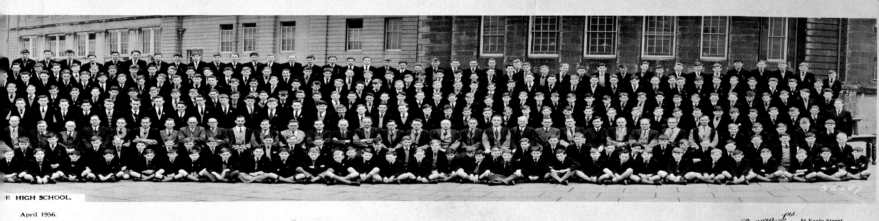

E HIGH SCHOOL.

April 1956.

Panora Ltd

56 Eagle Street,

It was when the Beatles (initially as the Silver Beatles) first started playing in the cellar clubs of Hamburg in 1960 that the earliest substantial photographic record of the group would be created. This was primarily the work of Astrid Kirchherr, a young German photographer who became the girlfriend of their then bass player Stuart Sutcliffe, and who took hundreds of pictures of the leather-clad group. Back in their hometown of Liverpool, however, they were still virtually unknown, so any photographs of their first appearances in the city's rock venues are few and far between.

In fact the first time a picture of John Lennon ever appeared in a national newspaper was when he was still attending Liverpool College of Art, and the *Sunday People* sent a reporter and photographer to report on the 'Beatnik Horror' that was apparently sweeping the nation. In the article, published in July 1960 a few months before he left the student life for the bright lights of Hamburg, Lennon and his art school cronies (including Sutcliffe) could be seen lounging around their litter-strewn beatnik 'pad', a stark warning that the nation's youth was 'on the road to hell'.

When the Beatles began playing regularly around Merseyside, they started to acquire a substantial local following, which was when local photographers sat up and took notice. They even had an amateur-run fan club, a couple of years before the Beatles' official club was a nationwide affair. The band was just one part of a rock'n'roll boom that was taking over the city; a response to which was the local music paper *Mersey Beat*, founded and edited by an ex-art student colleague of Lennon, Bill Harry. Photographers such as Les Chadwick and Alan Swerdlow undertook a lot of work for Harry's weekly magazine, shooting the beat groups in the Cavern and other venues.

But it was after the Beatles' second single, 'Please Please Me', shot to the top of the national charts, that their every move seemed to be followed by the cameras. Beginning in the summer of 1963, as 'She Loves You' became their biggest hit yet, the country was gripped by what the press dubbed 'Beatlemania'. From then on, until the end of the decade, the four young men lived in the goldfish bowl of absolute celebrity, and even in their leisure moments a camera lens never seemed far away.

OPPOSITE: These early pictures of John Lennon and Paul McCartney on stage in a Liverpool club, by a photographer unknown, were purchased at a sale of memorabilia at Sotheby's auctioneers in 1986.

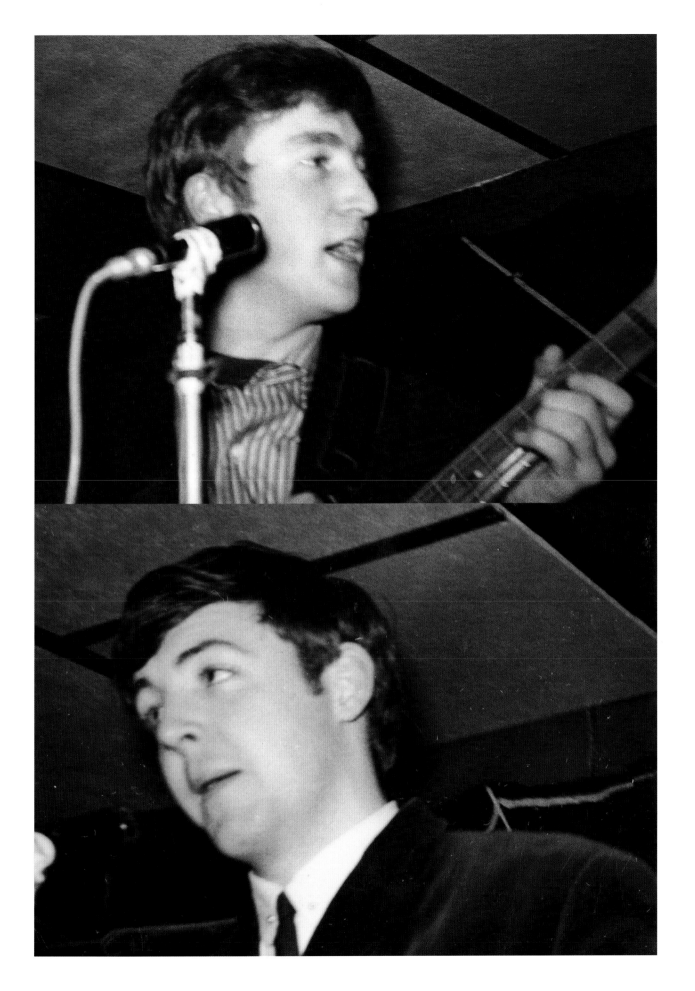

BEATLES FAN CLUB

c/o Miss R. Brown,
90 Buchanan Road,
Wallasey, Cheshire.

Miss M. O'Brien,
24 Lilly Street,
Rock Ferry,
Birkenhead.

Dear Miss O'Brien,

We acknowledge receipt of your postal order to the value
of 5s. 0d. we are enclosing Membership Card 521 and a
photograph of The Beatles. We would like to take this opportunity
of welcoming you to the Club, and hope you enjoy reading our
newsletters.

Should you wish details on George, John, Paul or Pete do
not hesitate in writing to us.

Yours sincerely,
BEATLES FAN CLUB

R. Brown,
Secretary.

★ MAJESTIC BALLROOM ★
CONWAY STREET · BIRKENHEAD
TOP RANK DANCING PRESENTS
BRITAINS No. 1 VOCAL / INSTRUMENTAL GROUP
THE BEATLES
and
FREDDIE STARR and the MIDNIGHTERS
1st Session 6·0 p.m to 8·0 p.m. 3|-
THURSDAY, 21st FEBRUARY 1963

№ 200

As a special offer to our regular patrons'
this ticket will admit two for 7/6 (pay at door) to

Rory Storm's Birthday Night
TOWER BALLROOM · NEW BRIGHTON
NEXT FRIDAY SEPTEMBER 21st 7.30—12.00
2 FOR 7/6

with guests THE BEATLES WITH THE COASTERS
BILLY KRAMER WITH THE COASTERS
THE BIG THREE

and introducing BUDDY DEAN AND THE TEACHERS

and of course RORY BACKED BY THE HURRICANES

Licensed Bar (applied for) Late transport

ABOVE: A letter from the Secretary of the earliest Beatles fan club to a Miss O'Brian in Rock Ferry, Birkenhead, welcoming her to the club and thanking her for the fee of 5 shillings (25 pence). Inset: When the Beatles played at Rory Storm's Birthday Night, Ringo had left Rory's band the Hurricanes for the Beatles just a month before, in August 1962.

Detail s of The Beatles appearances in Great Britain following
their engagements in Germany.

6th June	Wednesday.	Recording session at E.M.I. studios, London
9th June	Saturday.	Special 'Welcome Home' at the Cavern Club.
11th June	Monday.	B.B.C. Recording at Playhouse Theatre, Manchester for "Teenagers Turn"at 8.0.p.m. (for transmission Friday 15th June at 5.0.p.m.)
12th June	Tuesday.	Lunchtime and Evening session at the Cavern Club, Liverpool.
13th June	Wednesday.	Lunchtime and Evening session at the Cavern Club, Liverpool.
15th June	Friday.	Lunchtime and Evening session at the Cavern Club, Liverpool.
16th June	Saturday.	Evening performance at the Cavern Club.
?th June	Tuesday.	Lunchtime and Evening session at the Cavern Club, Liverpool.
20th June	Wednesday.	Lunchtime and Evening session at the Cavern Club, Liverpool.
21st June	Thursday.	Bruce Channel show at the Tower, New Brighton.
22nd June	Friday.	Evening performance at the Cavern Club.
23rd June	Saturday.	Northwich.
24th June	Sunday.	Casbah Club, West Derby, Liverpool.
25th June	Monday.	Plaza Ballroom, St. Helens.
27th June	Wednesday.	Evening performance at the Cavern Club.
28th June	Thursday.	Majestic Ballroom, Birkenhead.
29th June	Friday.	Tower Ballroom, New Brighton.
30th June	Saturday.	Evening performance at the Cavern Club.
2nd July	Monday.	Plaza Ballroom, St. Helens.
4th July	Wednesday.	Evening performance at the Cavern Club.
5th July	Thursday.	Majestic Ballroom, Birkenhead.
6th July	Friday.	Riverboat Shuffle, on Mersey with Acker Bilk.
7th July	Saturday.	Hulme Hall Golf Club, Port Sunlight Village
8th July	Sunday.	Evening performance at the Cavern Club.
9th July	Monday.	Plaza Ballroom, St. Helens.
11th July	Wednesday.	Evening performance at the Cavern Club.
12th July	Thursday.	Majestic Ballroom Birkenhead.
13th July	Friday.	Evening performance at the Cavern Club.
14th July	Saturday.	Tower Ballroom, New Brighton.
15th July	Sunday.	Evening performance at the Cavern Club,

Special Dates for your Diary.

26th July	Thursday.	Cambridge Hall Soutport with Joe Brown.
27th July	Friday	Tower Ballroom New Brighton with Joe Brown.
3rd August	Friday.	Grafton Rooms, Liverpool
28th Sept.	Friday.	Royal Iris River Cruise.(Aut. Telephone Co.)

ABOVE: A list of gigs, all around the Liverpool area, in June and July of 1962. It was sent out to fan club members as the Beatles returned from one of their trips to Hamburg.

LOOK !
THREE TOP GROUPS
AGAIN
NEXT WEDNESDAY NIGHT
AT HAMBLETON HALL
Page Moss, Huyton

—— What a terrific line up for ——
WEDNESDAY, 25th JANUARY 1961

● The Sensational Beatles ●

 ● Derry & The Seniors ●

● Faron & The Tempest Tornadoes ●

YES! You must come along early
and bring your friends !

PAY AT
THE DOOR
2/6 before 8 p.m. 3/- afterwards

NOTE ! No admission after 9-30 p.m.

INVOICE

MERSEY

DIRECTORS : A. R. McFALL, W. HARRY

81a, RENSHAW STREET, LIVERPOOL, 1. Tel. ROYal 0033. Editor : **W. HARRY**

BEAT

Mr.Brian Epstein 3rd April, 1962.

12-14 Whitechapel

Liverpool 1.

Advertisement in "Mersey Beat" issue number 18......£15. 0. 0.

£15. 0. 0.

Nº 48 16th April 1962

Received from Mr. B Epstein

the sum of

FIFTEEN Pounds

shillings and pence

ADV IN MERSEY BEAT NO 18

£ 15 - 0 - 0 W Harry

ABOVE: An invoice and receipt from *Mersey Beat* magazine to Beatles' manager Brian Epstein,
for an advertisement placed in the paper in April 1962.
OPPOSITE: Hambleton Hall, in the Liverpool district of Huyton, was typical of the dates the Beatles would play in
the very early 1960s around Merseyside.

ABOVE AND OVERLEAF: Chas McDevitt filmed the Beatles from the backstage wings of the theatre. He also caught a unique shot of his wife Shirley Douglas, who performed with him at the time, holding the bass guitar while Paul McCartney looked on. Hank Marvin of the Shadows also appeared backstage, fooling around with his spectacles with John Lennon. McDevitt couldn't recall why the Shadows guitar player happened to be there.

ABC CINEMA, BLACKPOOL
SUNDAY 25 AUGUST 1963

THOUGHT TO BE THE EARLIEST FILM OF THE BEATLES IN COLOUR, I purchased this rare piece of history from Sotheby's auctioneers in 1997. The film was taken by the 1950s skiffle star Chas McDevitt who was on the supporting bill at the ABC Cinema, Blackpool. Chas told me that having performed his hit song 'Freight Train', he went backstage, initially forgetting to put his newly acquired 8mm home movie camera on ready for action. When Chas did start filming, he realised he had the camera at the wrong speed, hence the switch from colour to black and white in between sequences.

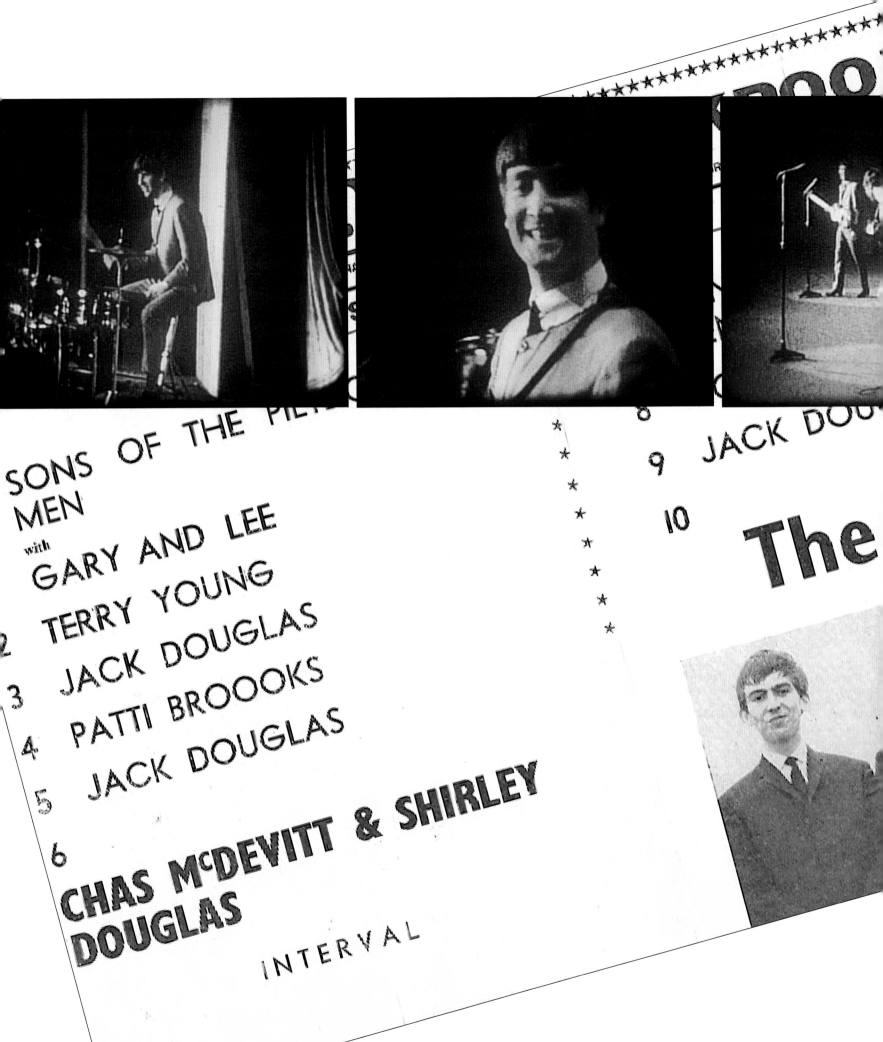

SONS OF THE PIE... MEN

with

GARY AND LEE

TERRY YOUNG

2 JACK DOUGLAS

3 PATTI BROOOKS

4 JACK DOUGLAS

5

6 CHAS McDEVITT & SHIRLEY DOUGLAS

8

9 JACK DOU...

10 The

INTERVAL

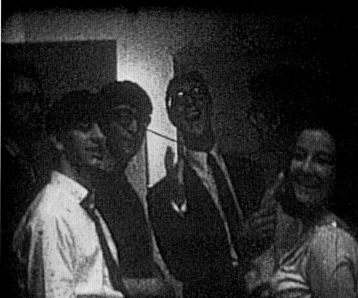

READY STEADY GO!
STUDIO 9, TELEVISION HOUSE,
KINGSWAY, LONDON
FRIDAY 4 OCTOBER 1963

THE FIRST EDITION OF THE GROUND-BREAKING POP MUSIC programme *Ready Steady Go!* was aired on 2 August 1963. The Beatles' first camera rehearsal for the show was in the afternoon of Friday 4 October 1963, followed by their recorded performance.

These pictures were taken by Richard Rosser whom I first encountered after buying a collection of photographs and negatives from a friend, Martyn Fenwick. The only clue as to who the photographer might be lay in the name 'Rosser' written on the envelopes, and after a certain amount of detective work I made contact, arranging to meet him. We met at a pub on the River Thames at Hammersmith. A shy man of modest means, rolling his own cigarettes and enjoying a pint of real ale, he explained how he'd sold his pictures and negatives at auction because he needed the money. He recalled how in the 1960s he would often receive a call from Brian Epstein, enabling him to be there first to photograph the Beatles at various locations, and including access to the live studio sessions of *Ready Steady Go!* His many pictures in the book represent the work of a great undiscovered photographer, now published for the first time.

With its 'Pop Art' sets, live audience, and the trendiest rock groups and singers, *Ready Steady Go!* was the TV programme setting the standard for music and fashion in the mid-1960s, way ahead of any previous 'youth' shows on British television.

The show included a brief interview conducted by the singer Dusty Springfield:

Dusty to Paul: Is it true you sleep with your eyes open?

Paul: Well, I haven't seen myself do it, but, actually, the fellas say that I do, they've sort of seen me... sleeping with my eyes open.

Dusty to Ringo: How many [rings] do you actually have?

Ringo: 649 and a half!

Dusty: Why do you like/dislike Donald Duck?

Ringo: [imitates Donald Duck's voice] You know you can't understand him!

OVERLEAF: Dusty Springfield with the Beatles, second left.

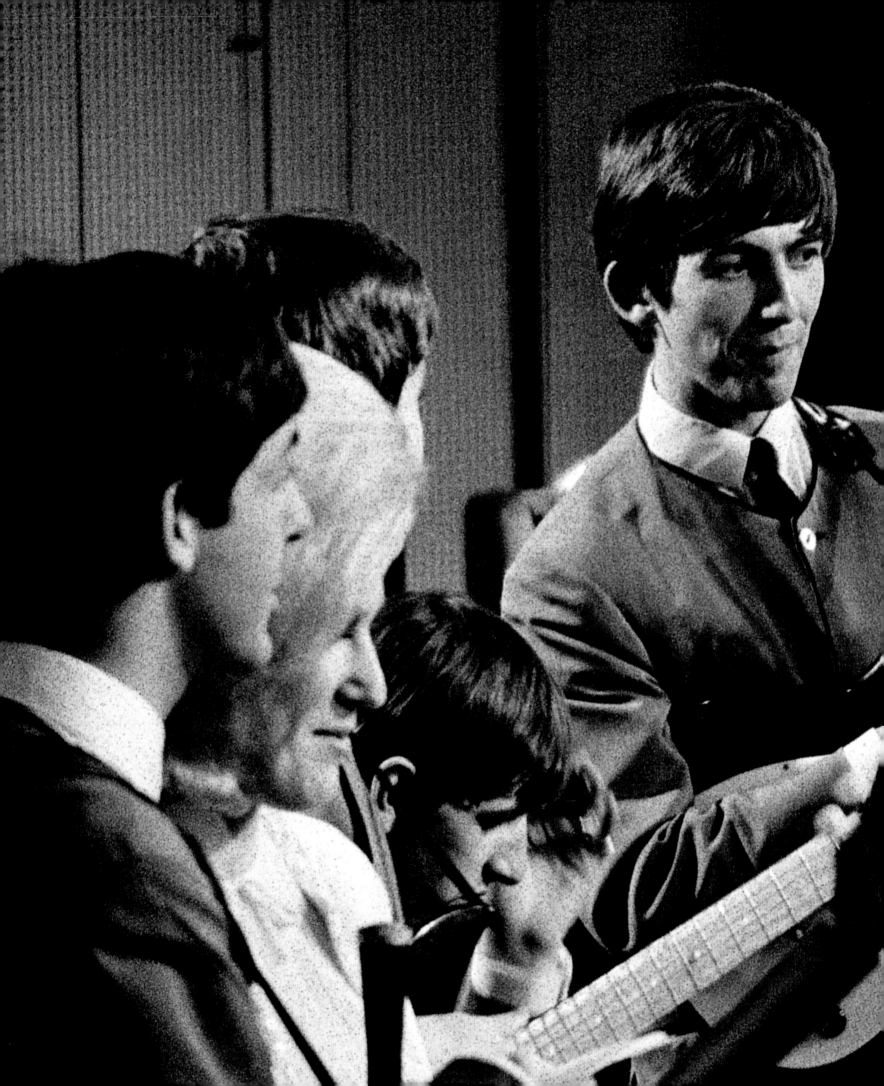

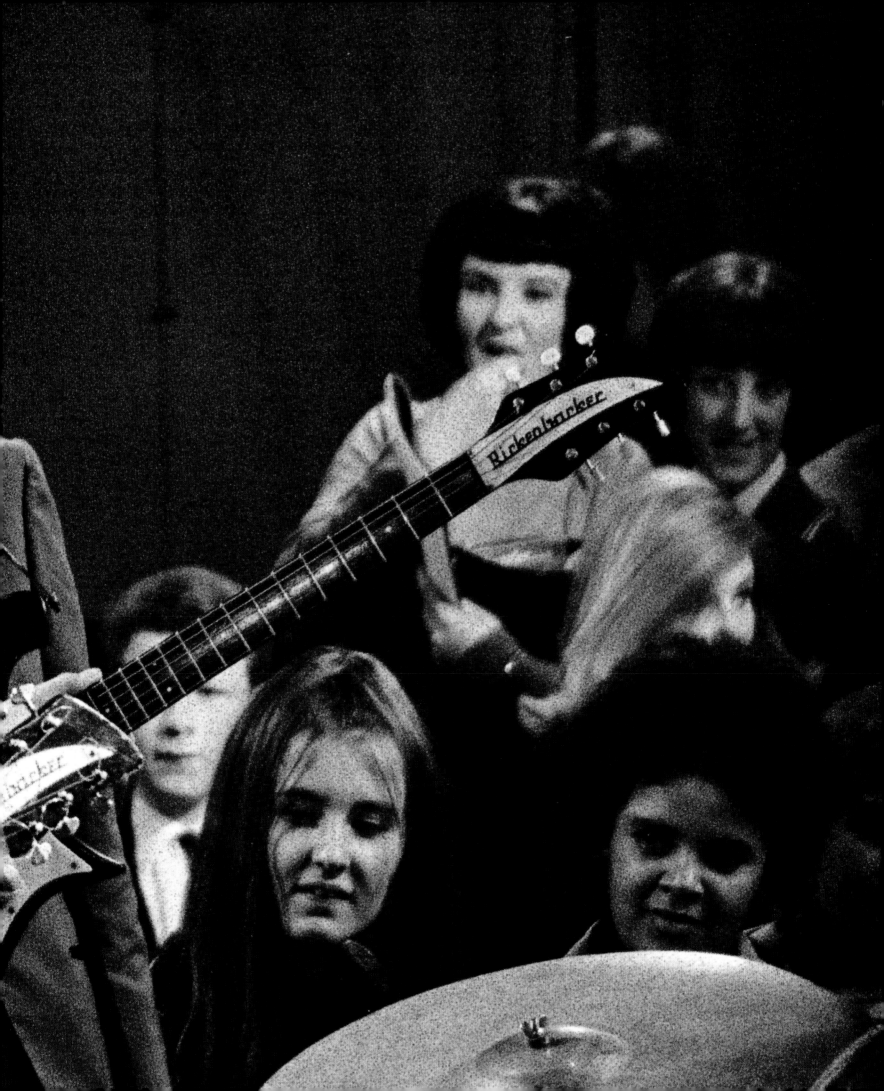

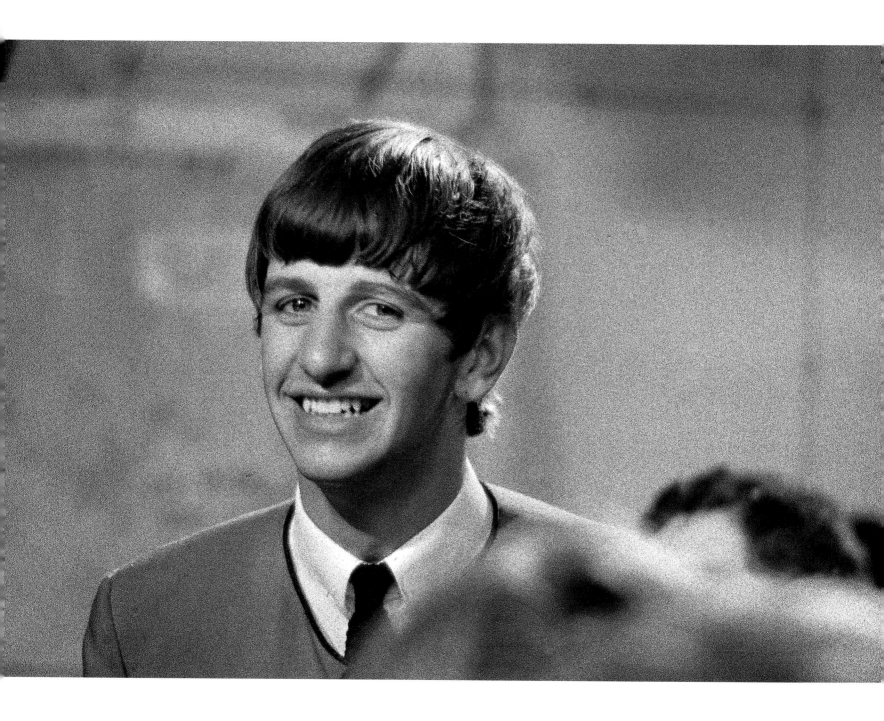

Although RSG (as it came to be known) eventually went out live, the Beatles mimed to 'Twist and Shout', 'I'll Get You' and 'She Loves You', for their first appearance on the programme.

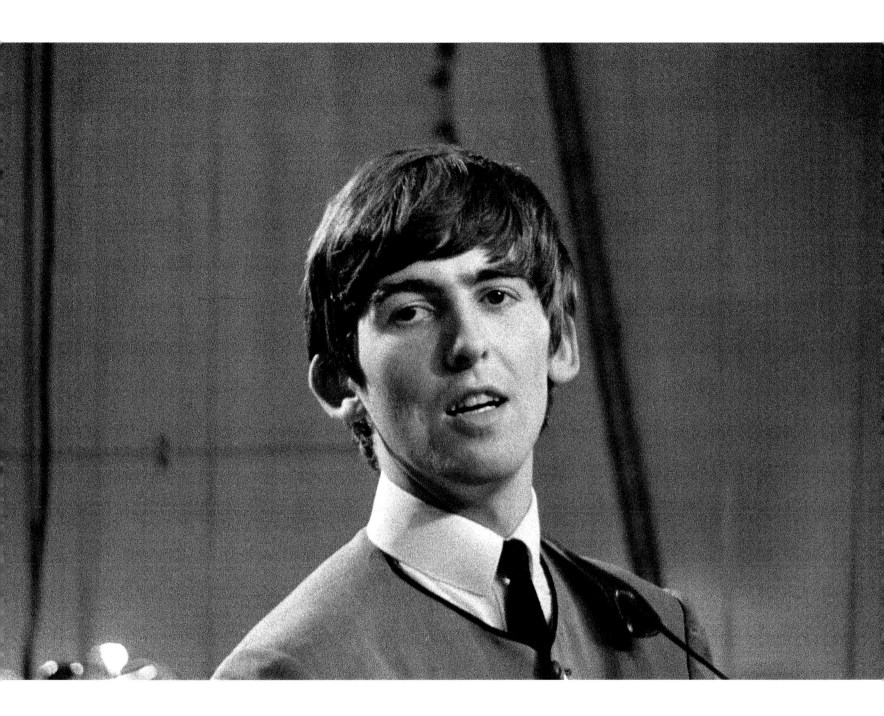

With all the recording complete, the programme was broadcast on that Friday evening, from 6.15 to 7.00 pm.

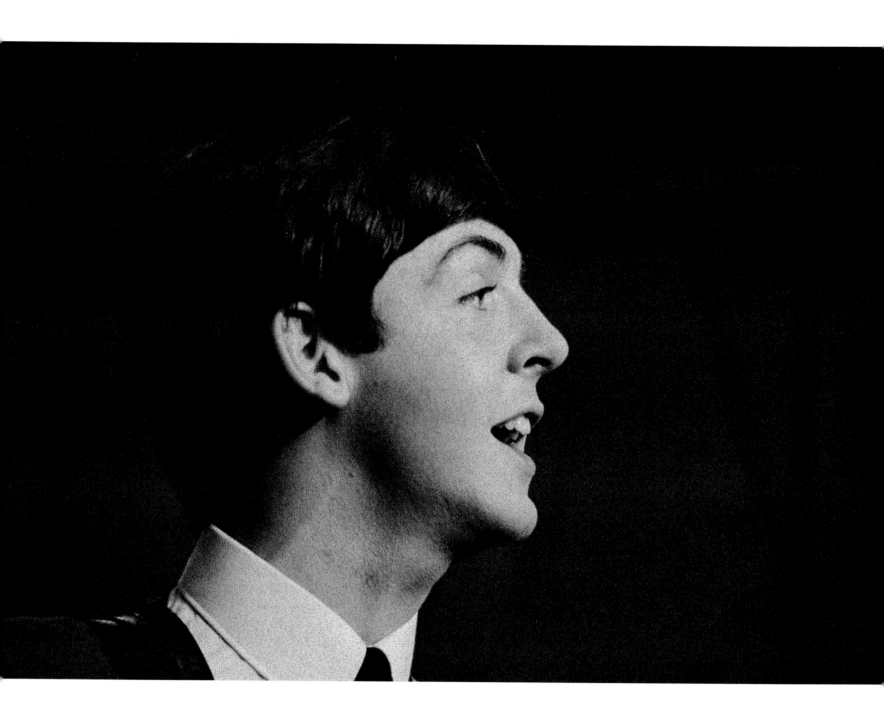

During the programme, Paul was called upon to judge a miming competition in which four girls mimed

to the Brenda Lee song 'Let's Jump The Broomstick'; Paul made Melanie Coe the winner.

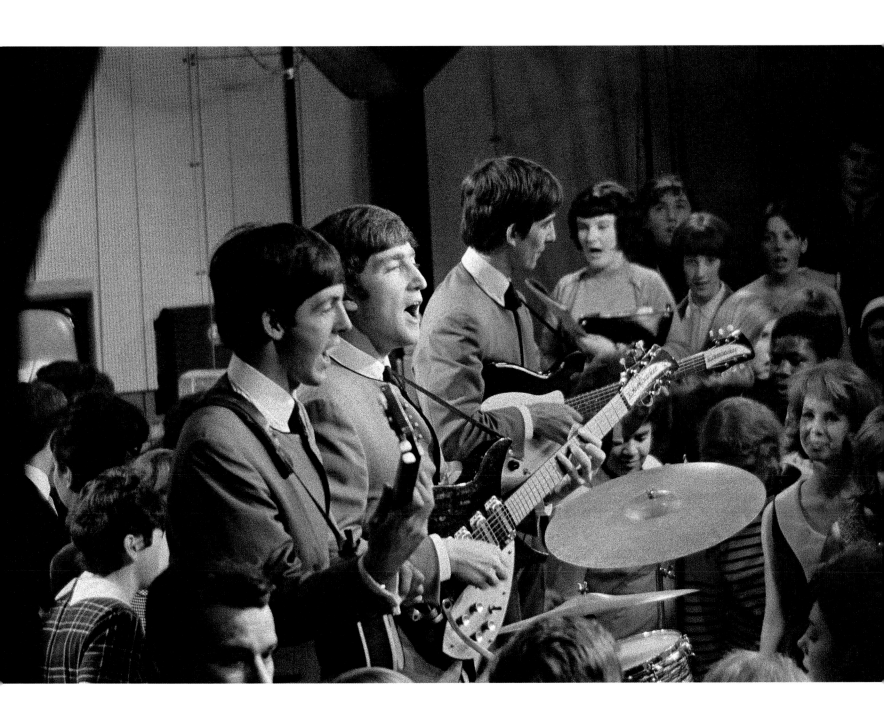

Significantly, little did Melanie know she would become part of Beatles folklore, as the girl McCartney wrote about in 'She's Leaving Home' a few years later.

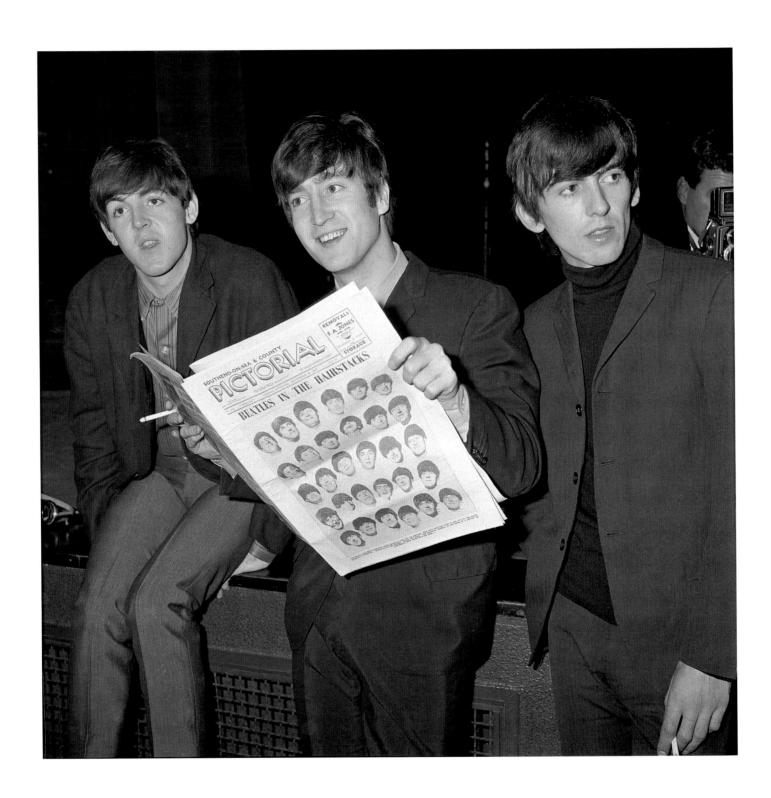

ABOVE: John peruses a special Beatles edition of the *Southend-on-Sea and County Pictorial*.

ODEON CINEMA
SOUTHEND-ON-SEA
MONDAY 9 DECEMBER 1963

WHEN THE BEATLES PLAYED SOUTHEND ON 9 DECEMBER 1963, Richard Rosser was able to get in the venue before the concert and photograph the Beatles from on the stage. Their visit was covered in detail by *Disc* magazine, in its edition of 21 December:

'*Both local and national press were waiting in the auditorium for the Beatles' arrival. Also present were Southend's chief constable, two Rank Theatre regional controllers, and half a dozen policemen. Bulbs flashed and cameras clicked as they made their entrance, but John, Paul, George, and Ringo vanished into the wings before the crowd could converge. Five minutes later all smiles and Scouse accents they emerged, posed willingly for a succession of photographs and joked with an 11-year-old fan who presented them with a Beatles display carved in wood.*

'*They remained on stage for about half an hour and although they looked in great shape, they admitted in their dressing room afterwards to being absolutely exhausted.*

'*Paul McCartney took a bite at a chicken leg and grimaced at his reflection in the mirror, "Do you know in the last six months, I've lost about a stone" he complained, "it's not funny any more. I've reached the stage where I'm happy if I get one square meal every two days".*

'*John Lennon stopped eating long enough to agree with Paul. "On this tour we've had to grab as many snacks as we can in our dressing room before and during shows" he explained, "we bless the co-operation of all theatre staffs for at least receiving us with hot meals. Trying to get out after a show to eat is impossible and the tiring process of getting in and out of theatres doesn't help very much. We finish up absolutely exhausted!" '*

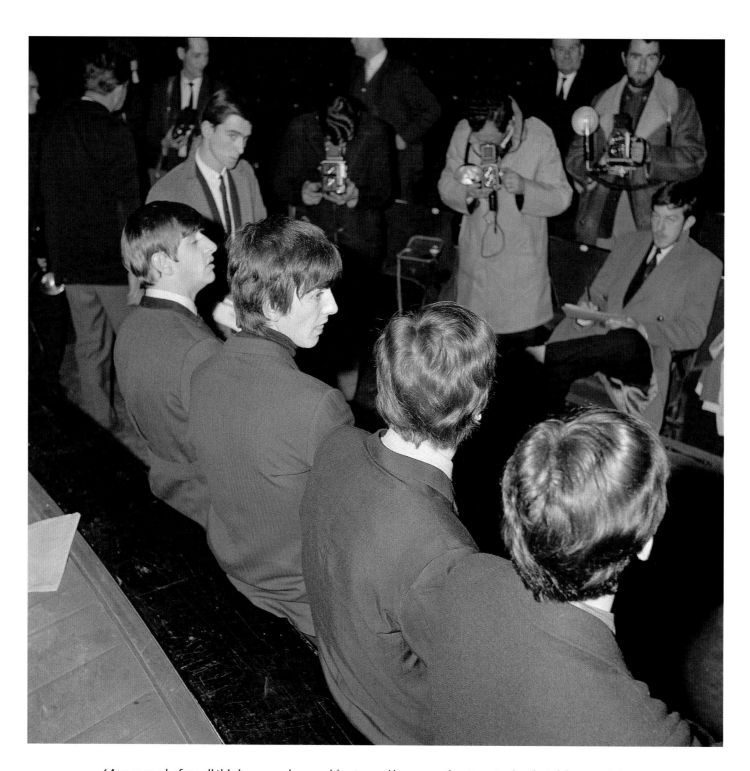

'A year ago before all this happened we could enter and leave any theatre, stay in a hotel, have a night out and go shopping without being mobbed. Things we really enjoyed have now become pipe dreams. Perhaps one day it will all die down, then we can go back to living normal peaceful lives.' John Lennon in Southend

THE BEATLES ON CAMERA

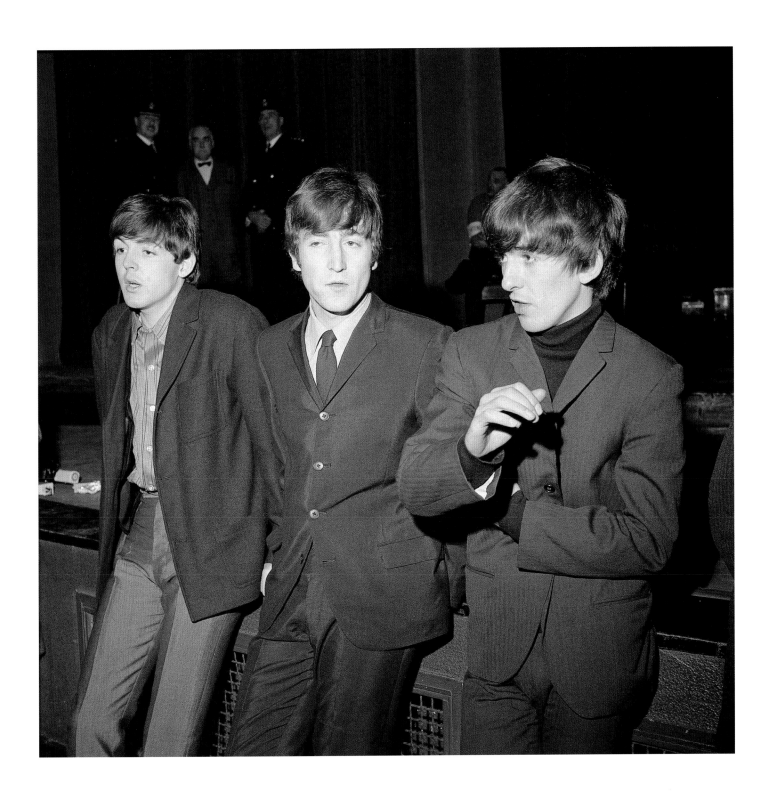

George told an interviewer that he was looking forward to the lure of Australia and New Zealand:

'I'd just like to spend a few weeks in the sun.'

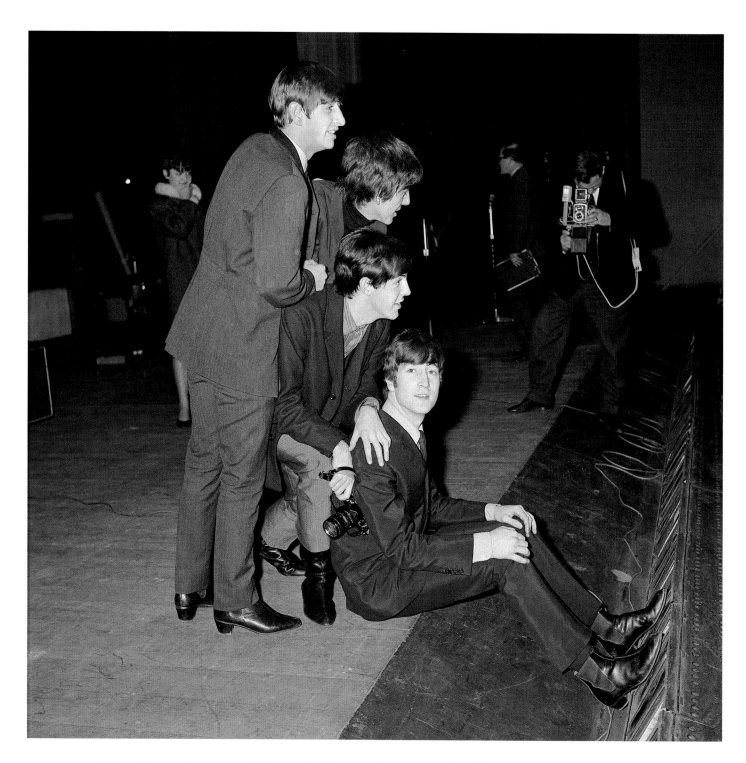

Before they met the press in Southend, John was first to enter the Odeon, in a suede cap and huge dark glasses. Paul and George followed, identical in black polo neck sweaters and leather jackets, and Ringo tagged along behind.

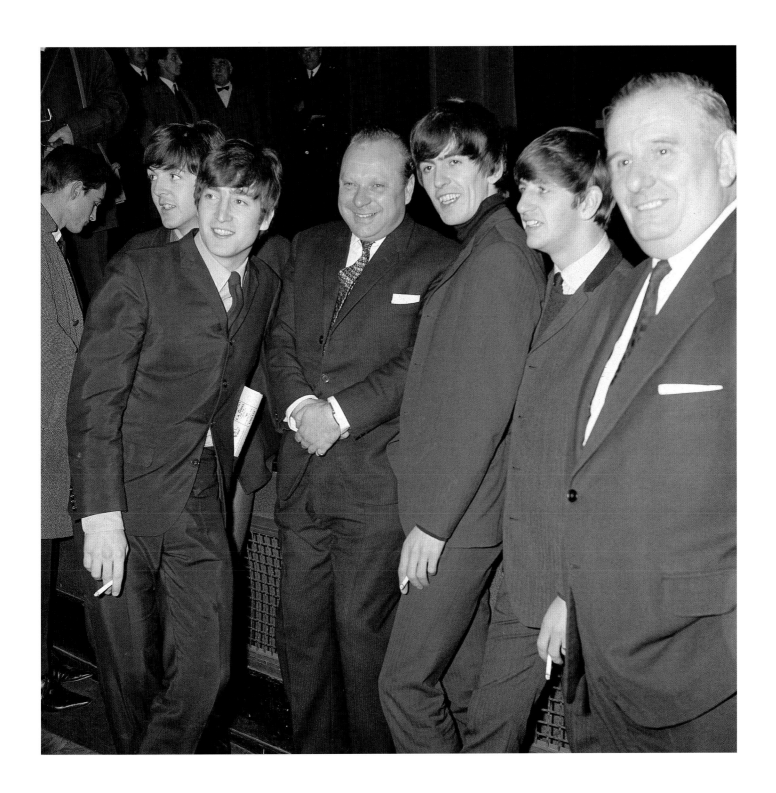

Among the welcoming party greeting the Beatles were two Rank Theatre regional controllers, and the local chief constable.

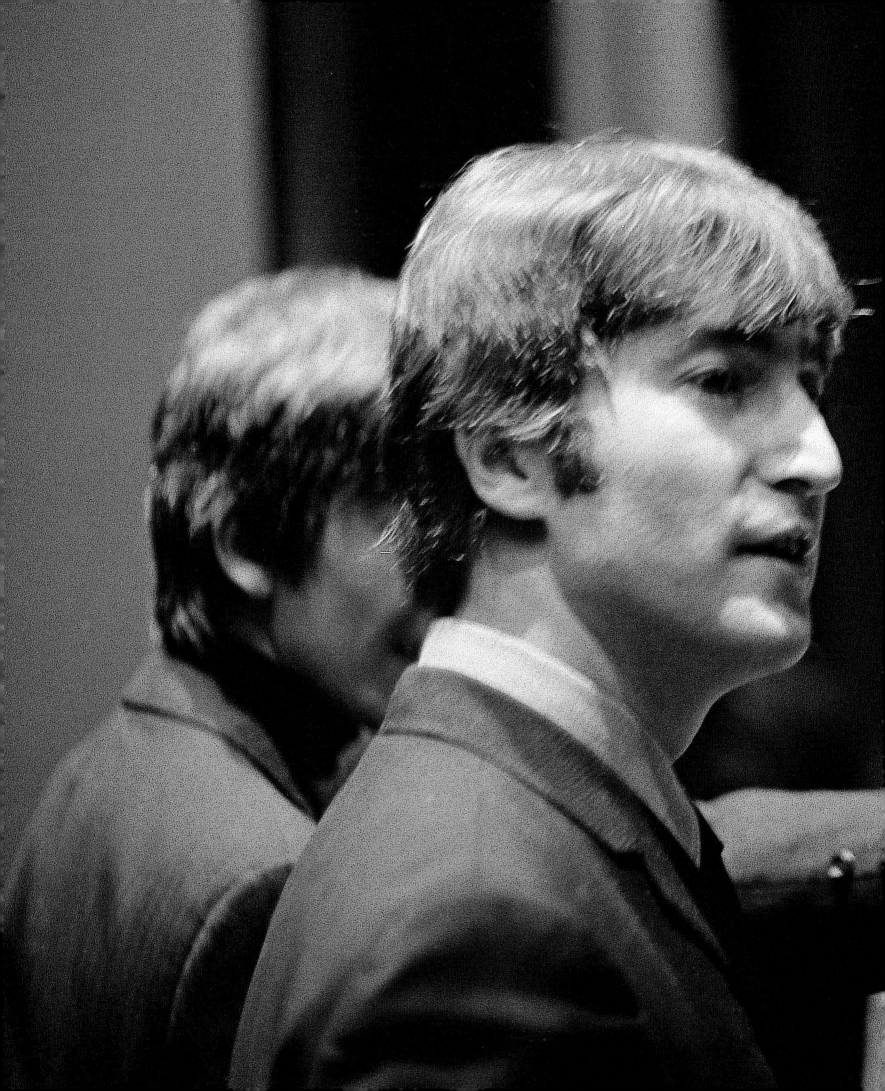

THANK YOUR LUCKY STARS
ALPHA STUDIOS, BIRMINGHAM
SUNDAY 15 DECEMBER 1963

RICHARD ROSSER WAS ON HAND ONCE MORE TO RECORD the Beatles in the television studio, this time for a special Merseyside edition of the Saturday night pop show *Thank Your Lucky Stars*. There had already been a Liverpool special in June 1963, and this second one featured – as well as the Beatles – Cilla Black, the Searchers, Billy J. Kramer and the Dakotas, Tommy Quickly, Gerry and the Pacemakers, and all-girl group the Breakaways. The show was transmitted by ABC Television on Saturday 21 December 1963.

The Beatles appeared on a triangular set which used their names as a backdrop, and played 'I Want To Hold Your Hand', followed by 'All My Loving' and 'Twist And Shout'. The show's presenter, Brian Matthew, then presented Beatles' producer George Martin with two gold records for the success of the singles 'She Loves You' and 'I Want To Hold Your Hand', before the Beatles closed the show with 'She Loves You'.

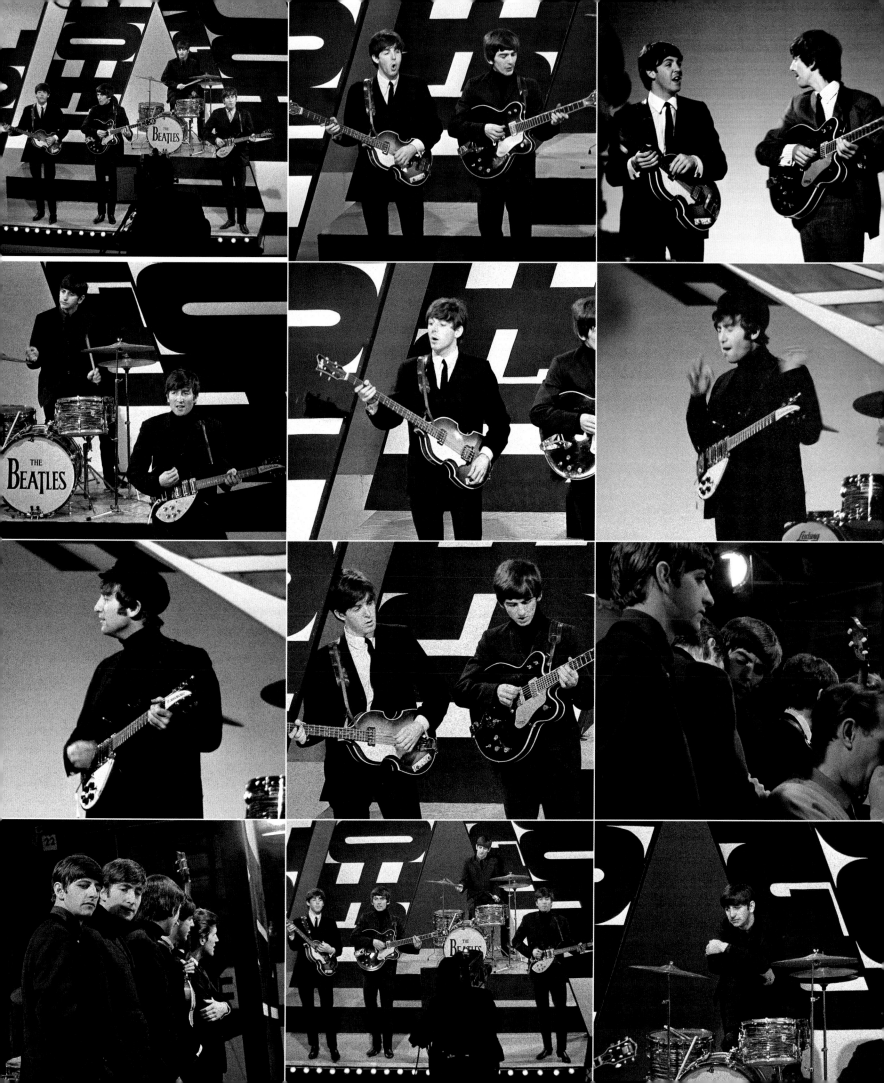

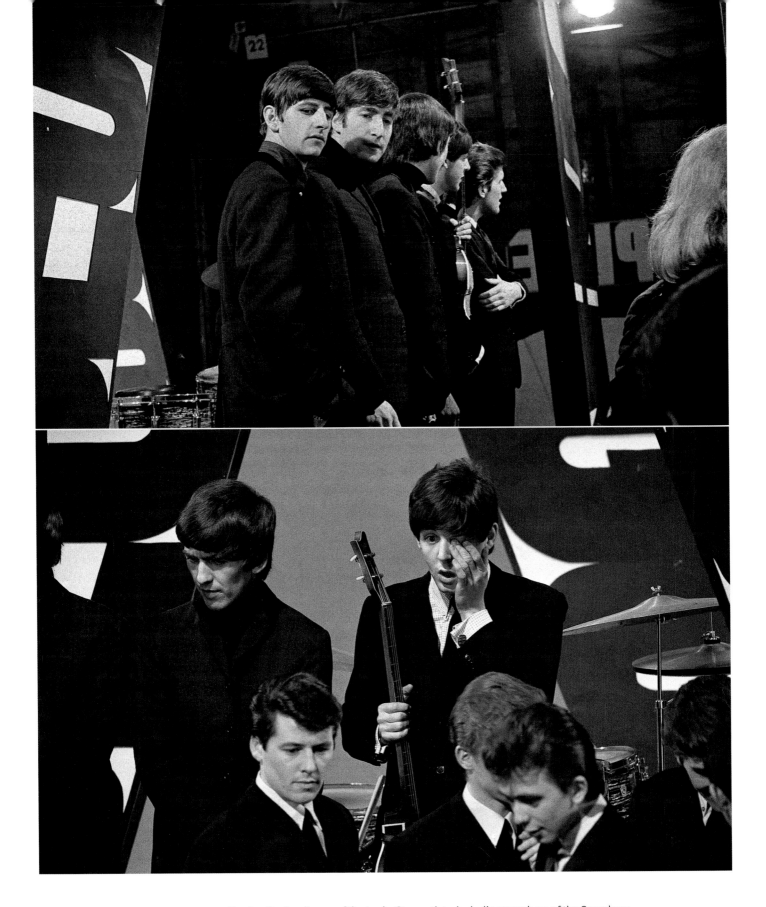

ABOVE AND TOP: The Beatles in a lineup of the *Lucky Stars* artists, including members of the Searchers and Billy J. Kramer's Dakotas.

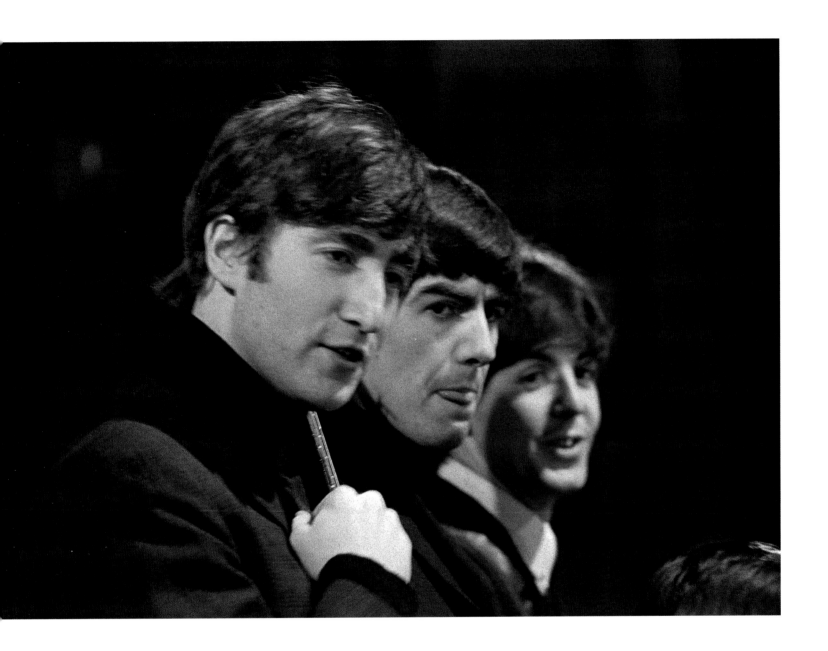

ABOVE: John and George adopt the Beatles' signature look of black polo neck sweaters, made iconic in Robert Freeman's cover photograph for *With The Beatles* released a month earlier.

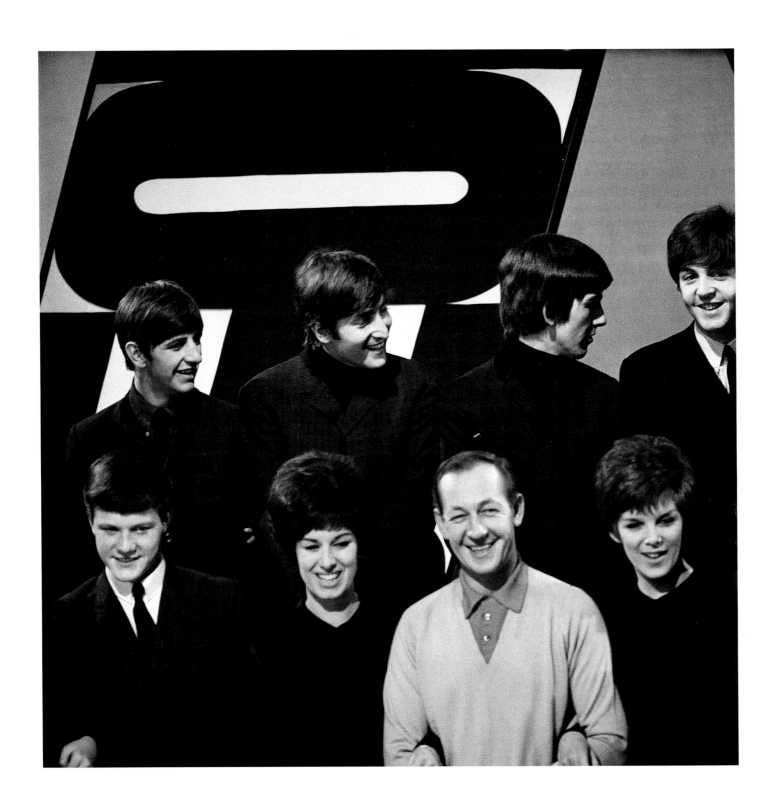

ABOVE: The Beatles with (bottom row) vocalist Tommy Quickly (left) and compère Brian Matthew, who's flanked by two members of the girl group the Breakaways.

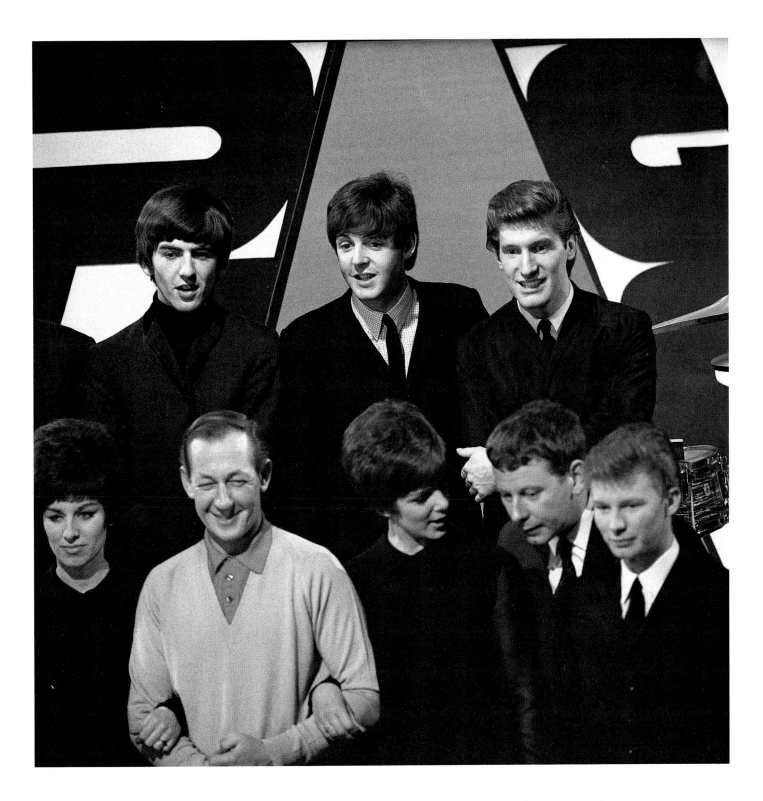

ABOVE: To the right of Paul McCartney, a member of the Searchers, and below (far right) another Searcher next to the Cavern club DJ Bob Wooler.

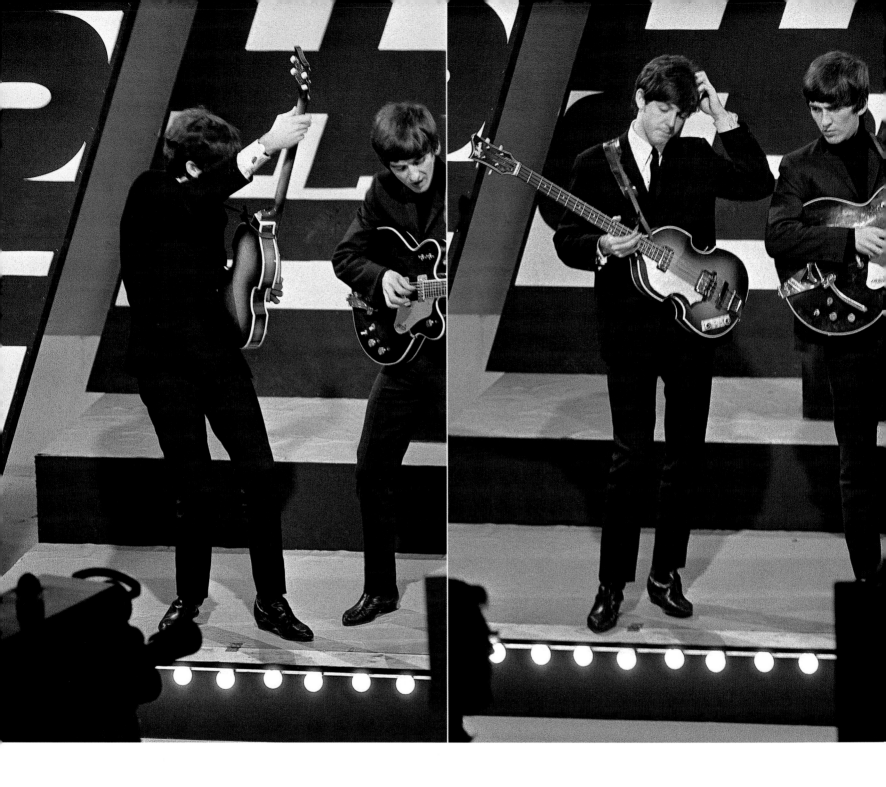

ABOVE AND OPPOSITE: Richard Rosser captures the Beatles during the run-through for their *Lucky Stars* spot.

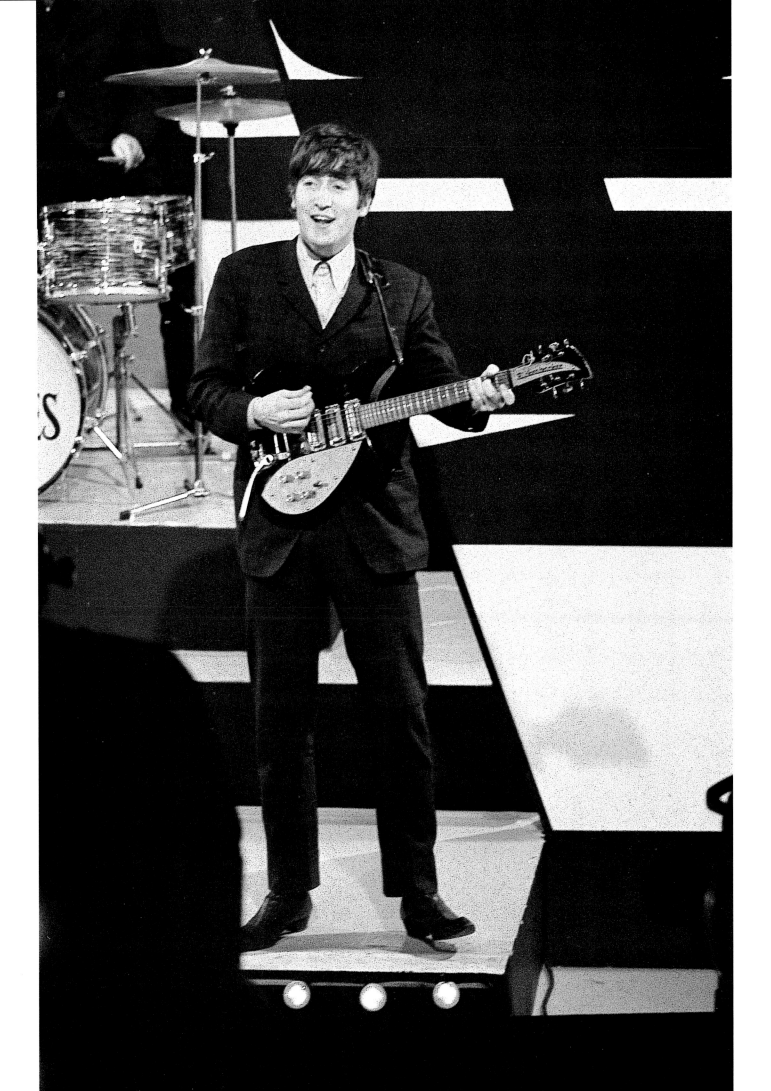

BEATLES CHRISTMAS SHOW
ASTORIA THEATRE,
SEVEN SISTERS ROAD,
FINSBURY PARK, LONDON
TUESDAY 24 DECEMBER 1963

THESE PICTURES WERE TAKEN BY RICHARD ROSSER, whom Brian Epstein would contact so he could catch the Beatles at various events before the other press photographers.

The Beatles Christmas Show was conceived and presented by Brian Epstein. It would normally be staged twice per night, but as this was Christmas Eve only the one show took place. It had previewed at the Gaumont Cinema, Bradford, on 21 December, then played the Empire Theatre, Liverpool, on the 22nd. It ran at the Finsbury Park Astoria until Saturday 11 January.

The lineup included Cilla Black (once the cloakroom attendant at the Cavern), Tommy Quickly, Billy J. Kramer and the Dakotas, the Fourmost—all part of Epstein's 'stable' of artists—plus comedy group the Barron Knights, with Australian artist/comedian Rolf Harris acting as compère.

After all the support acts had performed, the Beatles played 'Roll Over Beethoven', 'All My Loving', 'This Boy', 'I Wanna Be Your Man', 'She Loves You', 'I Want To Hold Your Hand', and 'Money', ending the set with 'Twist And Shout'. Epstein had hired a private plane to fly most of the acts home to Liverpool in time for Christmas.

SOUVENIR PROGRAMME

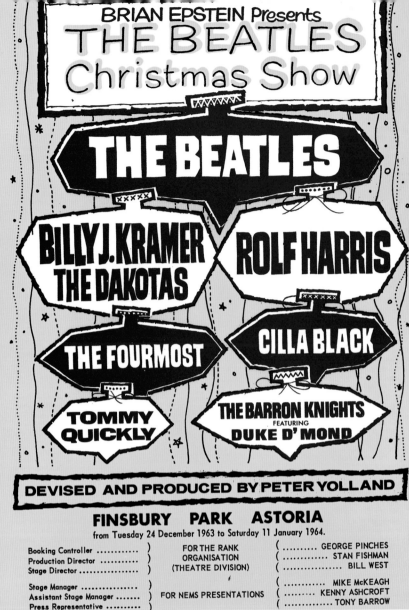

Backstage at the Finsbury Park Astoria, Terry Carroll of Southern Television interviewed the group, asking them about their upcoming visit to the United States:

Carroll: What are you thinking about the upcoming US visit and the three Ed Sullivan shows?
John: Well personally I don't think we stand a chance, but I don't know about you Paul, he might have a different view.
Paul: No, we're not worried if we don't do anything great, we don't expect to do an awful lot because we're only there for three TV shows, and apparently – we've heard from Americans – that you've got to go right round every little bit of America to have a great success, unless you're very lucky. So we don't expect too much. We hope for a lot, but we don't expect it.
John: That was nicely put.

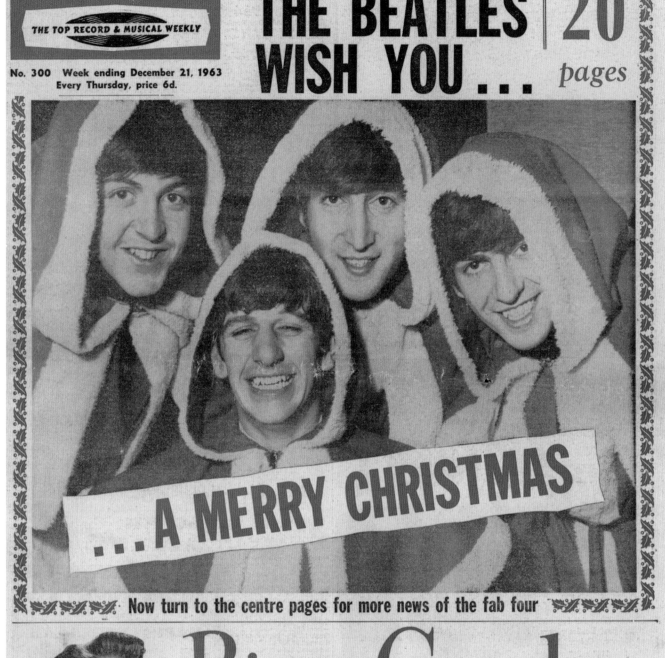

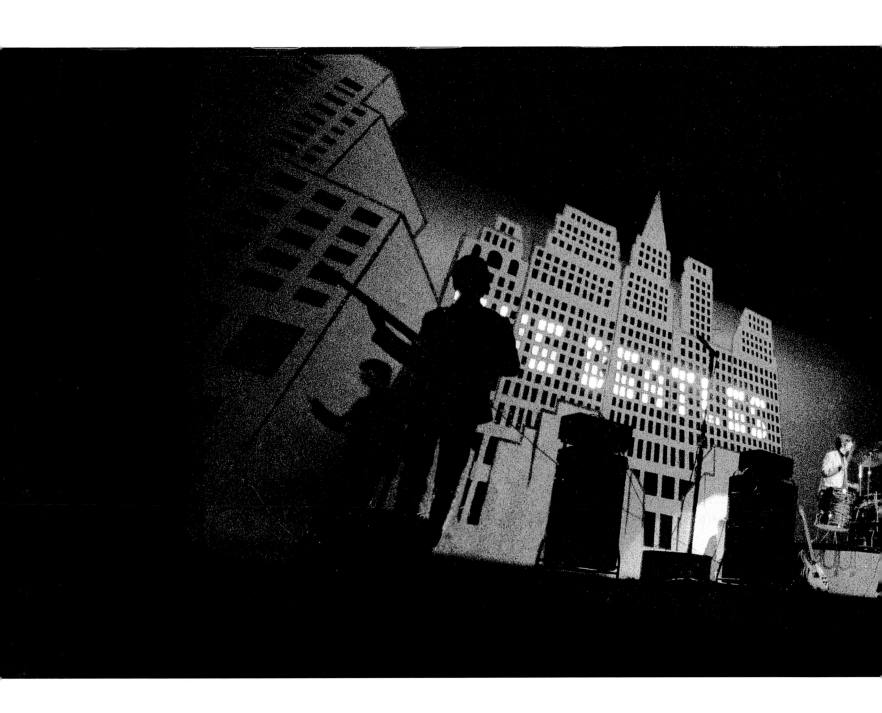

OPPOSITE: By the end of 1963, the Beatles were so big in the UK that they could command the front page of the weekly pop paper *Disc*, even though it wasn't a paid-for advertisement.

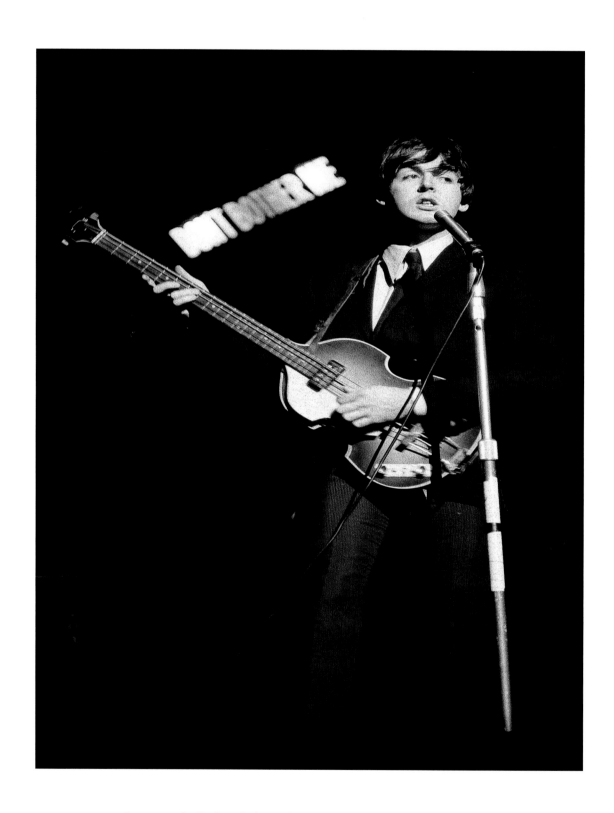

ABOVE: On stage at the Finsbury Park Astoria, Paul with his signature Hofner 'violin' bass guitar.

OPPOSITE: Paul and John at the Astoria Christmas Eve show.

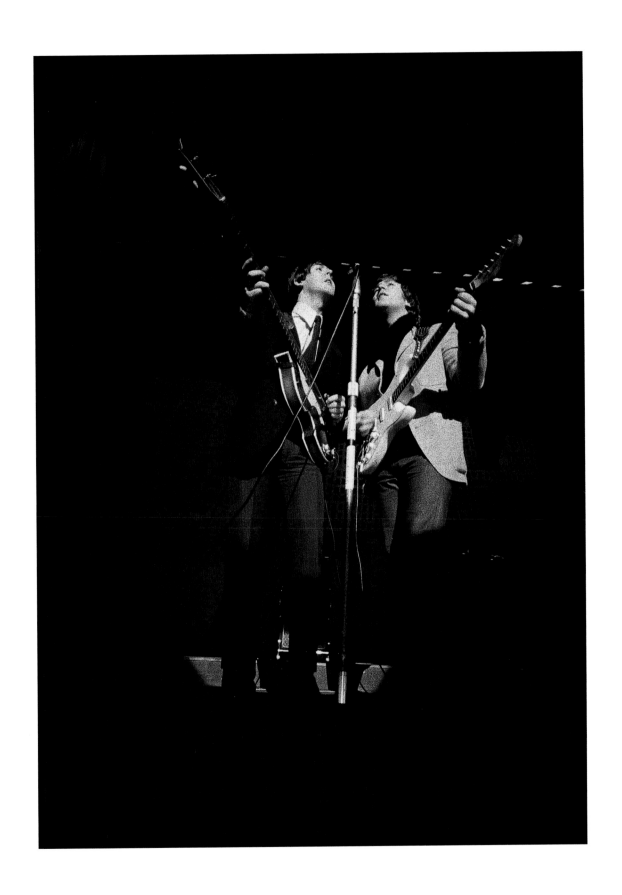

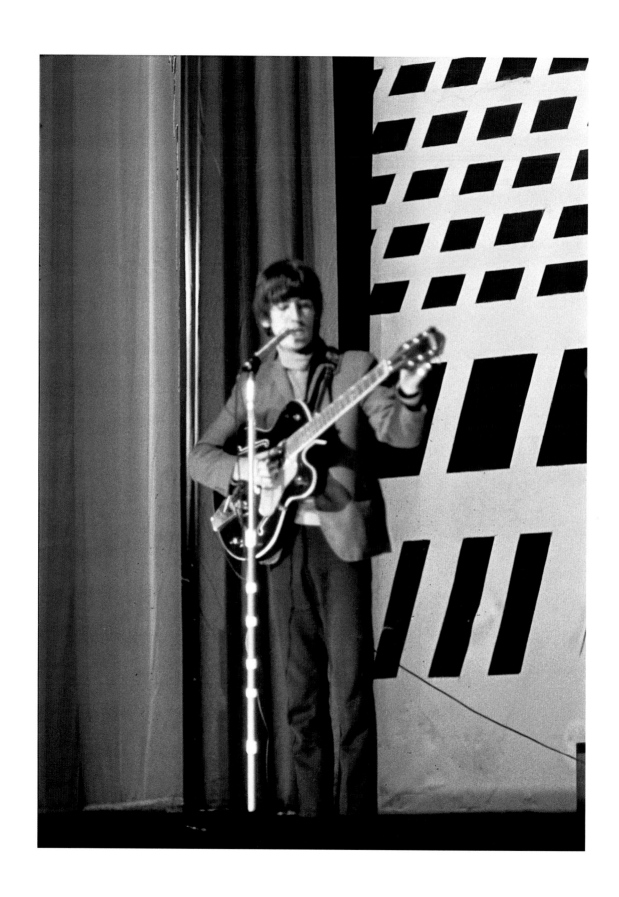

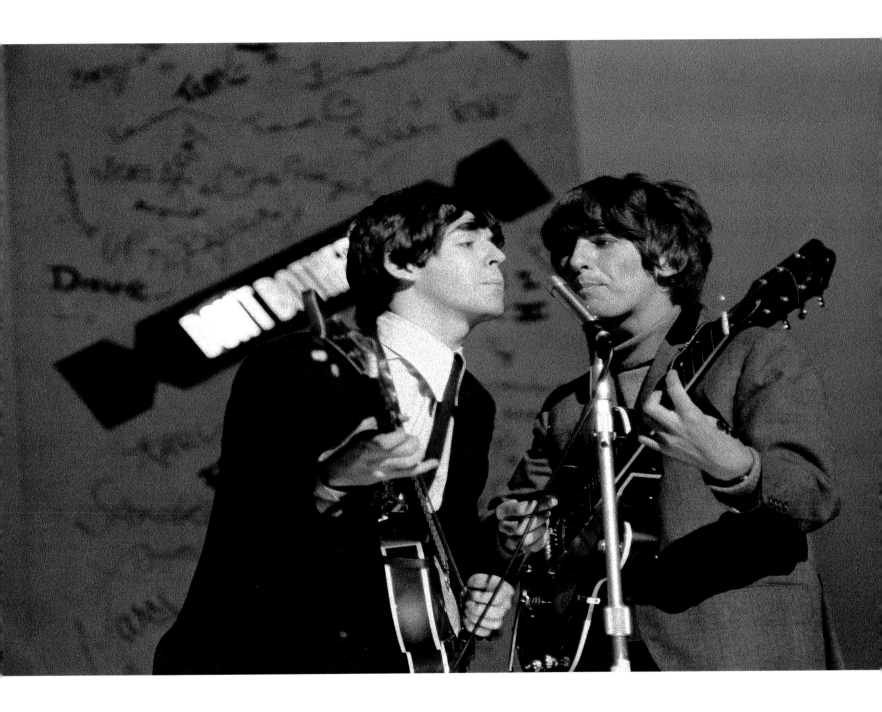

ABOVE AND OPPOSITE: More shots from the Finsbury Park show. Opened as a cinema in 1930 that also featured live stage shows, from the mid-1950s the exotically designed Astoria was host to all the big names in pop and jazz, and in the 1970s was transformed into one of London's leading rock venues, the Rainbow Theatre. A listed building, it now functions as an evangelical church.

BIG NIGHT OUT
TEDDINGTON STUDIO CENTRE, MIDDLESEX
SUNDAY 23 FEBRUARY 1964

HAVING JUST ARRIVED FROM THE USA THE NIGHT BEFORE, the Beatles were scheduled to appear on the *Big Night Out* television show, hosted by the comedy duo Mike and Bernie Winters. Again Richard Rosser captured the moments on and off set.

The programme was filmed in front of a live audience, and it was common practice on TV variety shows of this kind for guest stars to perform humorous sketches with their hosts—something the Beatles tired of later in their career. Accordingly, on this occasion the Beatles joined in with various knock-about sketches with the Winters brothers.

The Beatles appear exhausted in these pictures, evidence of the fact that they had come almost straight into the TV studio off a transatlantic flight. The recorded show was broadcast to most of the UK on 29 February from 6.35 to 7.25 pm, and in the London area on 3 March from 8.00 to 8.55 pm.

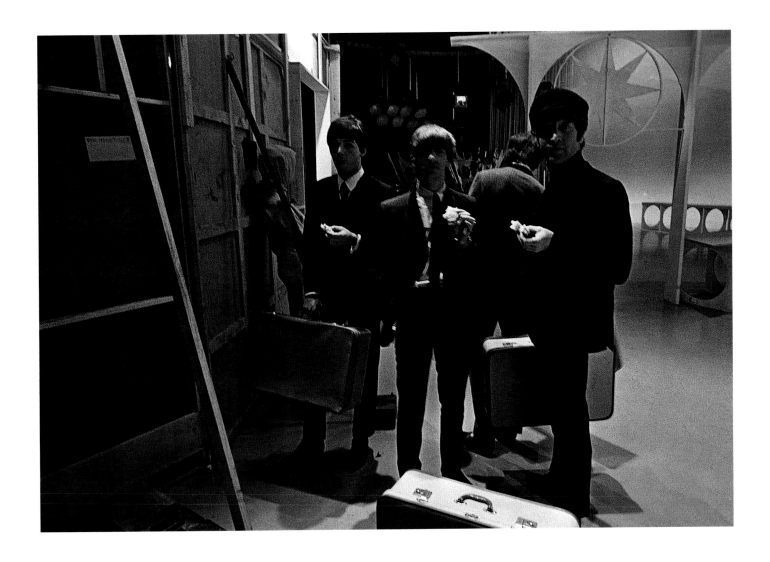

ABOVE: The Beatles behind the studio set, about to take part in the 'customs desk' sketch.

THE BEATLES ON CAMERA

. .

59

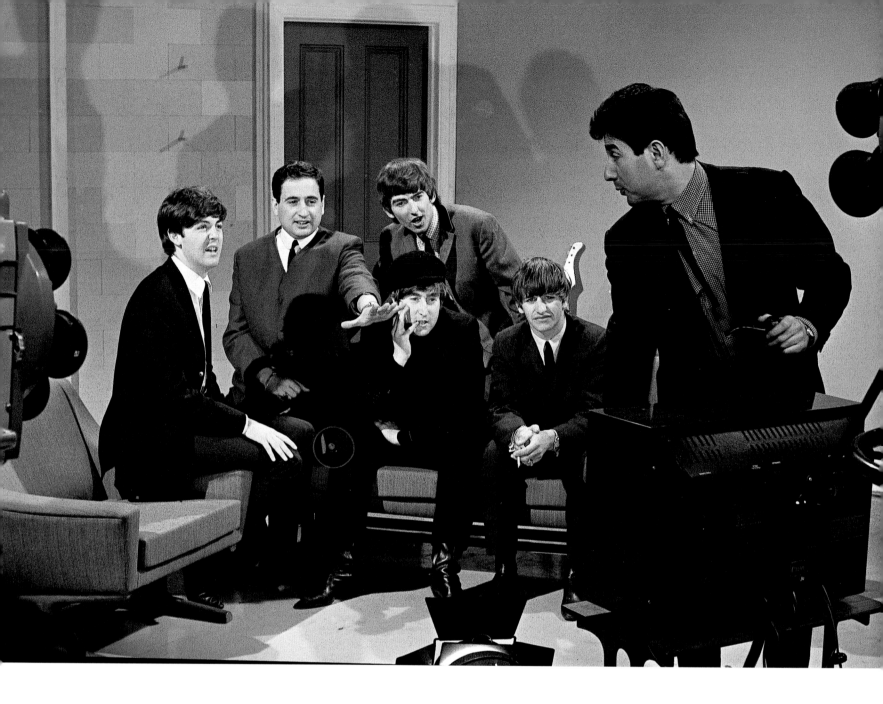

The first sketch involved the Beatles going off set to 'make a cup of tea', while Bernie Winters (in a Beatles-style suit) complains to his brother Mike that the Beatles are holding him back in his musical career because they're jealous of him being the sexy one in the group.

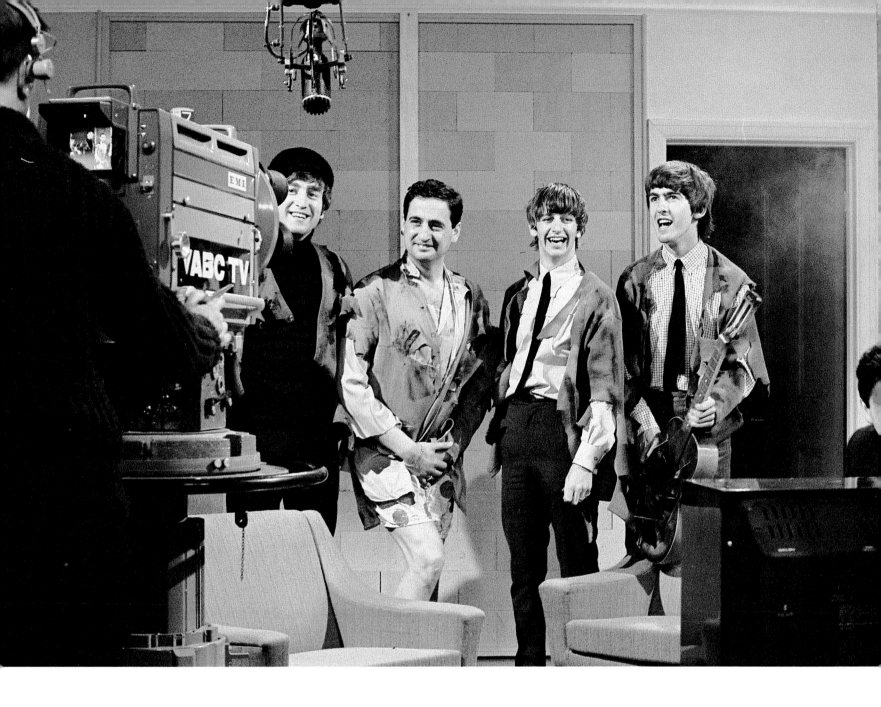

Bernie then joins the Beatles making tea, leaving his brother sitting on a couch thinking aloud: 'The Beatles, the Beatles? No, it couldn't catch on... 'ere Bern, is the tea ready yet?' There's a loud explosion, and the Beatles come through the kitchen wall into the living room with their clothes in tatters and guitars smashed. Bernie Winters looks into the camera and announces 'Welcome to *Big Night Out!*'

The next sketch had the Beatles getting off a boat into a vintage car, pretending to be going through customs on their journey from the USA. Bernie is dressed as a customs officer, letting the Beatles through a mock-up customs checkpoint without looking in their suitcases. His colleague is surprised, saying that he hasn't searched the cases, Bernie replies that he knows what's in them – money. The Beatles then throw the money out of their suitcases into the air.

Another sketch involved the Beatles reading out fan letters requesting songs that should be performed by Bernie Winters, only to find Bernie writing out the letters himself, and John threatening to 'smash' him in the face.

OPPOSITE: Mike and Bernie Winters running through the 'customs officer' sketch.

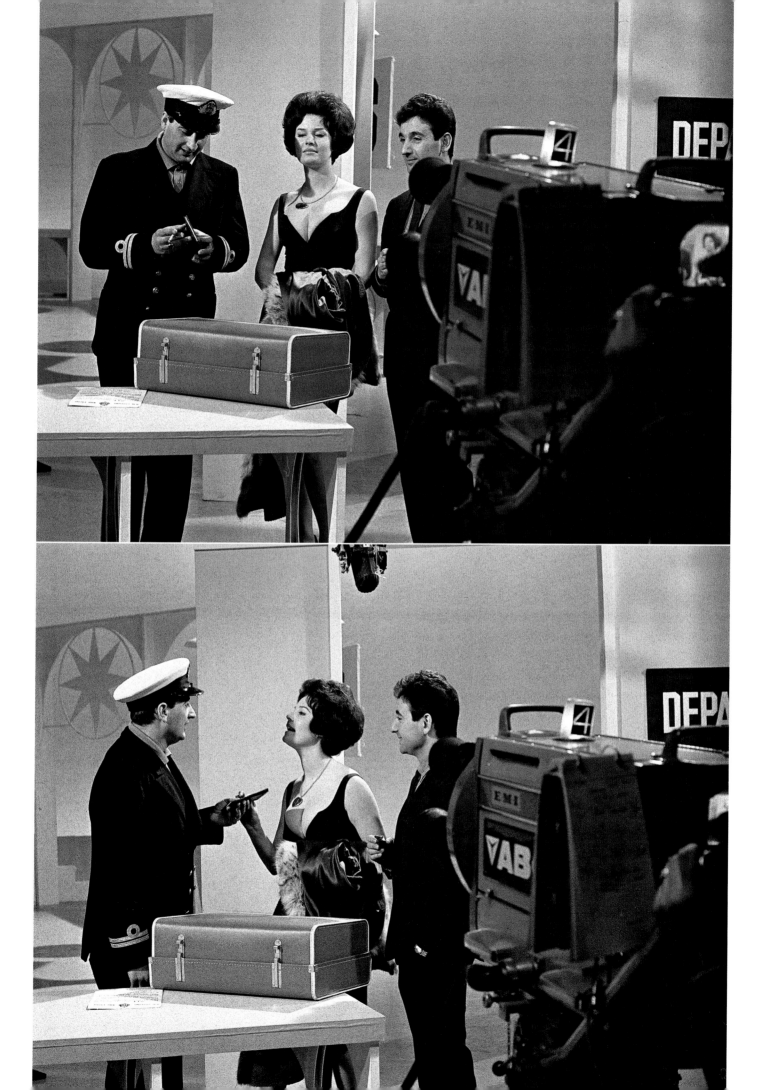

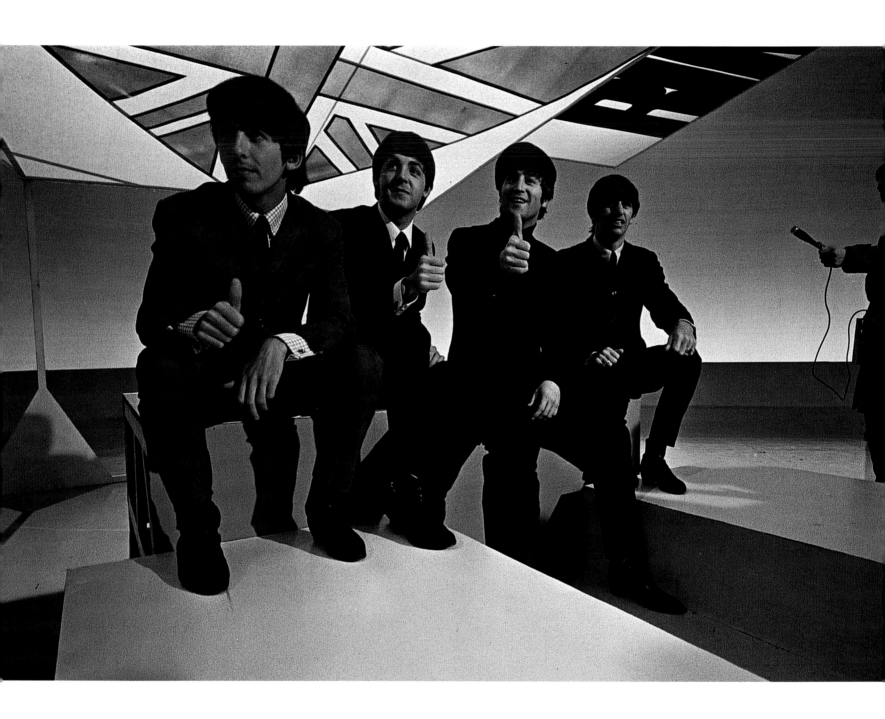

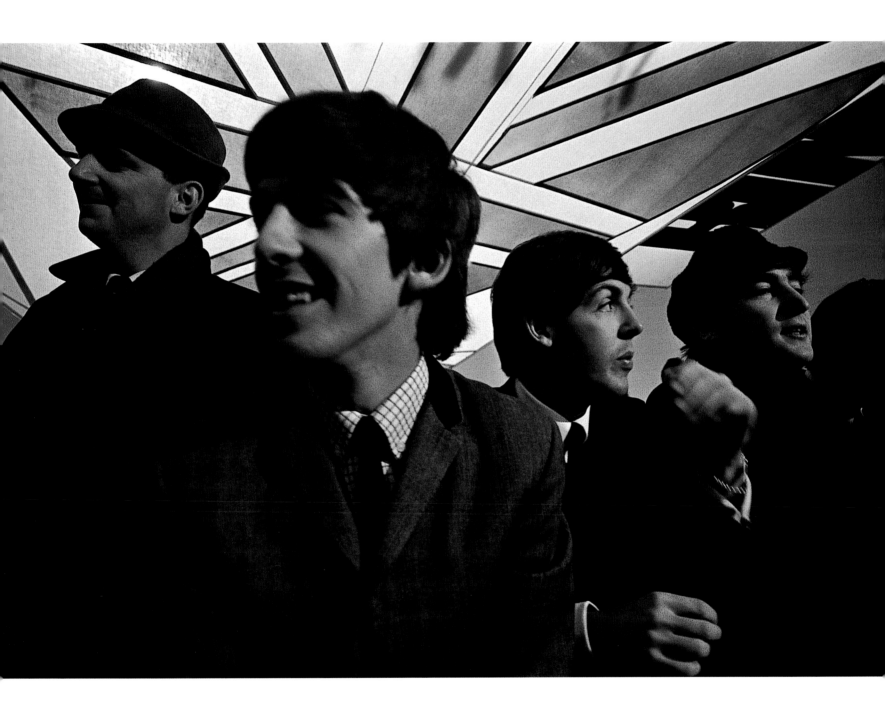

As it was announced 'It's time for the fabulous Beatles', the group went into 'All My Loving', standing on individual podiums. Their first names were spelled out above their heads, surrounding a huge heart painted in a 'Union Jack' design. They also mimed 'I Wanna Be Your Man', 'Till There Was You', 'Please Mr Postman', ending with 'I Want To Hold Your Hand', while other guests including Billy Dainty, Jackie Trent, and Lionel Blair danced to the music along with Mike and Bernie.

THE DORCHESTER HOTEL
PARK LANE, LONDON
THURSDAY 19 MARCH 1964

I WAS LIVING 50 YARDS UP THE ROAD IN PARK LANE when the Beatles arrived at the Dorchester Hotel for the 12th Annual Luncheon of the Variety Club of Great Britain. Richard Rosser was already prepared, having the lucky chance to be situated to the left of Mr Harold Wilson (leader of the Labour Party, who would be Prime Minister before the end of the year), while other photographers were crammed in away to the other side.

Paul McCartney interviewed both Harry Corbet, the children's TV entertainer who found fame with his puppet bear Sooty, and the Beatles' co-star from *A Hard Day's Night* Wilfrid Brambell (best known for his role in television's *Steptoe and Son*). TV cameras filmed George Harrison with a cup of tea, while John was caught with a glass of wine in his hand – which he promptly put down in favour of tea, for appearance's sake. Ringo proceeded to put on his Variety Club tie, when Brian Epstein and Mr Wilson joined them for the usual politician-meets-best-mates-the-Beatles photo opportunity. (It's a ritual that still goes on today, as in Martin Scorsese's Rolling Stones film *Shine A Light*, in which Bill Clinton is seen several times shaking hands with the band.)

Eventually Lennon announced their departure – 'We've got to go now, 'cause the fella on the film wants us and he says it's costing him a fortune.' They had to rush back to Teddington to resume filming on their (as yet unnamed) movie, before recording *Top Of The Pops* that same evening.

The film's producers had come up with some possible titles including 'Moving On', 'Travelling On', and 'Let's Go', the Beatles having already rejected 'Beatlemania' as a title. At the end of this very busy day Ringo was heard to say 'Boy, this has been a hard day's night', without realising he had just coined the title for their first movie.

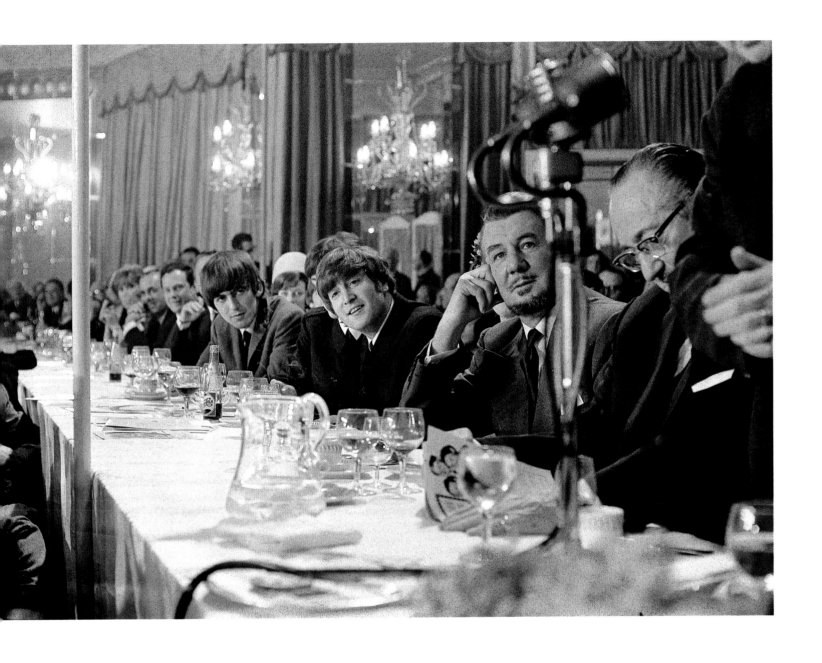

ABOVE: The whole Variety Club event was captured on camera by the BBC, who screened it from 10.30 to 11.00 pm on 23 March 1964.

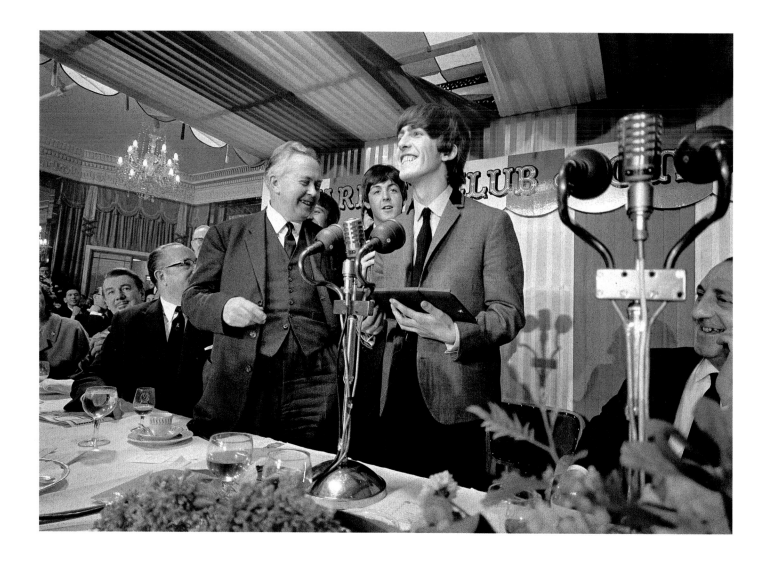

Harold Wilson presented the Beatles with Show Business Personalities of 1963 awards – cast in silver,
in the shape of a heart – which the Beatles received with their usual humour. George said they were
pleased: '...especially to get one each, because we usually have a bit of trouble cutting them in four';
Paul – 'But I still think you should've given one to good Mr Wilson'; Ringo – 'Anyone who knows us
knows I'm the one who never speaks, so I'd just like to say thanks a lot'; with John concluding 'Thanks
for the purple hearts', referring to both amphetamines and the US military decoration. Ringo pointed
out they were silver and John apologised with 'sorry about that, Harold'.

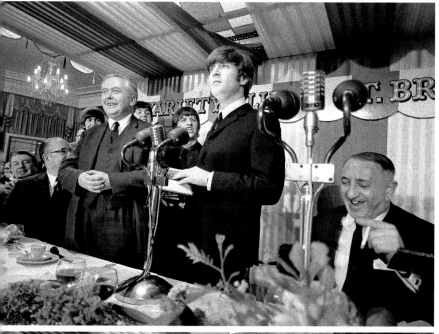
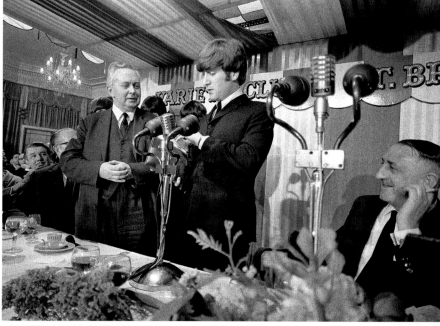
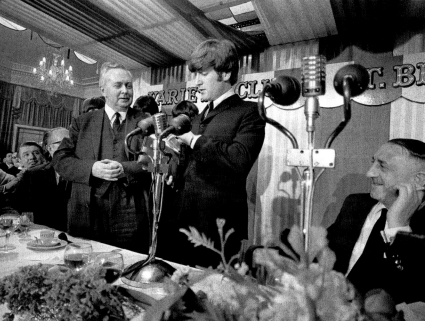
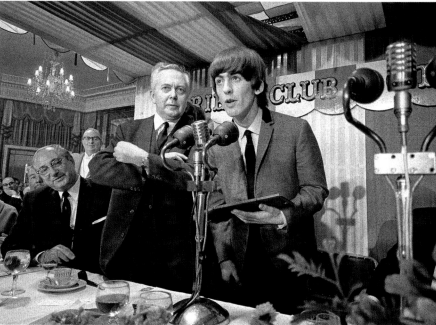

OPPOSITE, ABOVE AND OVERLEAF: Wilson was also referred to as 'chief barker' for his role at the luncheon, so John started calling him Mr Dobson, as in the famous confectionery company Barker and Dobson.

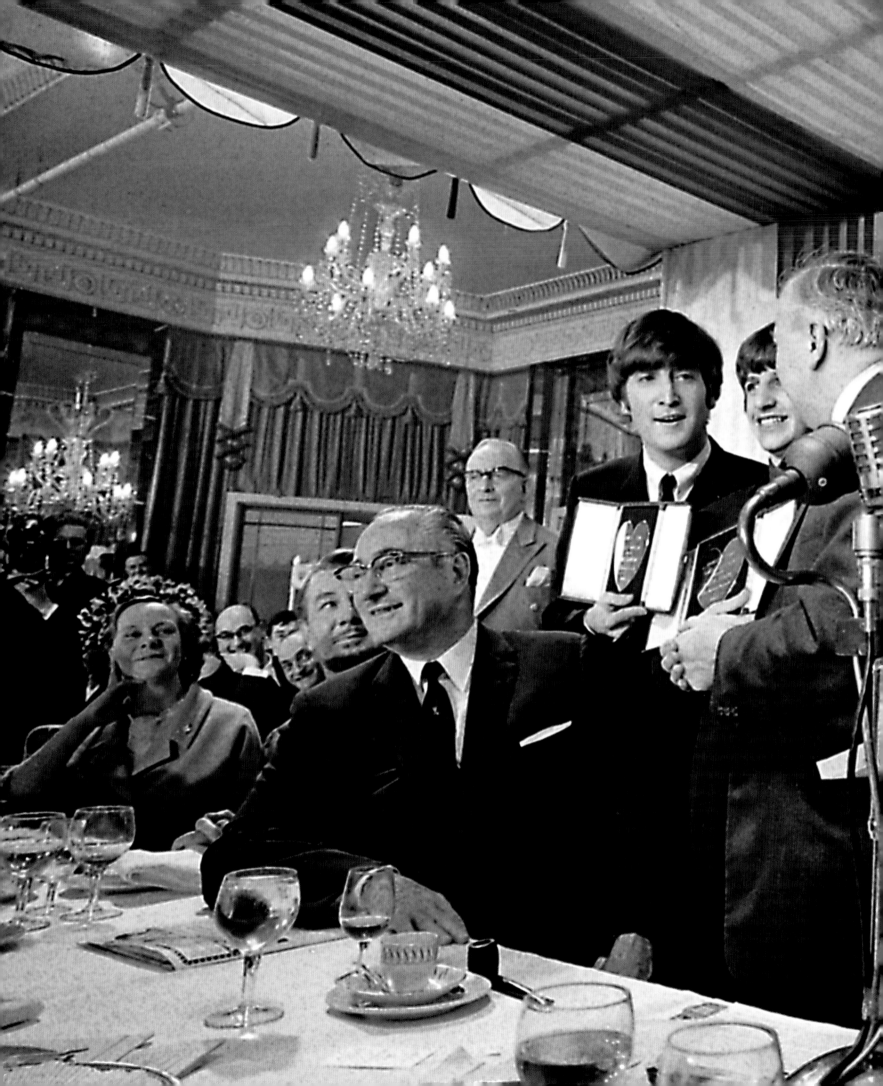

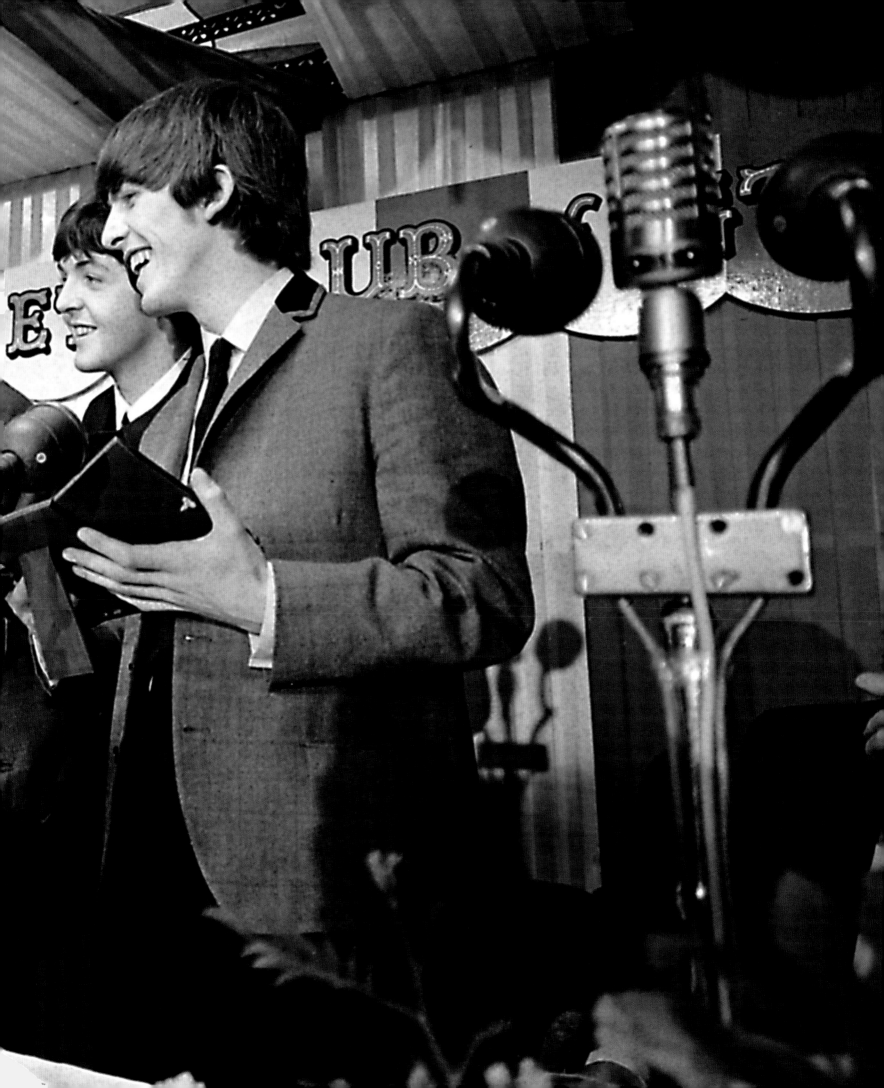

READY STEADY GO!
STUDIO 9, TELEVISION HOUSE,
KINGSWAY, LONDON
FRIDAY 20 MARCH 1964

BROADCAST FROM 6.15 TO 7.00 PM EVERY FRIDAY, and hosted by Cathy McGowan and Keith Fordyce, Associated Rediffusion's *Ready Steady Go!* was the alternative to the BBC's *Top Of The Pops*. There were only two TV channels in the UK in 1964, so music coverage was quite limited; when *Ready Steady Go!* began featuring live bands, many fans were seeing their idols for the first time.

Ready Steady Go! was rehearsed and broadcast on the same evening, so the Beatles arrived, quickly did a run-through, and then appeared live playing 'It Won't Be Long', 'Can't Buy Me Love', and 'You Can't Do That'. Keith Fordyce presented the group with a *Billboard* magazine award for having records at number 1, 2 and 3 in the US charts – then Keith told them, after presenting the award, that they had made the number 4 slot too! Fordyce went on to ask John Lennon about his book *In His Own Write*:

Keith: Tell us what's in it then we might feel like buying it.

John: Rubbish!

Keith: Have you in fact just done it, or did you do it a long time ago?

John: It's been a long time... about 40 years or so.

Keith: Is this another form of expression for you?

John: No, I don't express nothing in the writing, I just do it for fun.

Ringo was also interviewed, by Cathy McGowan:

Cathy: Do you think you're a mod, do you know what a mod is, Ringo?

Ringo: No I'm not a mod, or a rocker – I'm a mocker!

Then it was George's turn:

Cathy: Can you ever go anywhere now where you're not recognised?

George: Erm... bed, yeah, that's about the only place!

Cathy: How did you enjoy America... what did you like in particular about it?

George: All sorts of things – the entertainment, the radio, TV and drive-in movies...

Cathy: Where do you go here when you're not working? Do you go to films?

George: Sometimes we see private films... they're not sort of dirty ones... no, James Bond, all that, you know, only private because if we go out to a normal theatre, it's too much trouble.

Cathy: Can we hear your latest record now please?

George: No! [audience laugh] Yes, certainly you can hear it, and it's called 'Can't Buy Me Love and... on Parlophone, and it's six [shillings] and nine [pence].

The previous week, viewers had been invited to send in artwork for the Beatles to see and judge, so this show saw the Beatles walking around looking at the artwork, with John scribbling on one of the artworks 'Buy my book'. John handed the winner his chosen prize of albums by Shostakovich and Charlie Mingus, to which John screwed up his face and said 'each to his own'. He then introduced a close friend, the singer Alma Cogan, as 'Alma Warren'. As the show ended, Paul and John could be seen signing autographs while Ringo danced with Cathy McGowan.

These photographs, among the very earliest pictures of rock musicians taken with a fish-eye lens, were the work of Richard Rosser.

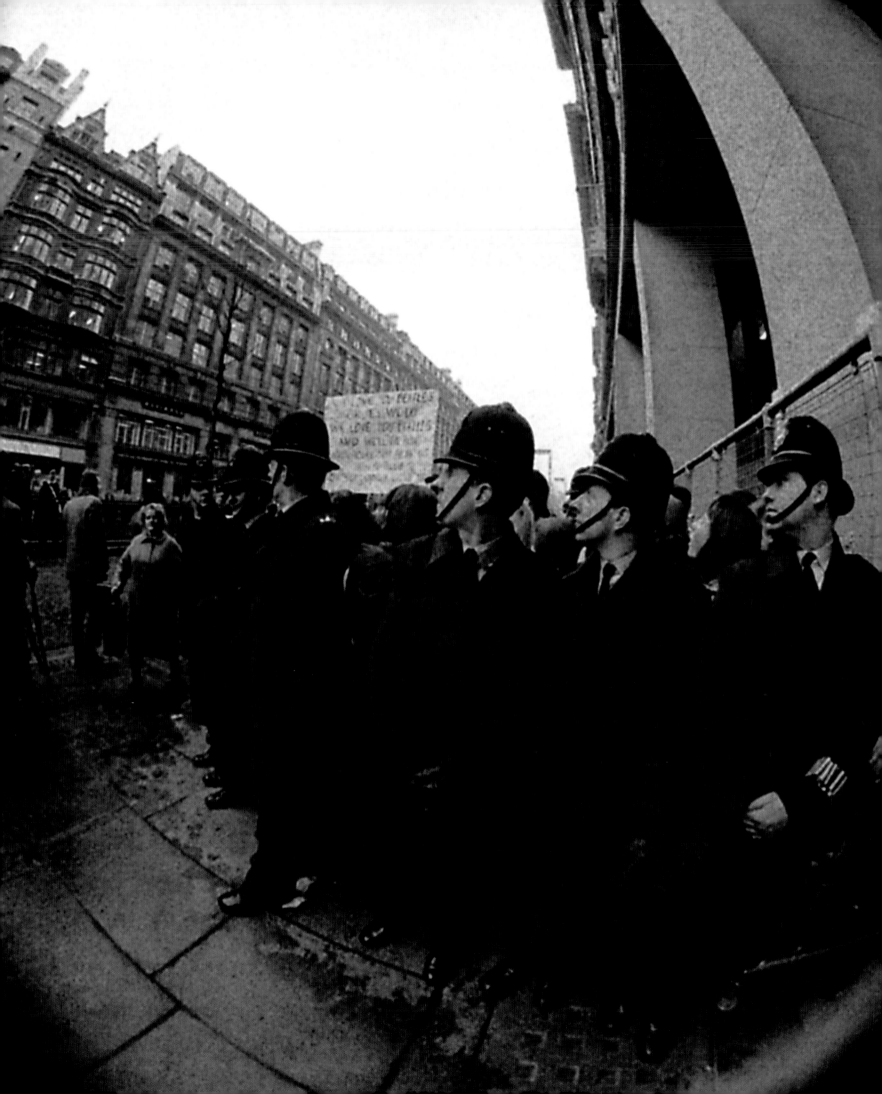

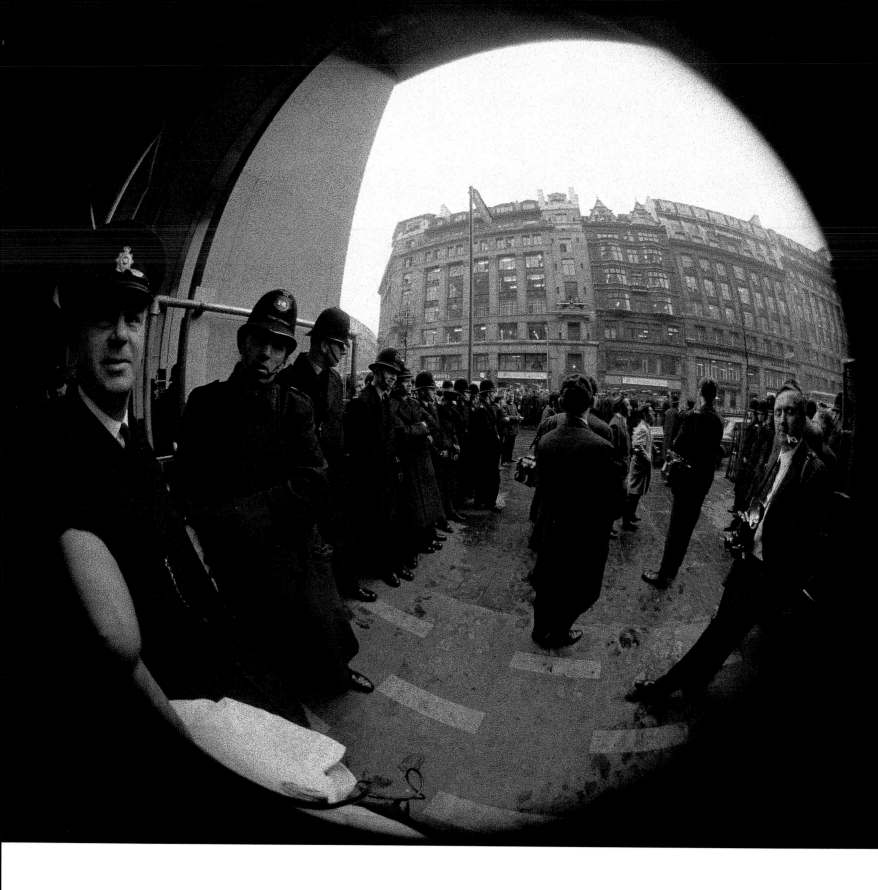

PREVIOUS PAGE, ABOVE AND OPPOSITE: Police line up outside the TV studios in London's Kingsway where they, with a phalanx of photographers, await the arrival of the Beatles and the inevitable hordes of fans.

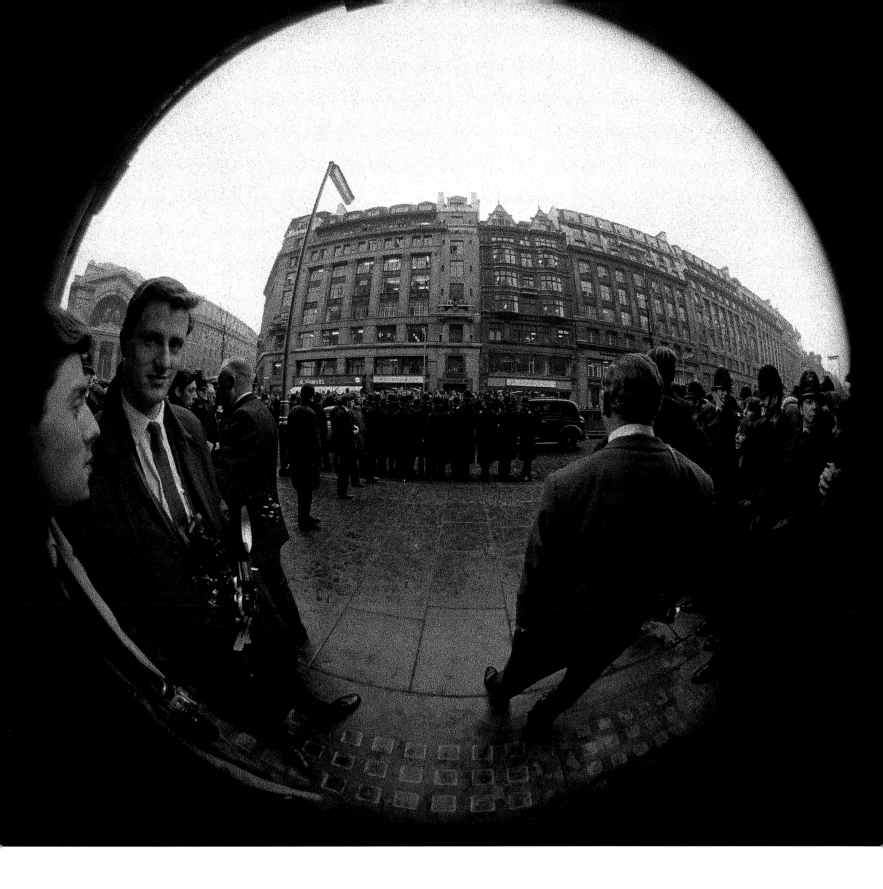

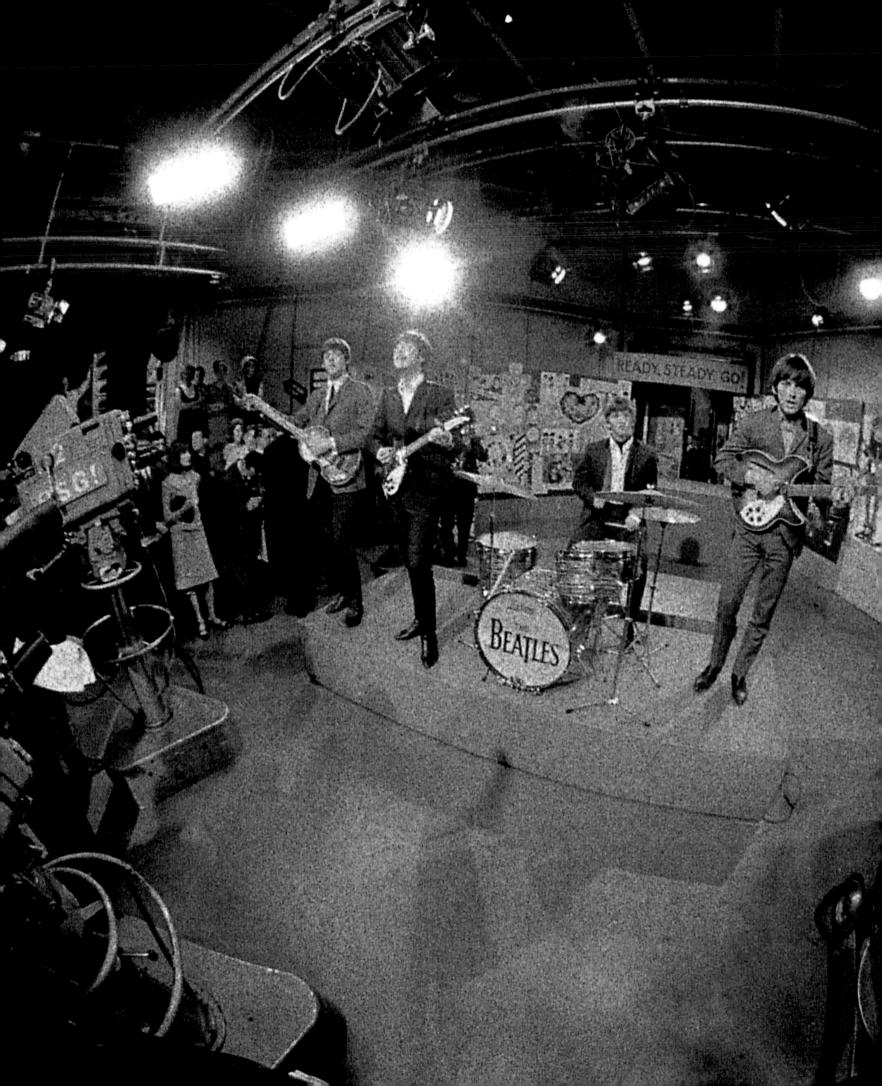

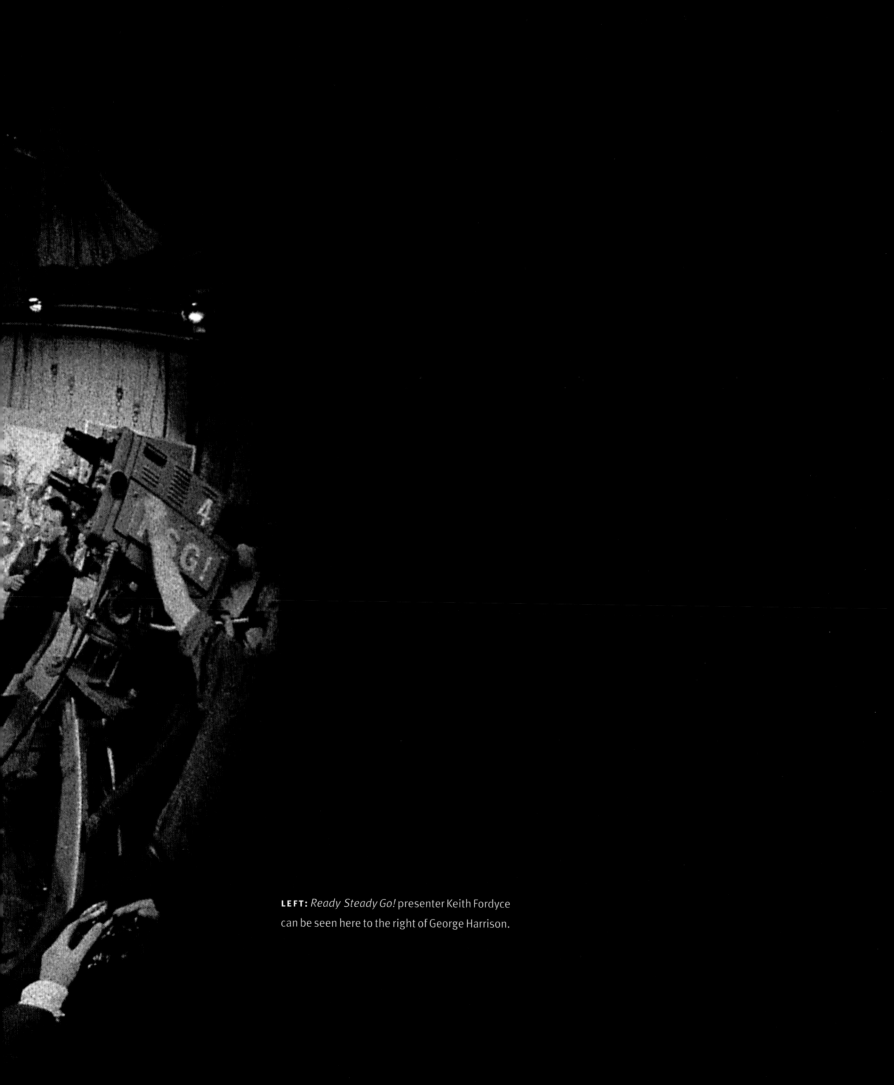

LEFT: *Ready Steady Go!* presenter Keith Fordyce can be seen here to the right of George Harrison.

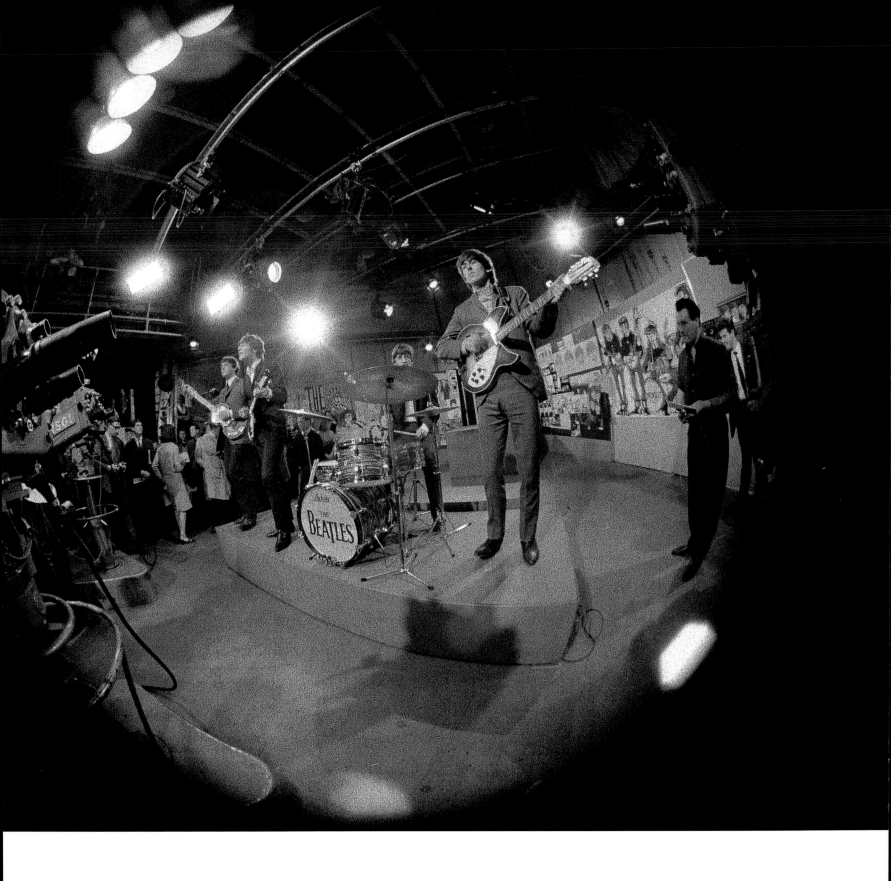

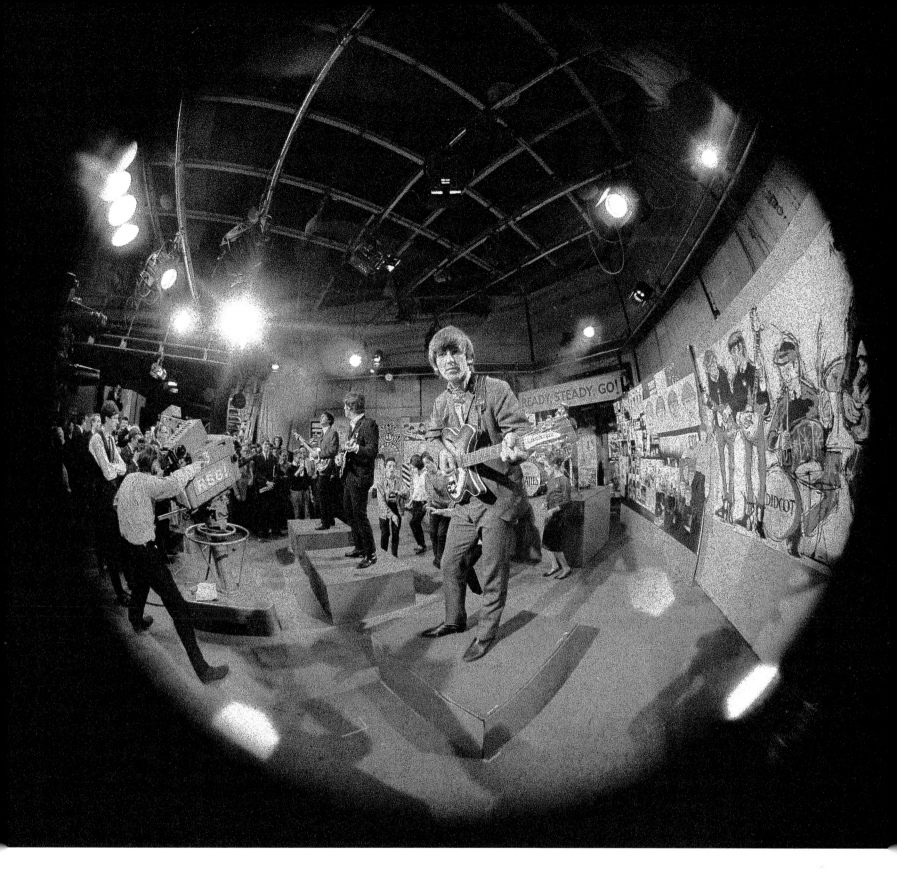

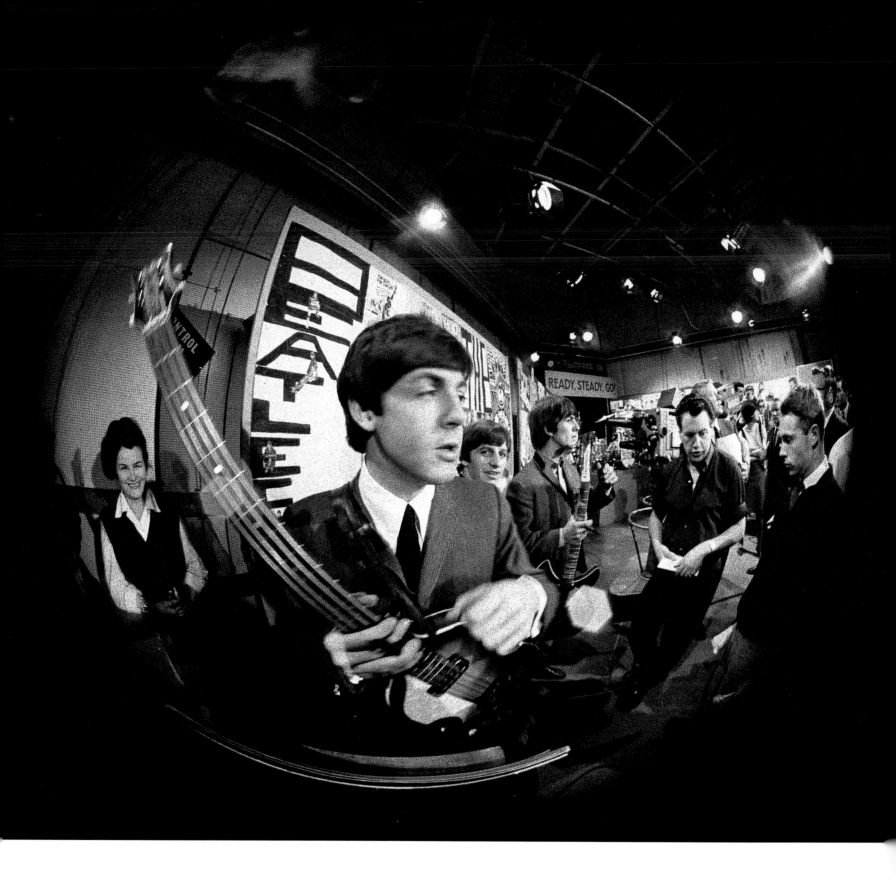

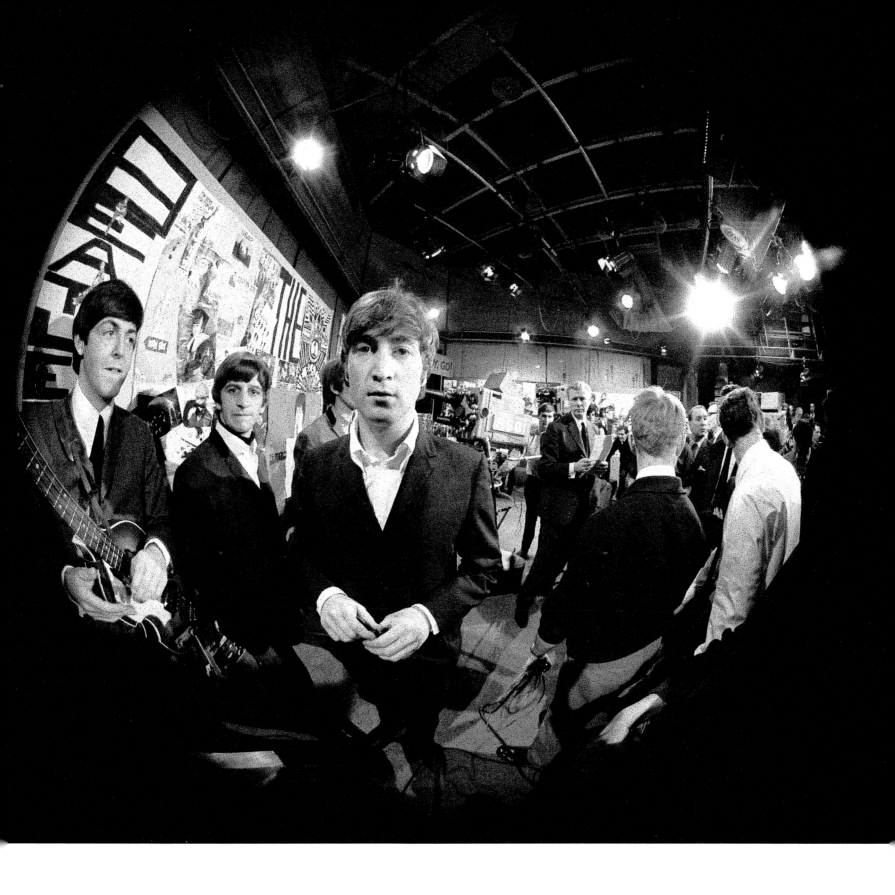

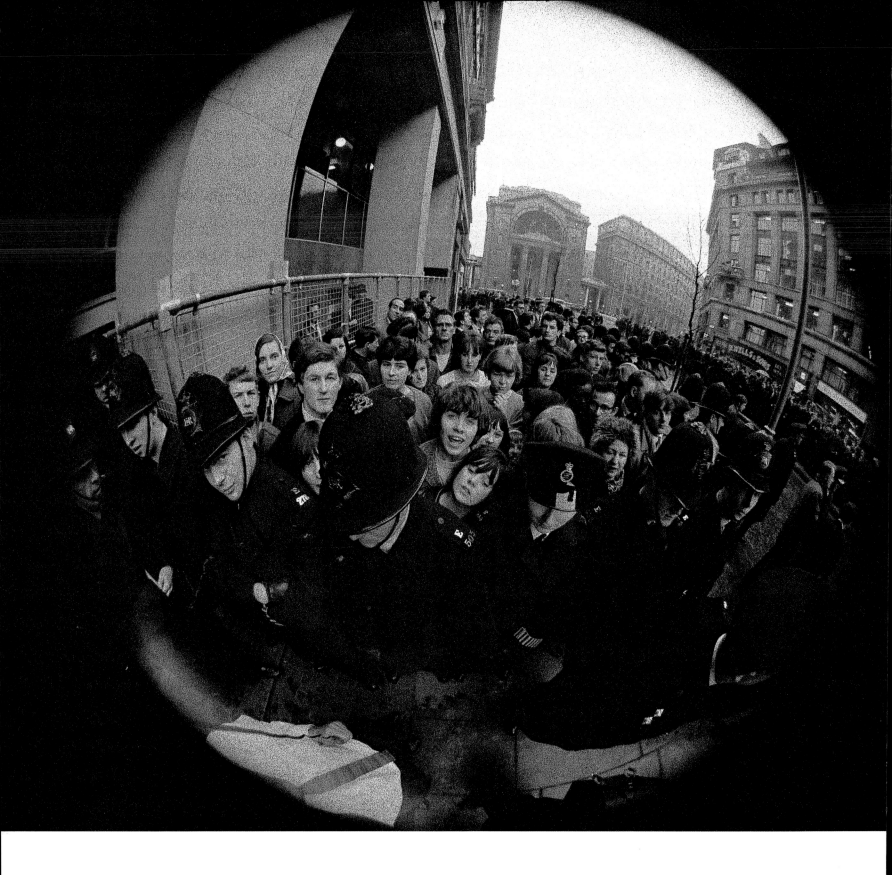

ABOVE AND OPPOSITE: Fans crowded Kingsway before and after the show, to catch a glimpse of the arrival and departure of the Beatles.

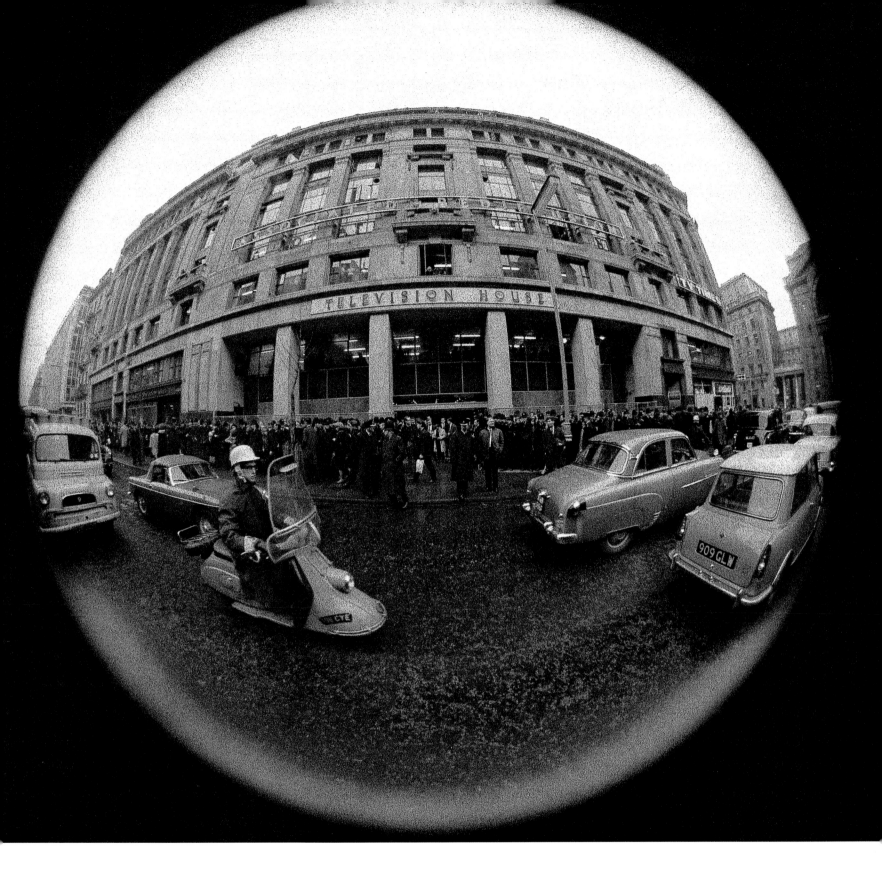

A HARD DAY'S NIGHT
MARYLEBONE STATION, LONDON
SUNDAY 5 APRIL 1964

RICHARD ROSSER HEARD FROM EPSTEIN that Marylebone railway station had been chosen as the location for a scene in the Richard Lester-directed movie *A Hard Day's Night*. Being just around the corner from Richard's studio in Praed Street, it was easy for him to get there early. The station, like a lot of London in those days, was closed on Sundays. But word had got around that the Beatles were being filmed, and the police arrived in force to hold back the crowds. Rosser captured some great moments. Paul is seen sitting on a bench on the station concourse disguised with a stick-on goatie beard and moustache, smoking a cigarette and reading a newspaper, and is then joined by Wilfrid Brambell posing as his grandfather.

There was plenty of opportunity for some great informal shots, such as John, Paul, and George crammed into a photo booth – the signage declares 'completed in 3 minutes: 4 poses for 2 shillings [10p]'. Later scenes show the Beatles running across the station being chased by the usual posse of screaming girls.

On the following Sunday – 12 April – Richard Rosser had another opportunity to photograph the Beatles at Marylebone station. In these shots the Beatles are seen running up the platform, this time minus the crowds, for the film's opening sequences.

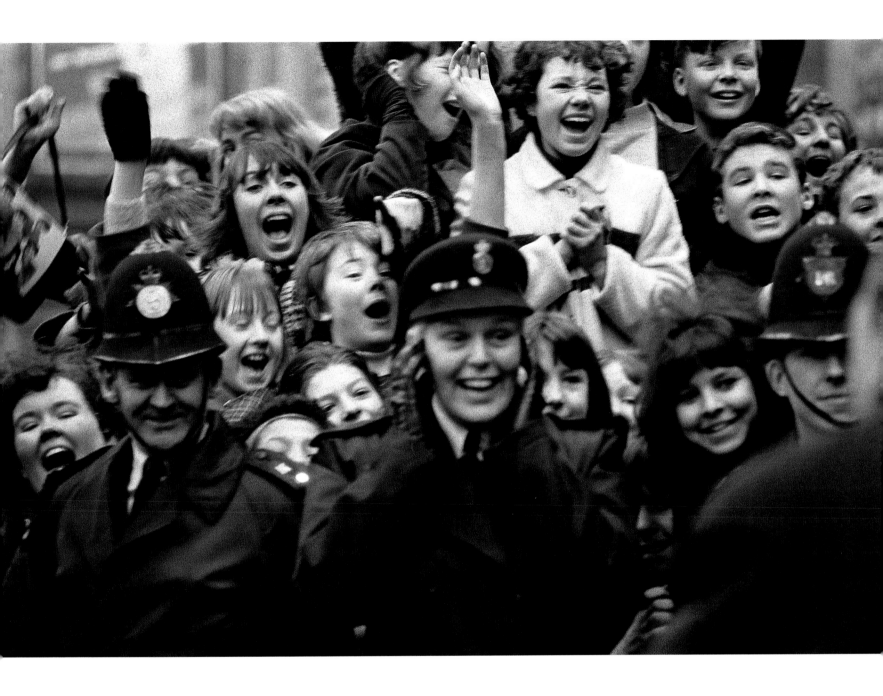

ABOVE: It was hard to divide fact from fiction when crowds of fans gathered at Marylebone station to see the Beatles filming *A Hard Day's Night*.

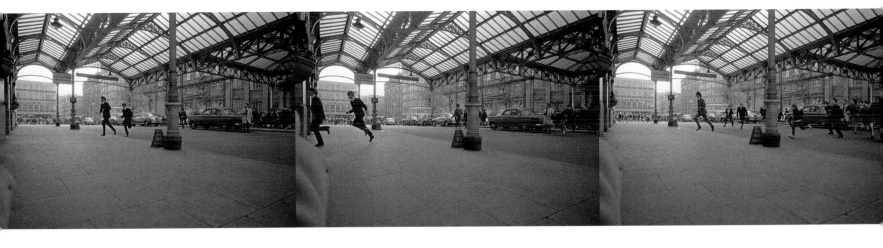

ABOVE: The Beatles running across the station concourse, pursued by fans who had become 'extras' for the day.

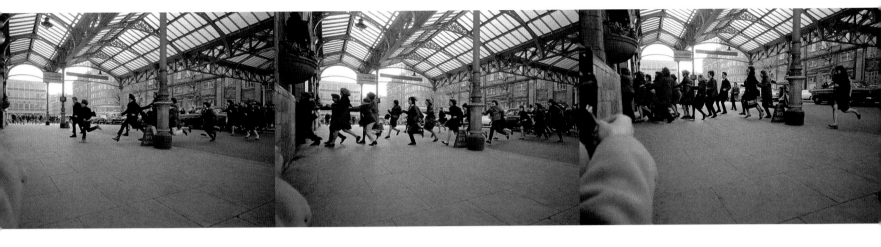

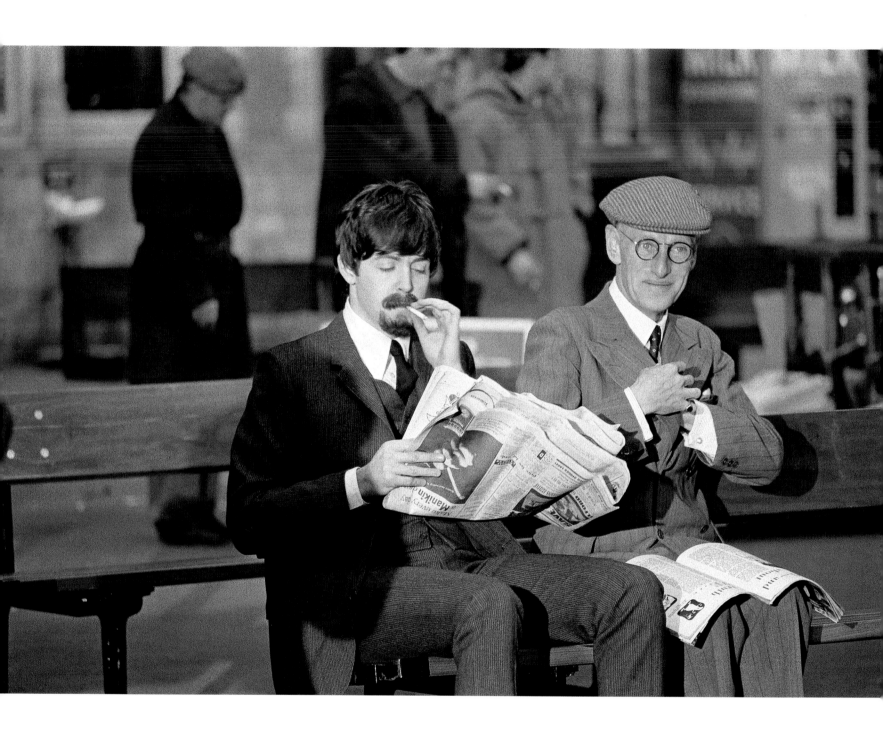

ABOVE: Paul sporting a fake beard and moustache, sitting next to TV's *Steptoe and Son* star Wilfrid Brambell.
OPPOSITE: How many Beatles can you get into a photo booth?

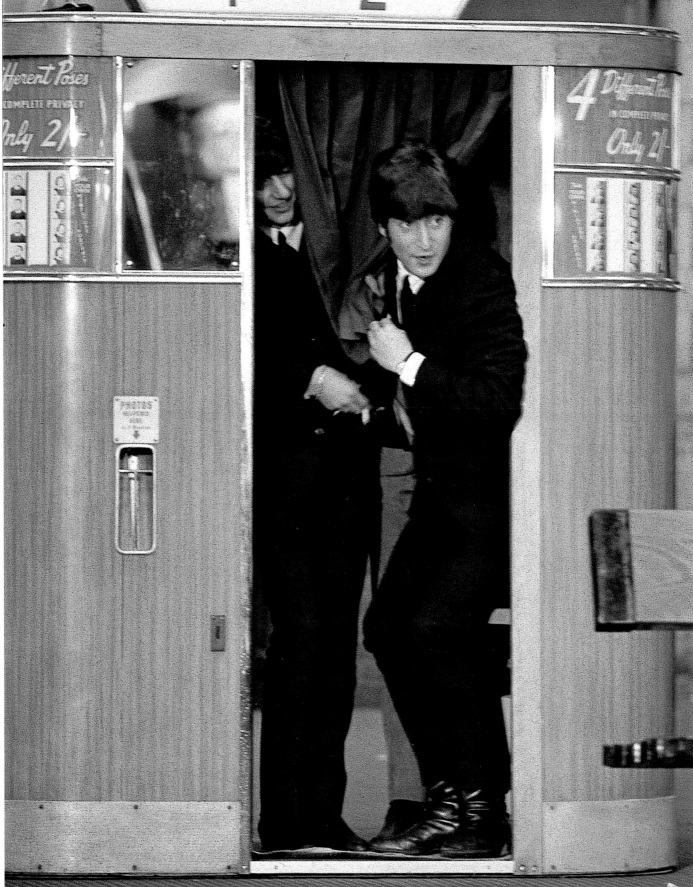

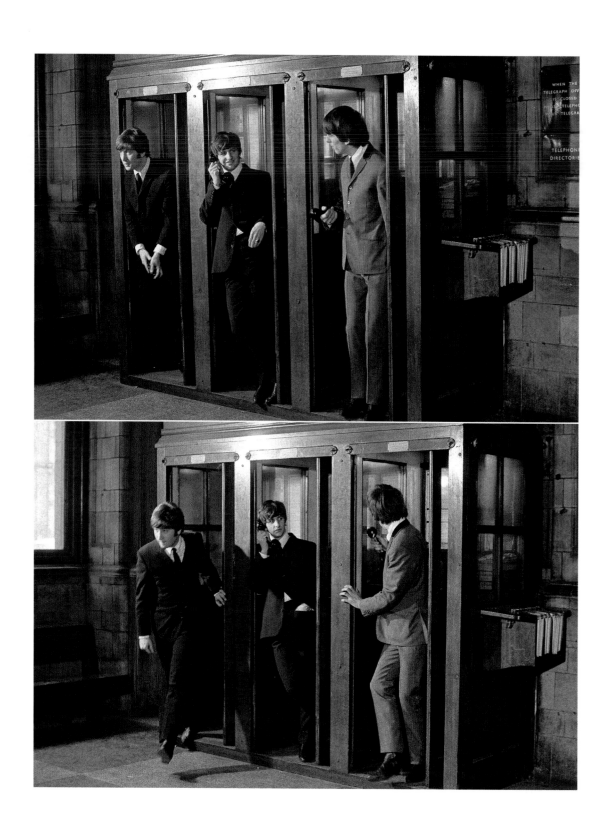

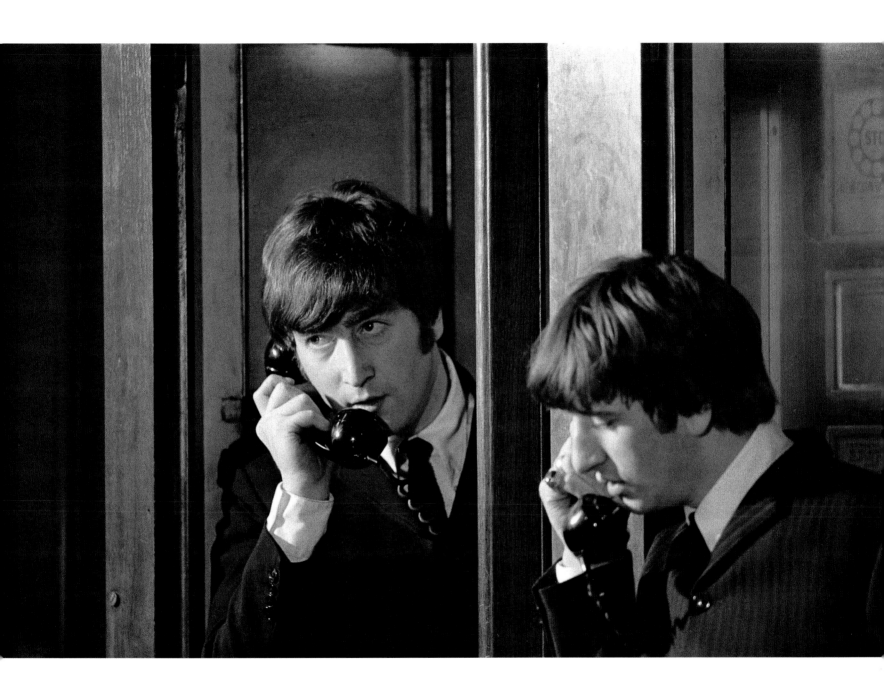

'It's as good as anybody who makes a film who can't act. The director knew we couldn't act, and we knew. So he had to try almost to catch us off guard, only you can't do that in film, you've got to repeat things over and over. But he did his best, the ten minutes that are natural stand out like a sore thumb.'

John Lennon

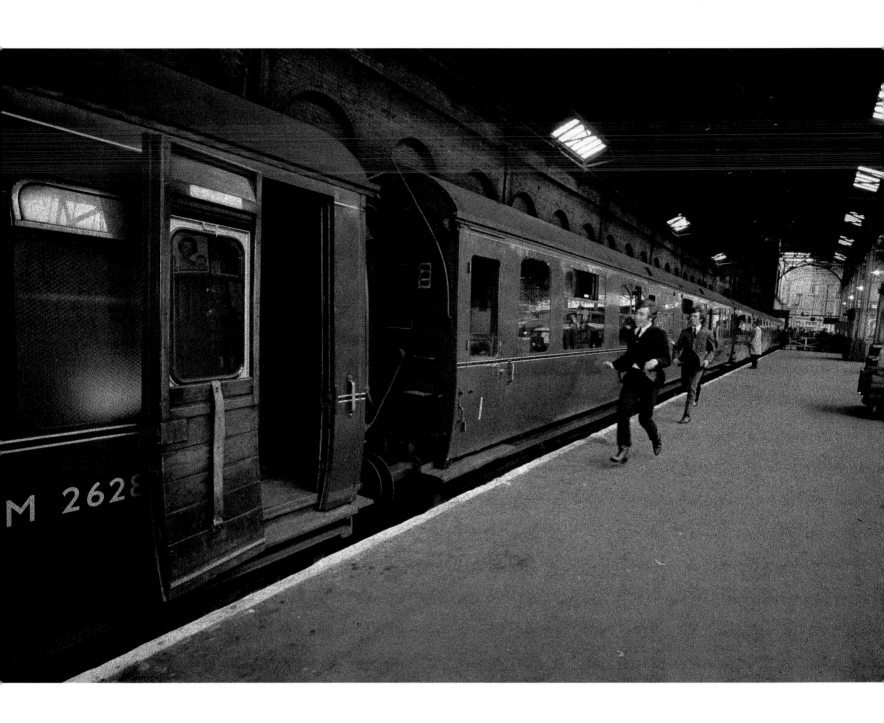

' The first scene we did was the train, which we were all dead nervous in. Practically the whole of the train bit we were going to pieces.' John Lennon

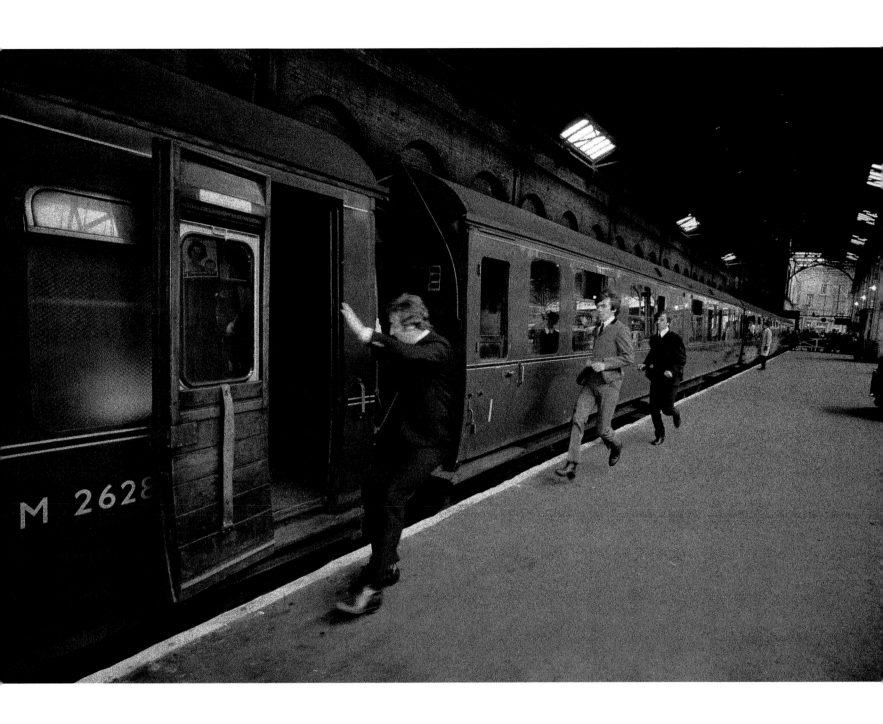

M 2628

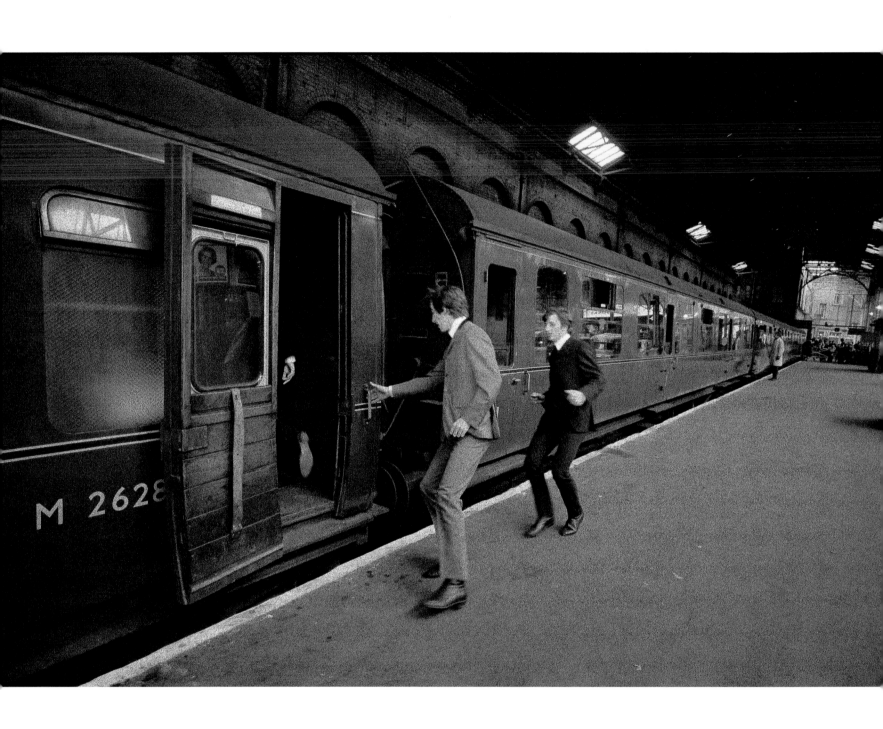

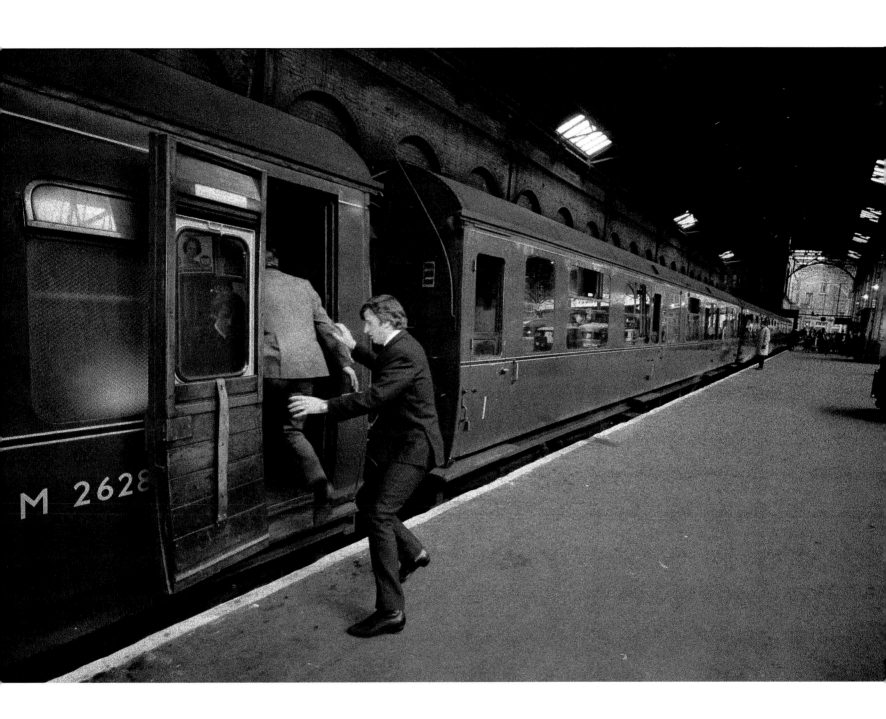

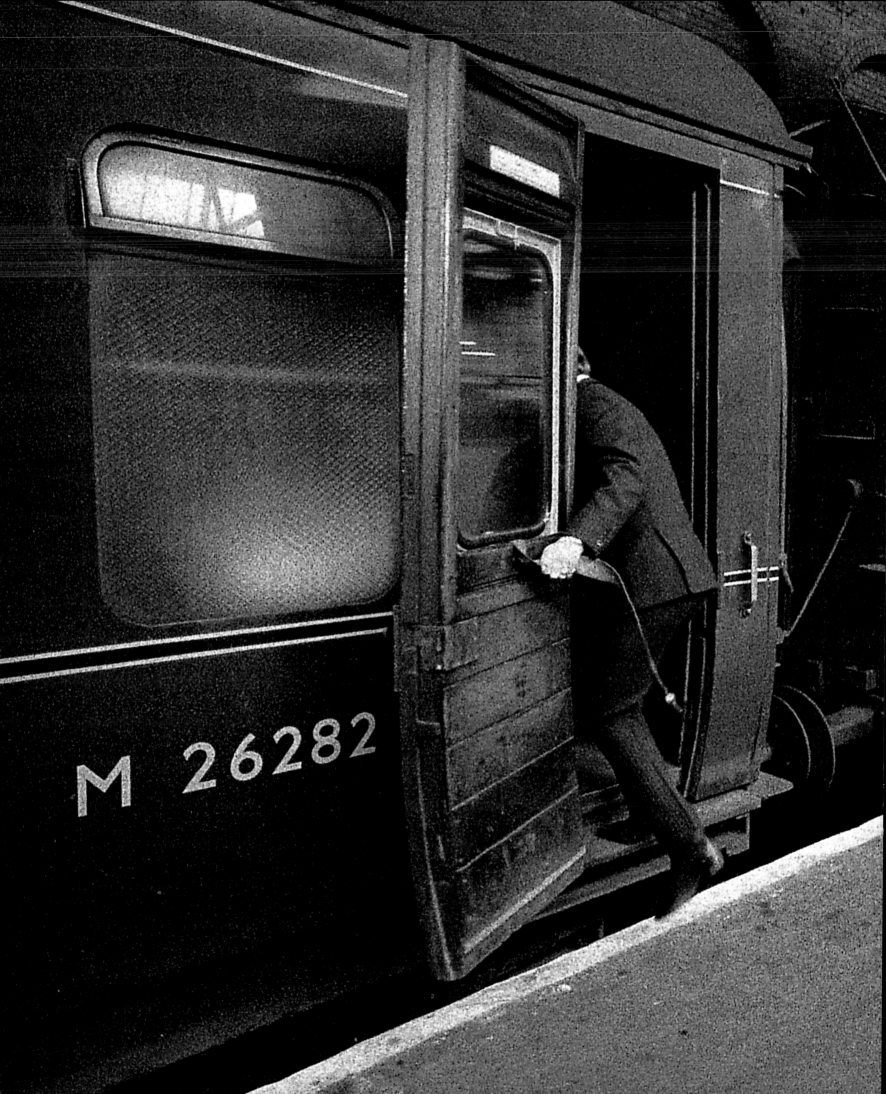

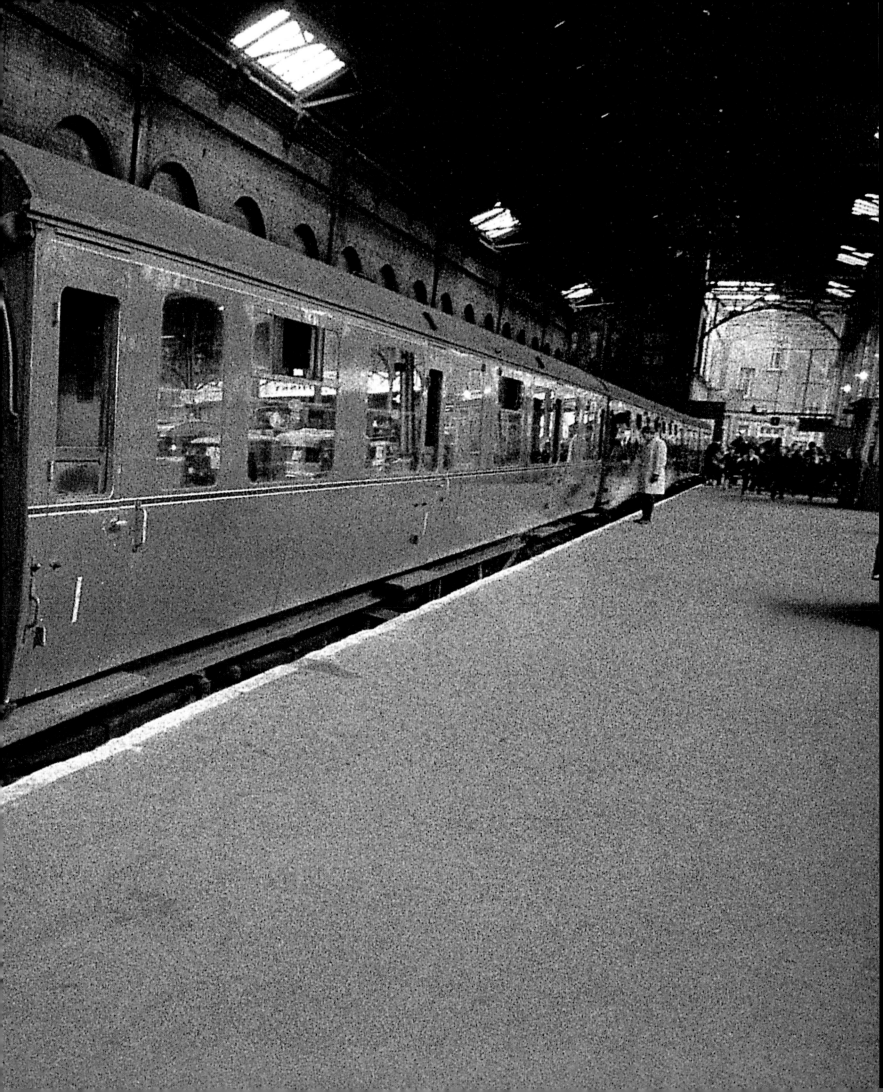

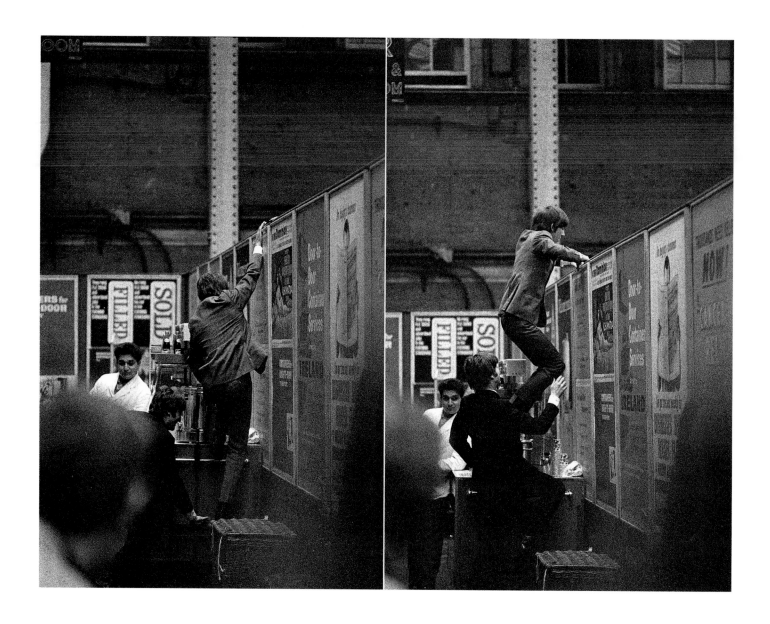

ABOVE AND OPPOSITE: The film's director, Richard Lester, had worked with the Goons on the zany *Running, Jumping and Standing Still Film* in 1959 (impressing the Beatles, particularly John Lennon) – and it showed.

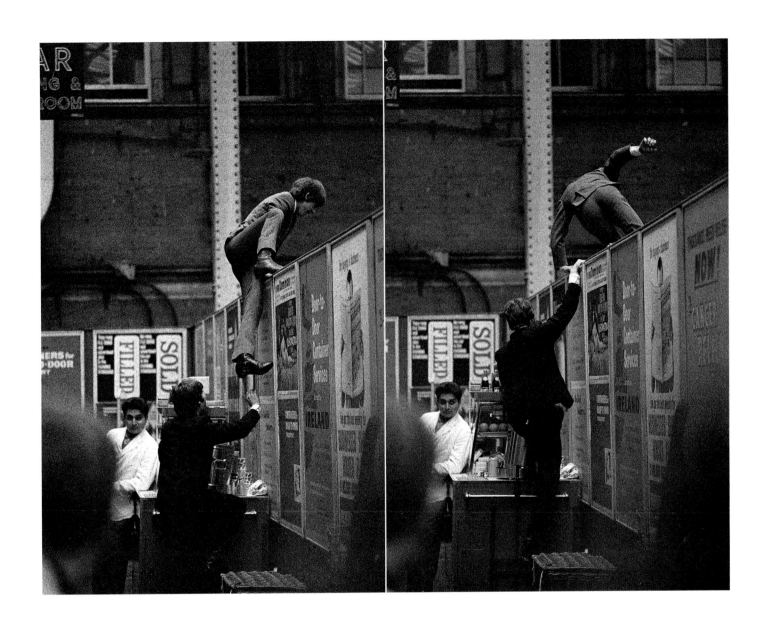

HONG KONG AND AUSTRALIA
SUNDAY 7–13 JUNE 1964

WHEN THE BEATLES EMBARKED ON A TOUR OF HONG KONG, Australia, and New Zealand on 7 June 1964 it was without Ringo Starr. The drummer had been taken ill with a severe case of tonsillitis, and as the tour dates could not be cancelled a replacement had to be found. So it was that a little-known session player, Jimmy Nichol, got to be a Beatle for a brief seven days.

All the pictures in this section (apart from those in Hong Kong, taken for the *Chinese Morning Post*, and which I bought in the late 1980s), were taken in Adelaide, where the Beatles arrived from Sydney on 12 June. Thousands of local fans were stopped by the police from entering the airport area, so a press reception arranged with the Beatles was relatively quiet. The Beatles were disappointed that there were no fans to greet them, but this was rectified the next day when a huge crowd of around 200,000 people assembled in the city centre. The Beatles drove through the crowd in an open car, and on to the Town Hall which was besieged by 30,000 people. The Beatles made an appearance on the Town Hall balcony where they were interviewed – George Harrison commented 'It's fabulous, it's the best reception ever!'. When a reporter pointed out that Adelaide had a population of only one million, John replied: 'They're all here though, aren't they!'.

The Beatles had taken the country by storm, with their records simultaneously holding the first six positions in the charts, a phenomenon which also occurred in America, and still stands as a record today.

In 2000 I came across a batch of 112 photographs of the Beatles in Adelaide, for sale at Christie's. They were taken by Rosemary Blackwell, who had virtually unlimited access to the Beatles on their visit, and are a sensational depiction of Beatlemania 'down under'.

OPPOSITE: John, George, and Paul exit the plane in Adelaide with deputy drummer Jimmy Nichol bringing up the rear.

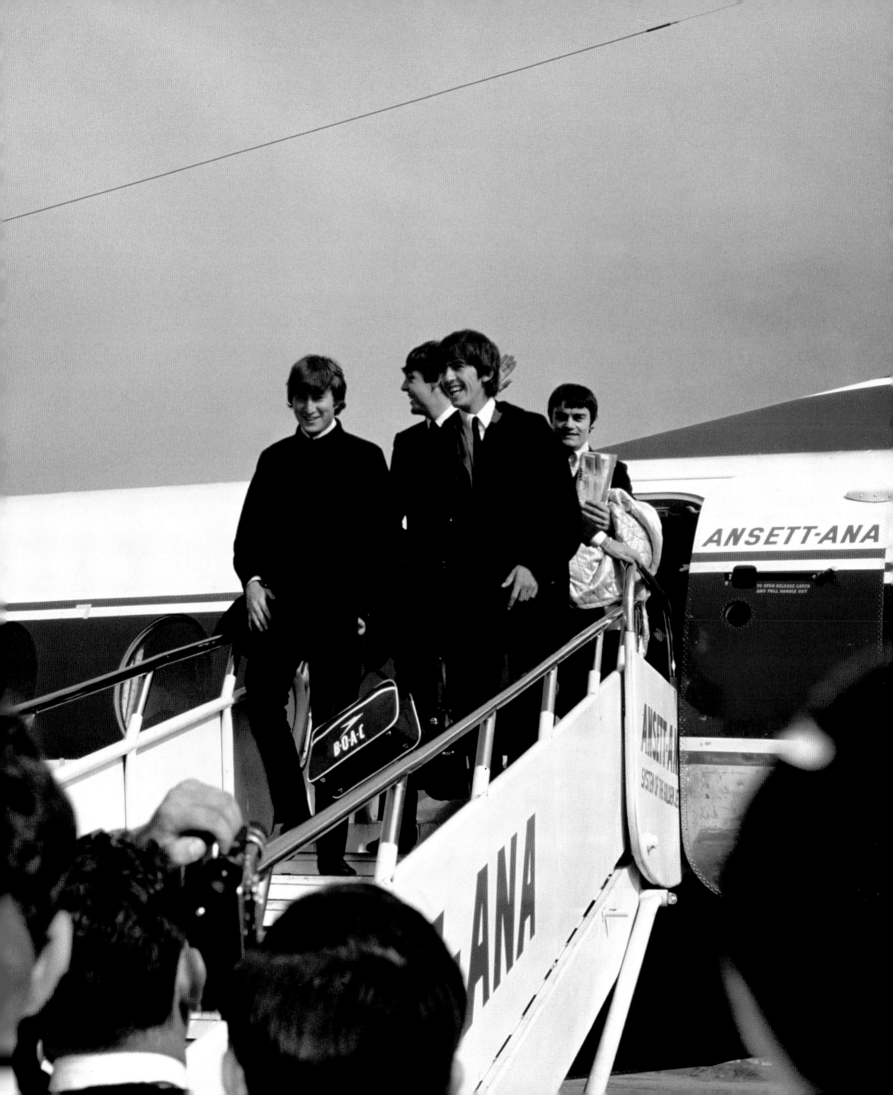

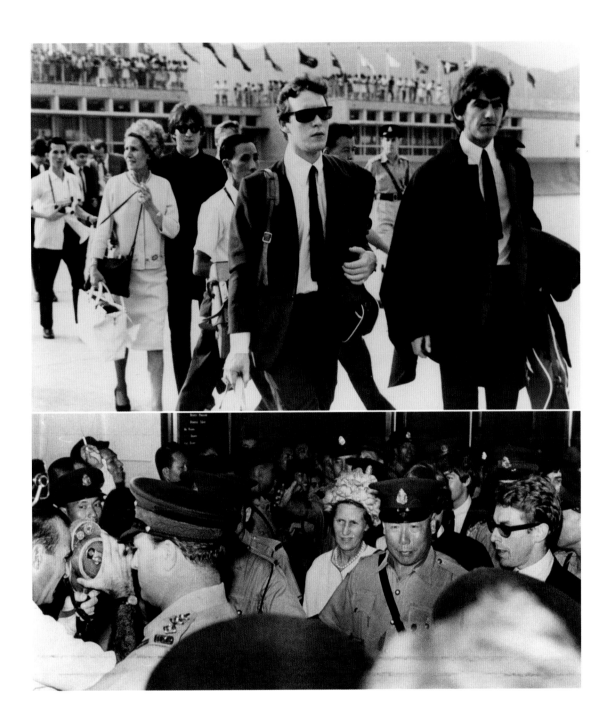

TOP: Arriving at Hong Kong airport, George with the Beatles' long-standing road manager and assistant Neil Aspinall, and John accompanied by Aunt Mimi.

ABOVE: Aunt Mimi and the band are escorted through crowds of journalists by police.

OPPOSITE: Fans awaiting the Beatles' arrival in Hong Kong, then still a British territory before its transfer to China in 1997.

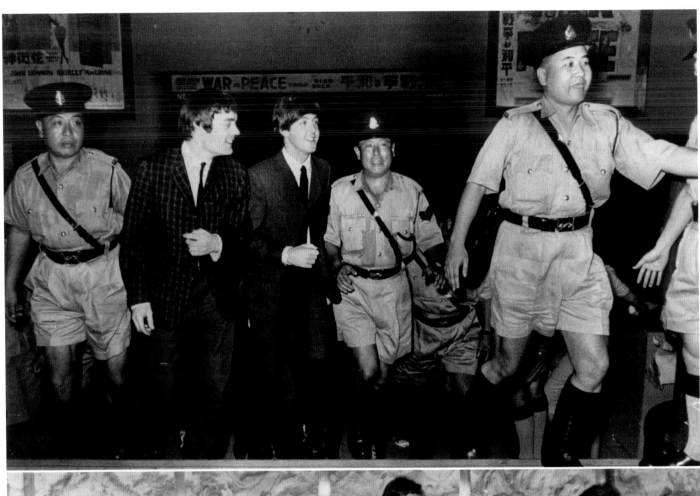

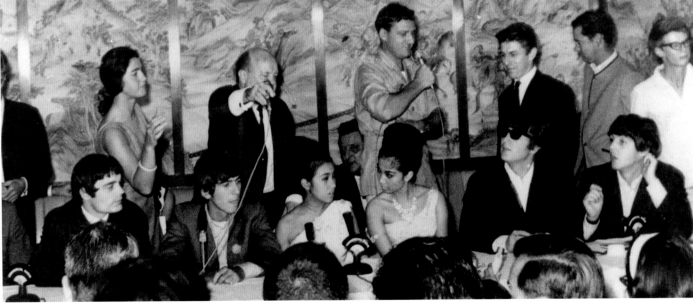

OPPOSITE, BOTTOM: Amid the potential mayhem in Hong Kong, the Beatles hold yet another press conference.

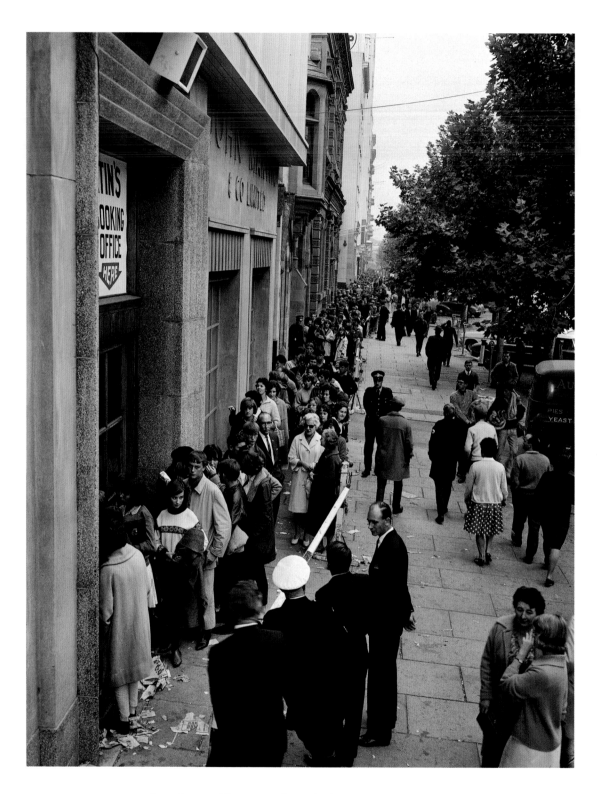

ABOVE AND OPPOSITE: Three thousand fans camped outside the ticket office waiting for it to open, and all 12,000 tickets for the Beatles' Adelaide concert, with a face value of £22,000, were sold within five hours.

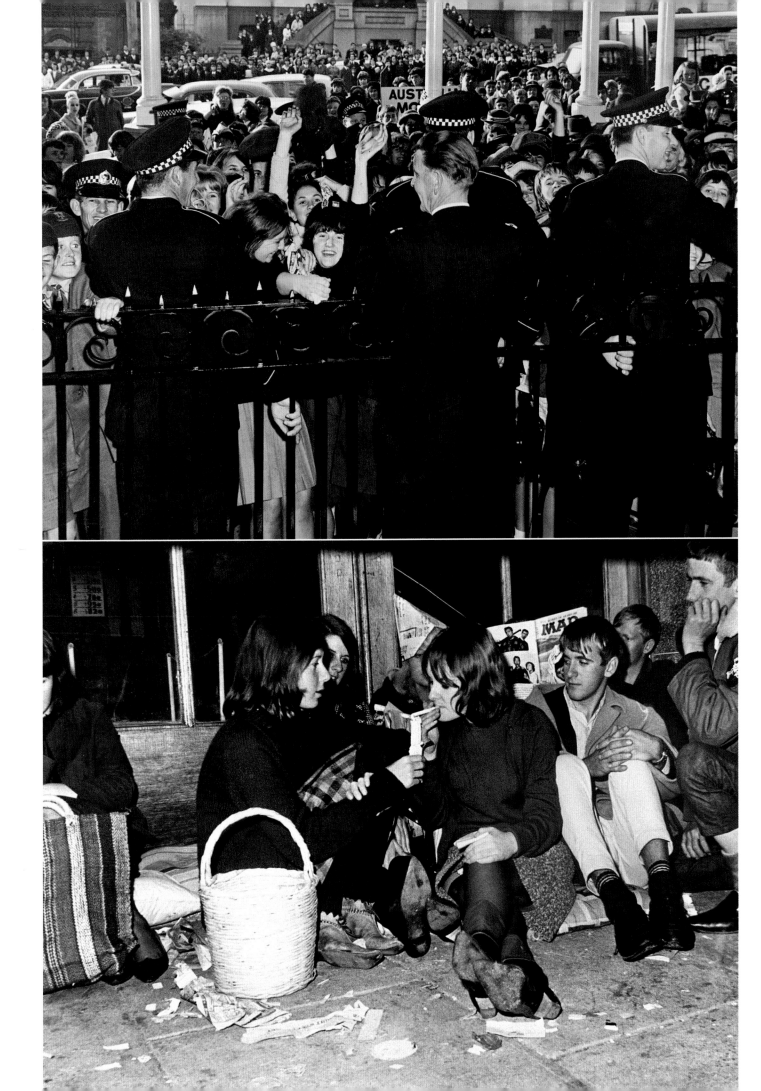

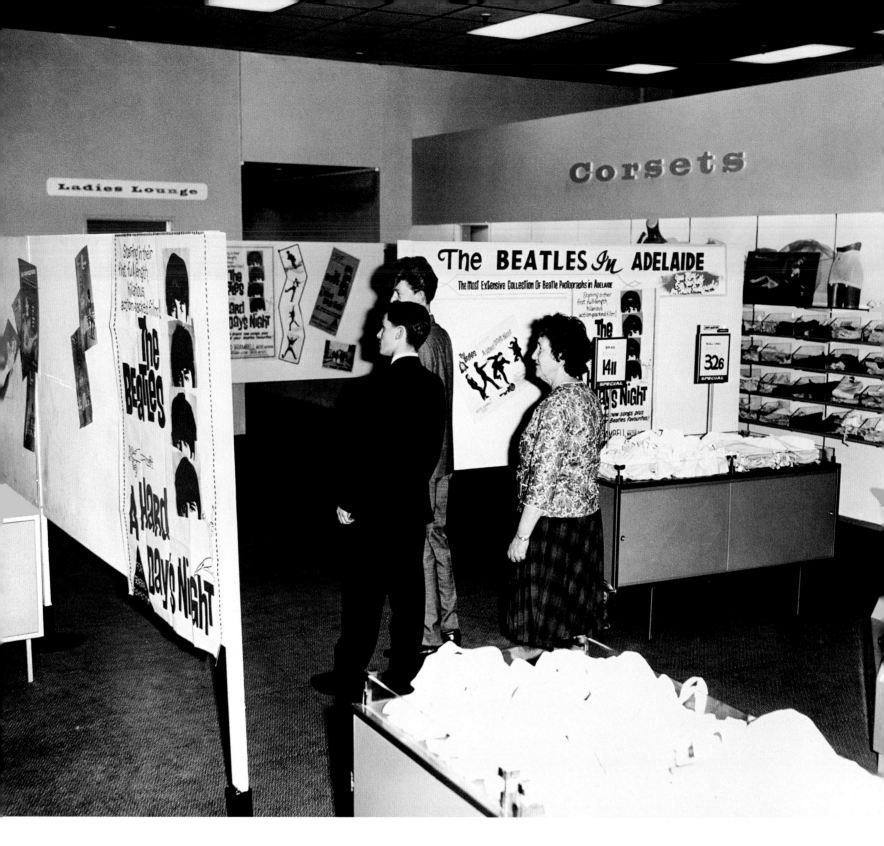

ABOVE: Among the ladies corsetry, an exhibit of photographs taken during the Beatles' visit goes on show in an Adelaide department store.

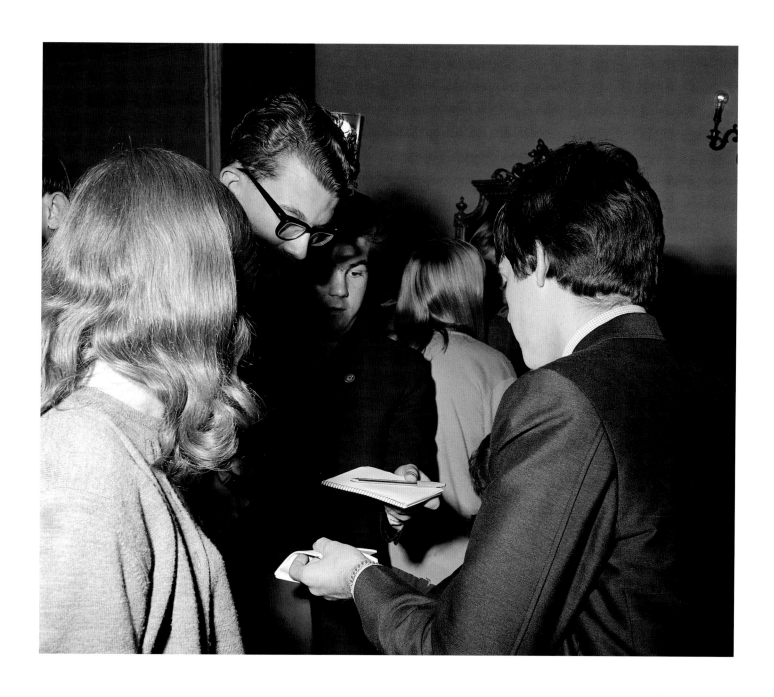

ABOVE: Paul signs for an Adelaide fan.

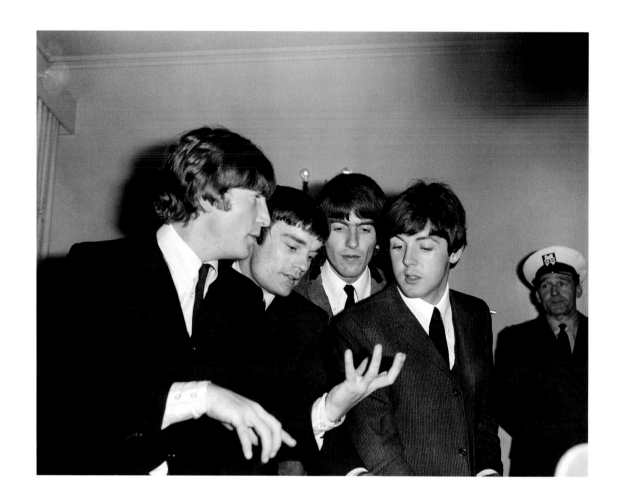

Q: How did the tickets go in Hong Kong, did you get full houses there?

John: I think so ...

Paul: [Correcting John] No ... there were a few five quid seats ...

John: I wouldn't go and see me for five quid ...

George: I wouldn't see you for two bob!

Q: John, has the Merseybeat changed since you've been playing it?

John: We still keep on saying 'there's no such thing as Merseybeat', it's something the press made up ...

it's just Rock'n'Roll, it just so happens we write most of it.

Q: What record do you all agree on, generally, as your best recording?

John: Well we always like the one we just made, don't we?.. so it's 'Long Tall Sally' for me.

George: I like 'You Can't Do That'.

From the Beatles' first press conference on their arrival at the Sheraton Hotel, Sydney.

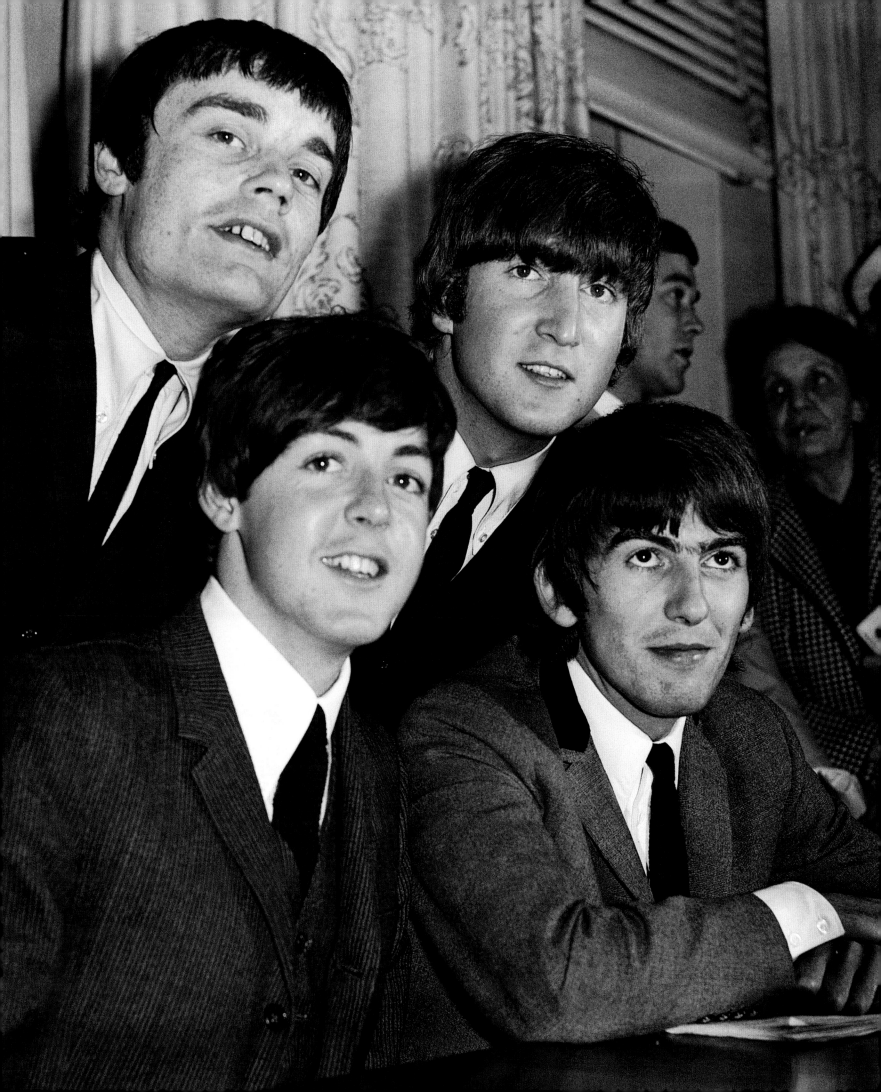

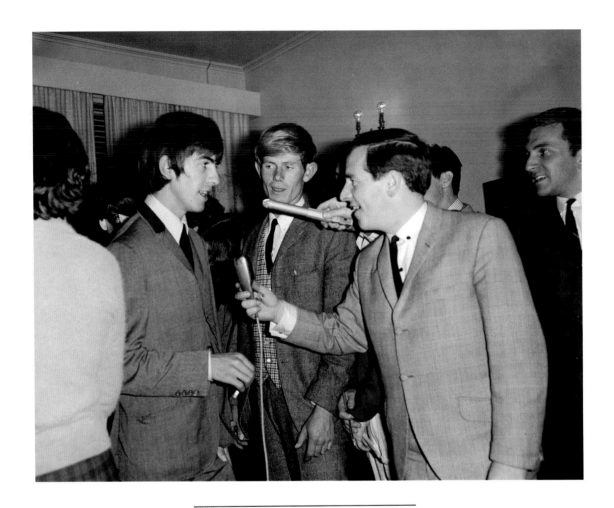

TOP: After their Adelaide press conference, the Beatles are interviewed by a local DJ and radio host.

ABOVE: Inside the tour programme, an ad for the hotel where the Beatles stayed in Melbourne.

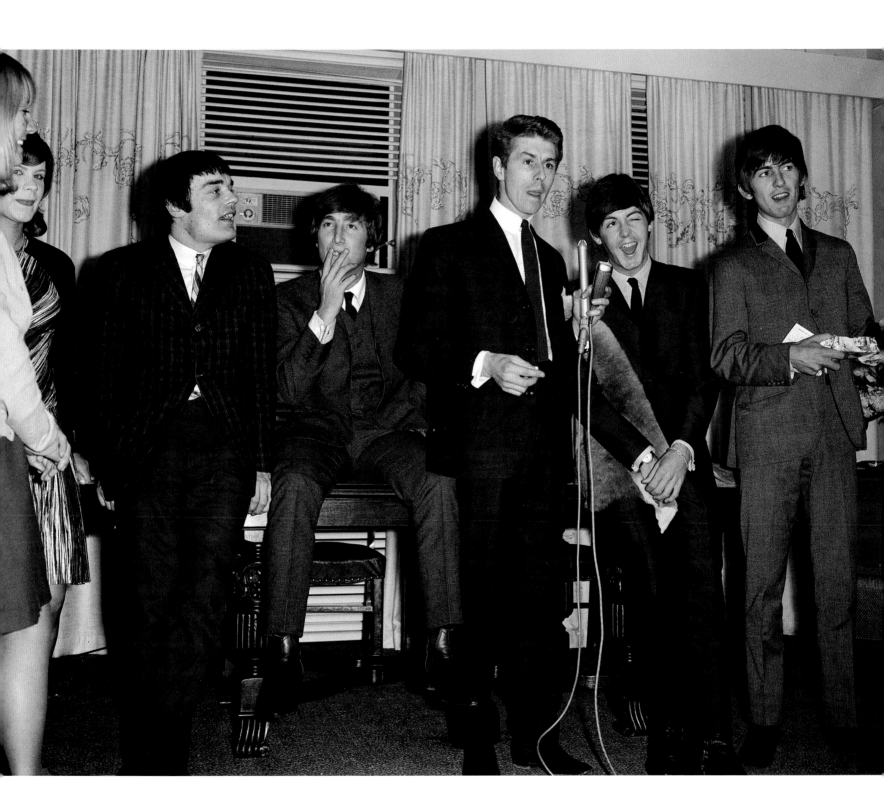

ABOVE: The Beatles' PR man Derek Taylor introduces the boys (and Jimmy Nichol) at their Adelaide press reception.

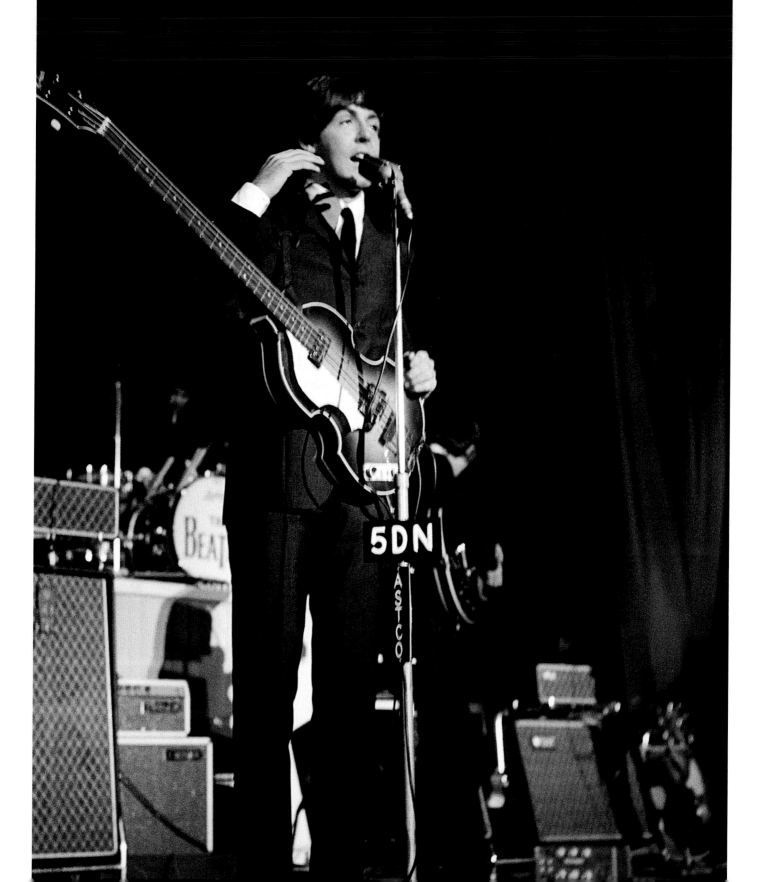

Originally, a visit to Adelaide had not been planned as part of the 1964 Australian tour, but after fans organised a petition – and in a very short time collected over 80,000 signatures – the city was added to the itinerary.

OFFICIAL
SOUVENIR

THE BEATLES

AUSTRALIAN
TOUR 1964

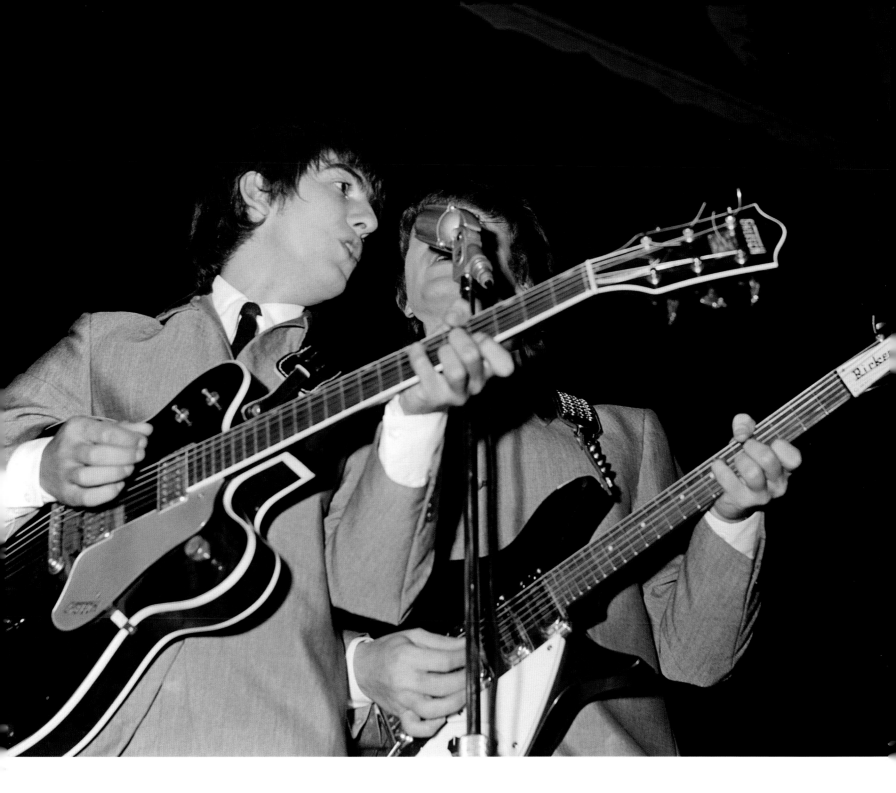

The four concerts in Adelaide, held at the Centennial Hall, were the first the Beatles actually played in Australia. They performed in front of a total of 12,000 fans – though 50,000 had applied for tickets.

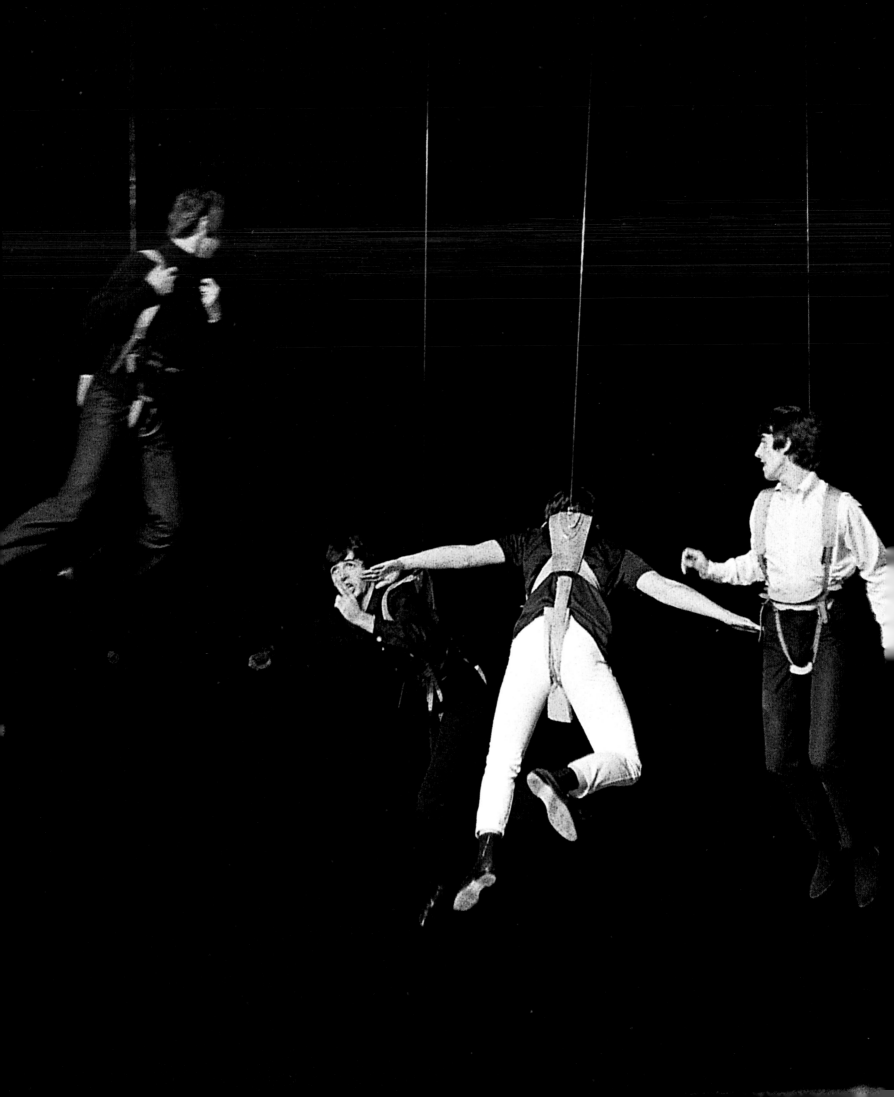

THE NIGHT OF A HUNDRED STARS
LONDON PALLADIUM, ARGYLL STREET, LONDON
THURSDAY 23 JULY 1964

RICHARD ROSSER ARRIVED IN THE AFTERNOON to decide where would be the best place to photograph the Beatles once they were on stage. The Palladium was *the* venue to appear at during the 1960s, and *The Night of a Hundred Stars* – in aid of the Combined Theatrical Charities Appeals Council – featured some of the top stars of the day including legendary entertainer Judy Garland, the eminent actor Sir Laurence Olivier and the Beatles representing the pop element. During the first part of the show, the group had to perform a 'flying ballet' sketch called 'I'm Flying', in which they were strapped into harnesses then raised high above the ground. The photographers certainly didn't have an easy task, as pre-digital cameras demanded they look down into the camera while raising it at the same time in the hope of catching the Beatles flying through the air. Nonetheless, these rare photographs show Rosser's versatility. The Beatles performed a brief musical set in the second half of the show.

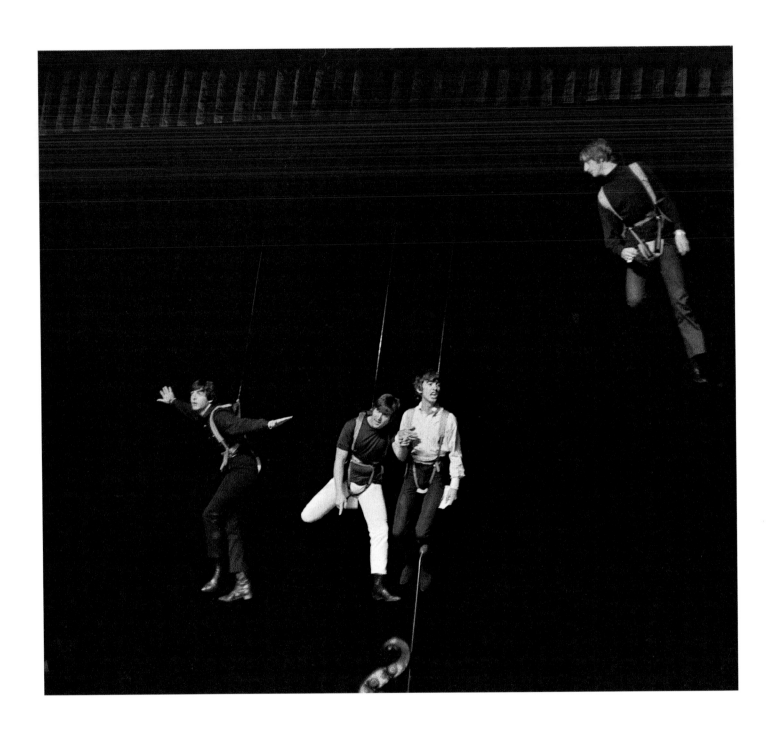

ABOVE AND OPPOSITE: Although they always conducted themselves professionally and 'got on with it',
the Beatles began to tire of the gimmicks and comedy sketches they were asked to perform in concerts like this
and various television variety shows.

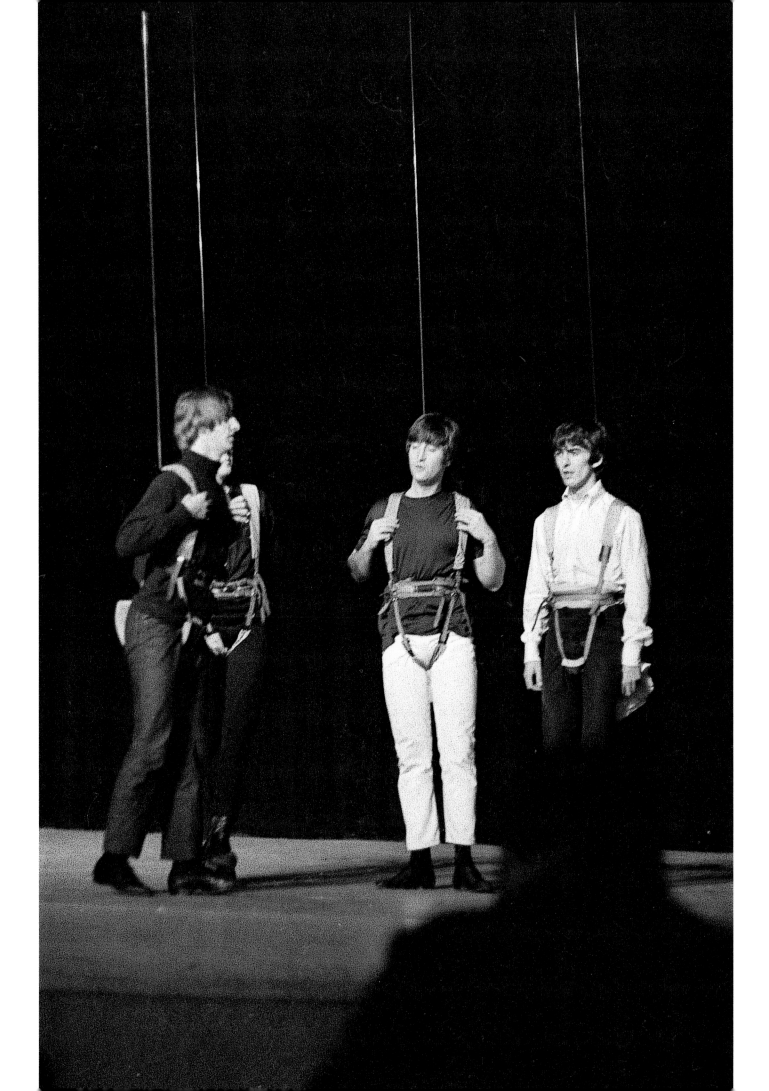

ANOTHER BEATLES CHRISTMAS SHOW
HAMMERSMITH ODEON, LONDON
TUESDAY 24 DECEMBER 1964

BILLED AS ANOTHER BEATLES CHRISTMAS SHOW, this second Beatles yuletide presentation featured the boys taking part in two comedy sketch routines – although they confessed to getting bored with the format – one featuring the abominable snowman and the four Beatles in fur 'eskimo' outfits.

Their music set, in which they appeared in blue mohair shirts, started with 'She's A Woman', Paul introduced 'I'm A Loser' as 'a song by Gracie Fields', then George introduced 'Everybody's Trying To Be My Baby'. It was followed by 'Baby's In Black', 'Honey Don't', 'A Hard Day's Night' with John in the centre of the stage, and finally George announced 'I Feel Fine', before they thanked the fans for buying the record, played 'Long Tall Sally' and exited to their waiting limousine. Other names on the bill included the Yardbirds, Freddie and the Dreamers, Elkie Brooks, and BBC *Top Of The Pops* presenter Jimmy Savile.

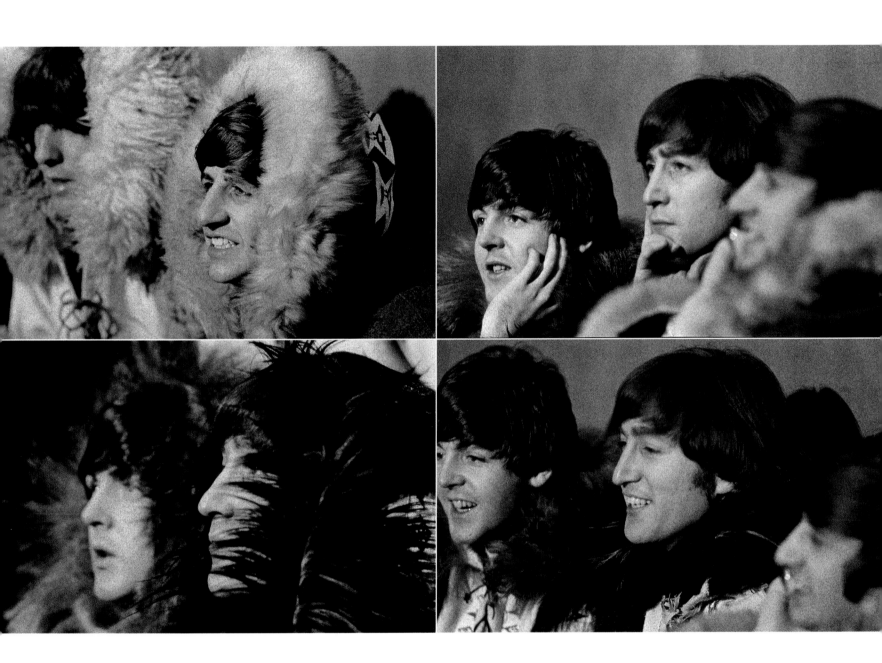

ABOVE AND OVERLEAF: The Beatles in 'eskimo' mode. Again, Richard Rosser was the man Brian Epstein invited to come and photograph the event to maximise publicity.

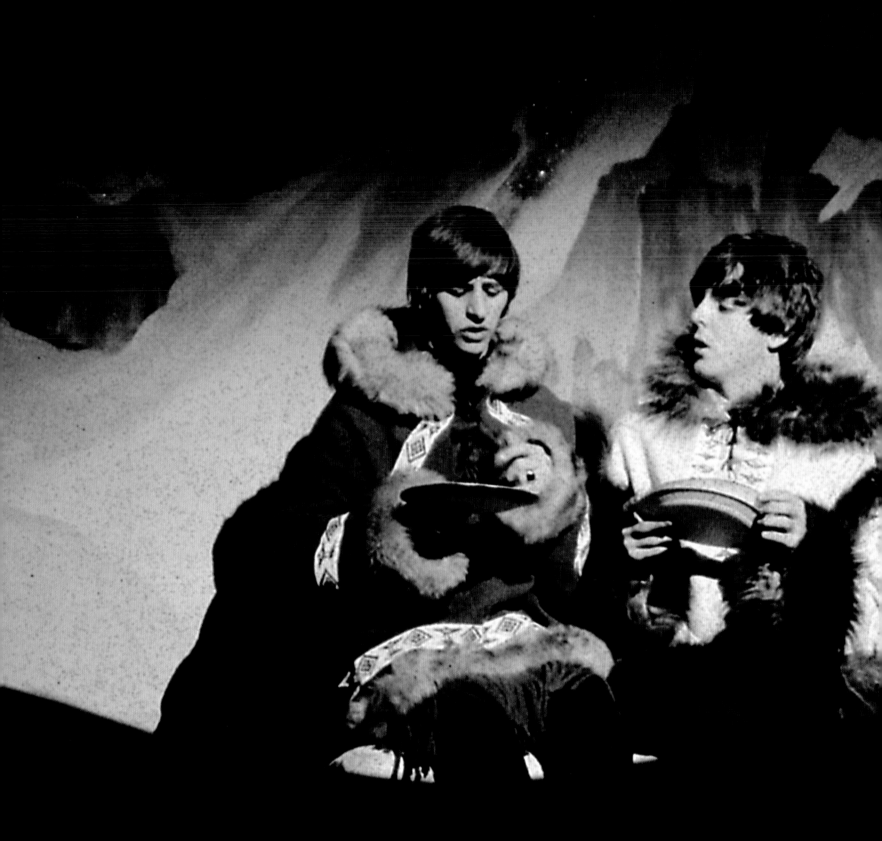

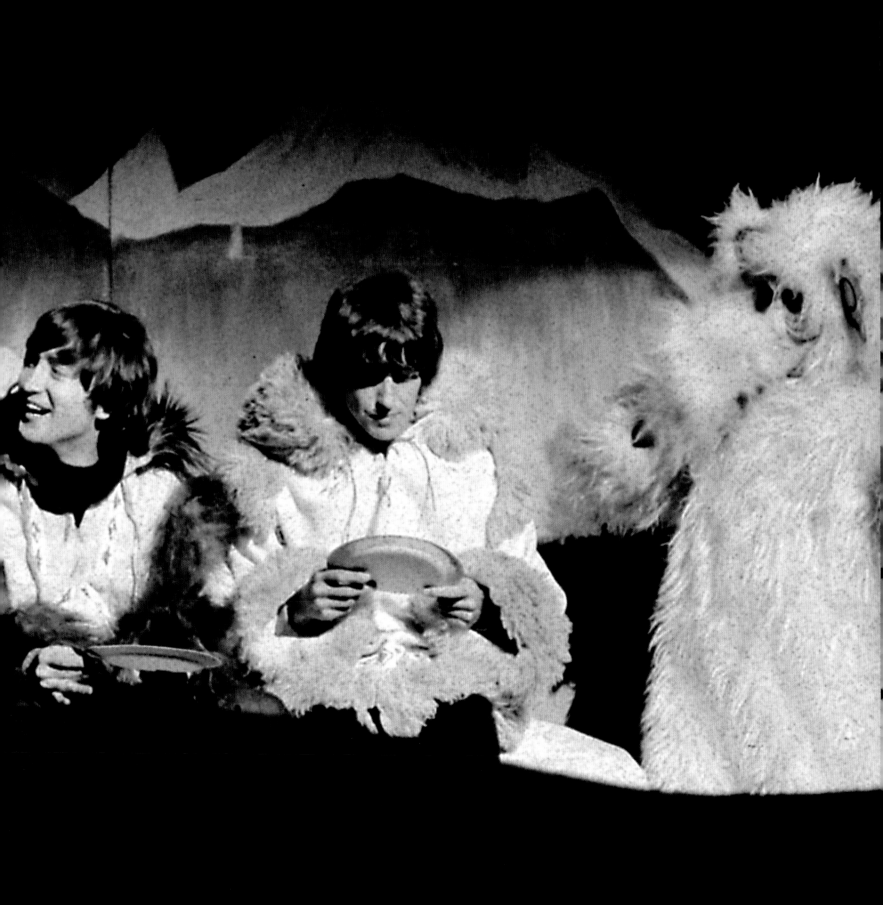

LOCATION FILMING FOR *HELP!*
NASSAU, THE BAHAMAS
TUESDAY 23 FEBRUARY–6 MARCH 1965

THE BEATLES NEXT LOCATION FOR A MOVIE was the exotic resort of Nassau, in the Bahamas, where they were working on their next cinema film, eventually to be called *Help!* As soon as they arrived the group were filmed filming each other, and descending the aeroplane steps onto the runway at Nassau airport – all captured on home movie camera by one of the film crew.

Their 'house photographer' Robert Freeman set up shots of the band riding bicycles (fully clothed) on the bottom of the swimming pool at the Nassau Beach Hotel on the West Bay area of the island, but the photographs here were taken by a lady named Manny Klimis. She was vacationing with a cousin, who had got some work on the film as an extra (she appeared in one scene wearing a red turban). So it was that Manny got access to the Beatles' location shoots and captured them on camera. I bought the photographs at Bonham's auctioneers, Manny having sold them to pay for a medical operation – a costly business in the USA. Manny also managed to get some pictures of John Lennon, apparently high on marijuana, recklessly scaling the floodlights at the grounds of the Bahamas Softball Association, and shots of the Beatles shooting the 'car boot' scene with actor Victor Spinetti. When I spoke to Manny, she recalled talking to John about the Rickenbacker twelve-string guitar he had used to compose the song 'Help!': 'He told me that he liked that type of guitar because it gave a full bodied sound to the song'.

The other photographs shown here are screen grabs taken from an 8mm Kodak home movie film. The film was taken by the wife of one of the British film cameramen, and purchased at Christie's auctioneers in the late 1980s. Here we see the Beatles rehearsing one of their songs, 'Another Girl', on the rocks of Balmoral Island on 27 February – there are also some exclusive images of the Beatles relaxing on a jetty, a scene that was never included in the original movie.

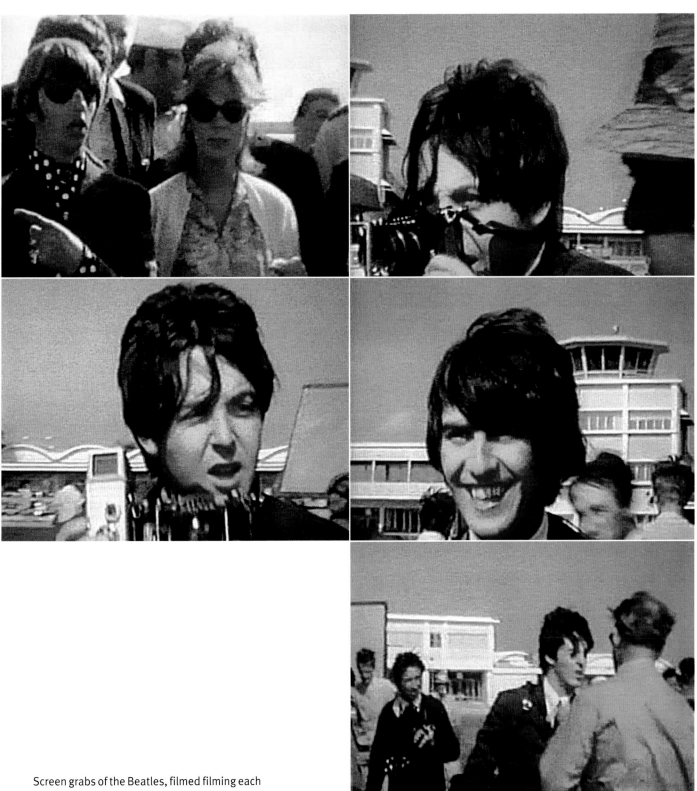

Screen grabs of the Beatles, filmed filming each
other at Nassau airport.

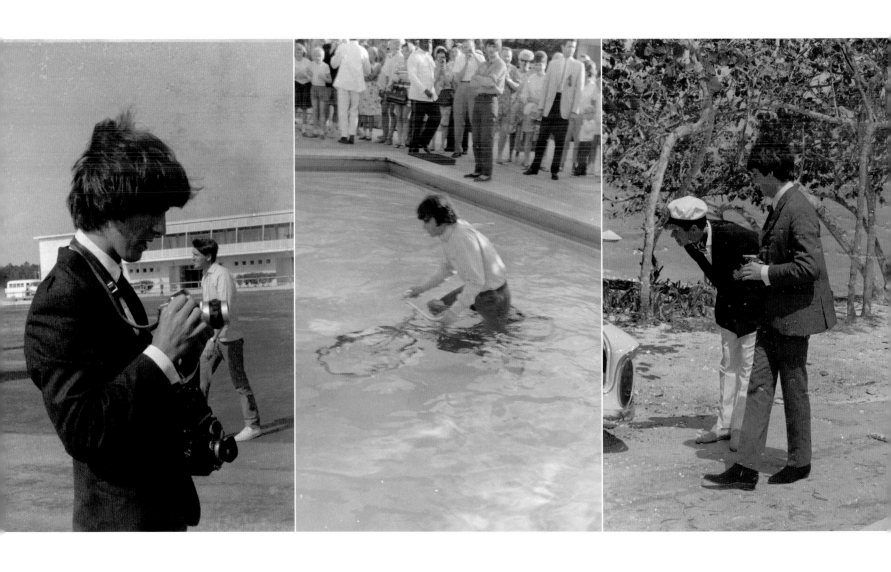

ABOVE: Left, George Harrison at Nassau airport. Centre, John rides a bike in the swimming pool of the Nassau Beach Hotel. Right, actor Victor Spinetti with Paul in the 'car boot' scene from the movie.

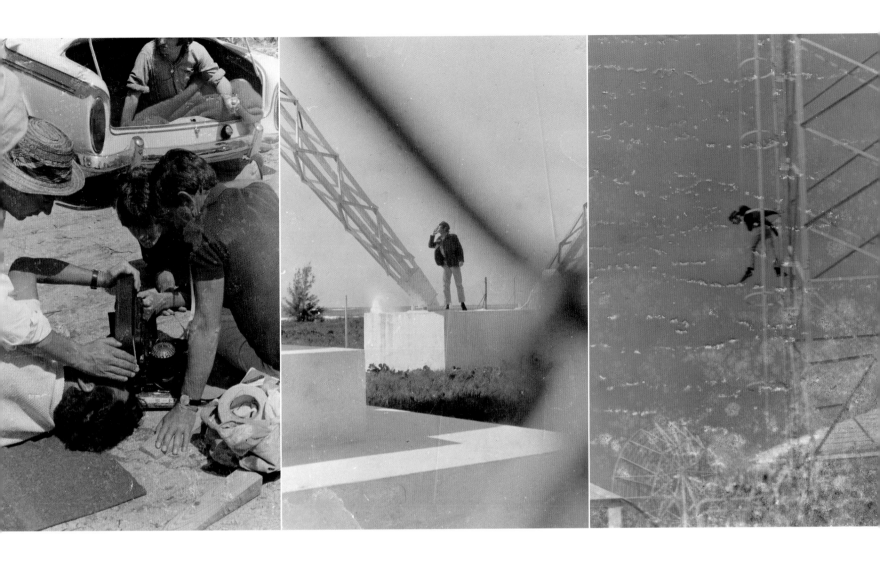

ABOVE: Left, shooting the scene in which George and Ringo are in the boot of a car being driven by a mad scientist (played by Spinetti). Centre and right, John clambering up the night lights of the Bahamas Softball Association.

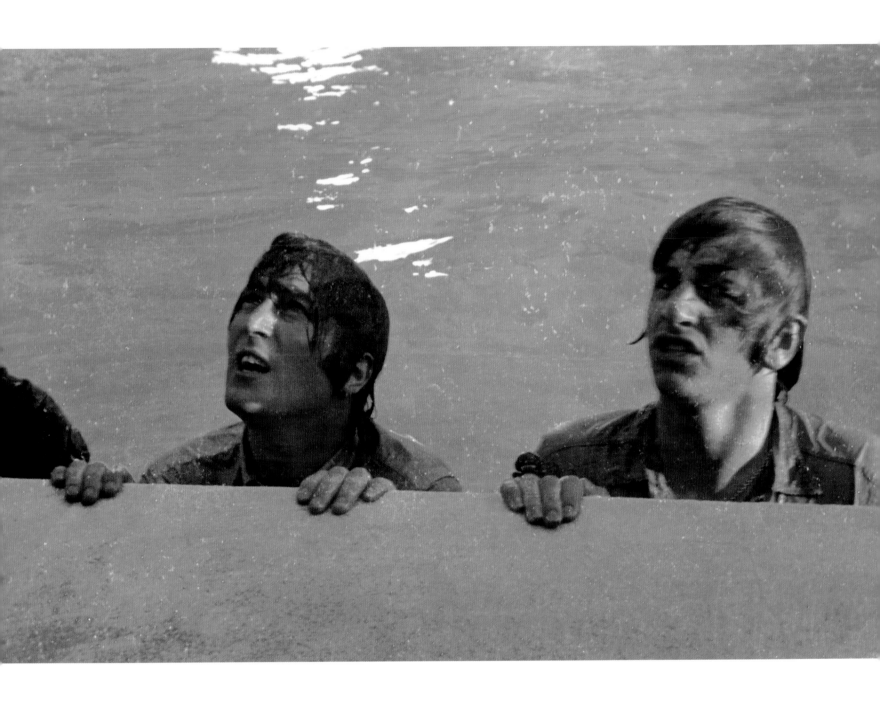

ABOVE: John and Ringo emerge from the pool at the Nassau Beach Hotel.

THE BEATLES ON CAMERA

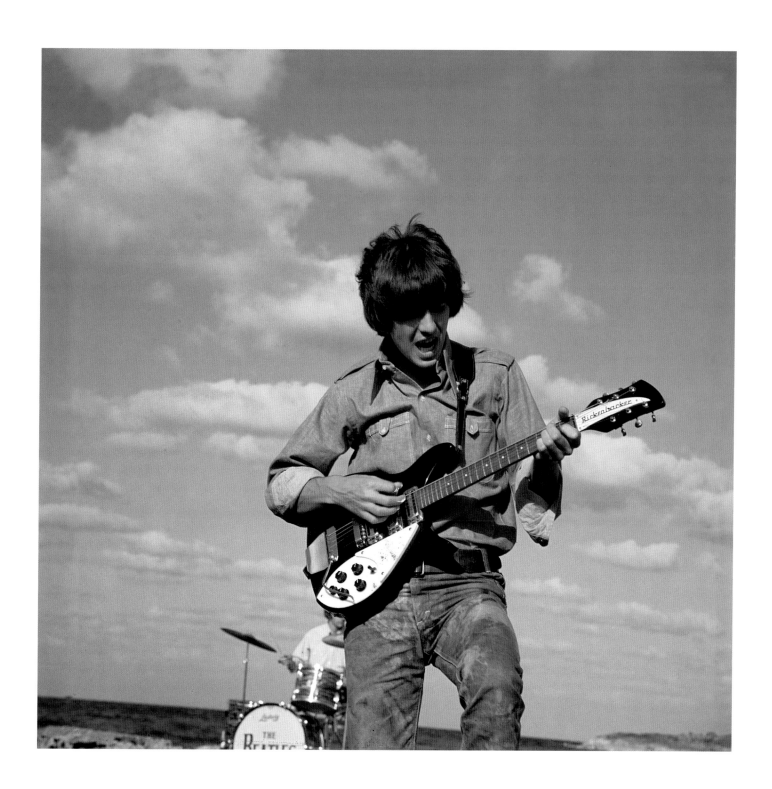

ABOVE: George Harrison rehearsing 'Another Girl' on the rocks of Balmoral Island during the Bahamas shoot.

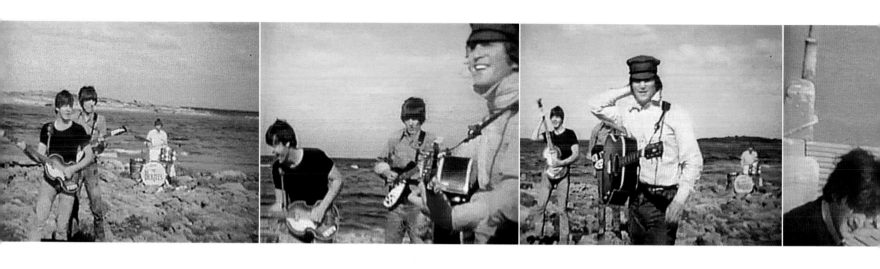

ABOVE: Screen grabs taken during the 'Another Girl' sequence.

OVERLEAF: A shot during the 'Another Girl' scene on Balmoral Island taken by fan Manny Klimis.

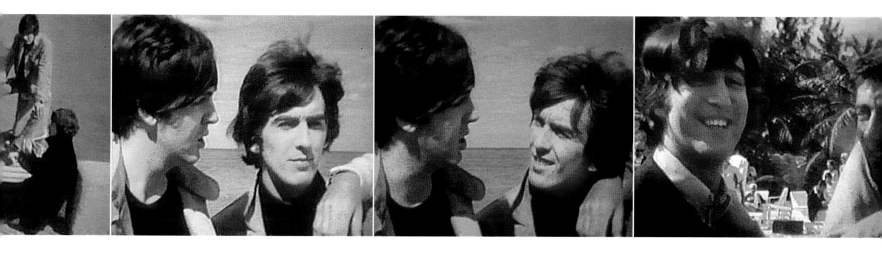

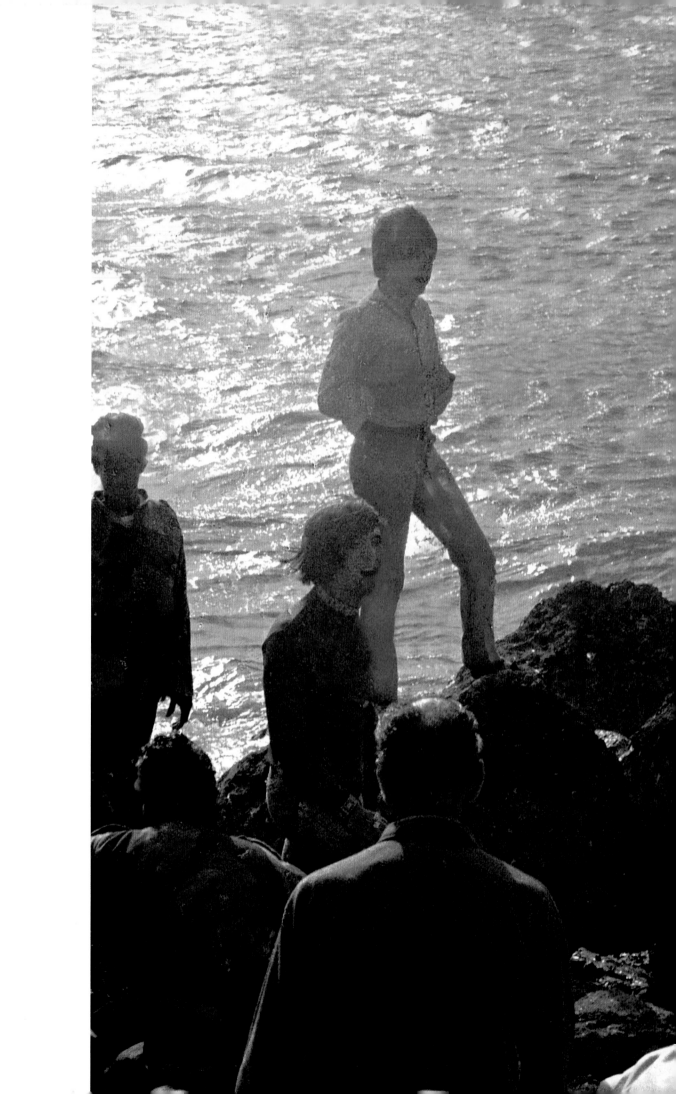

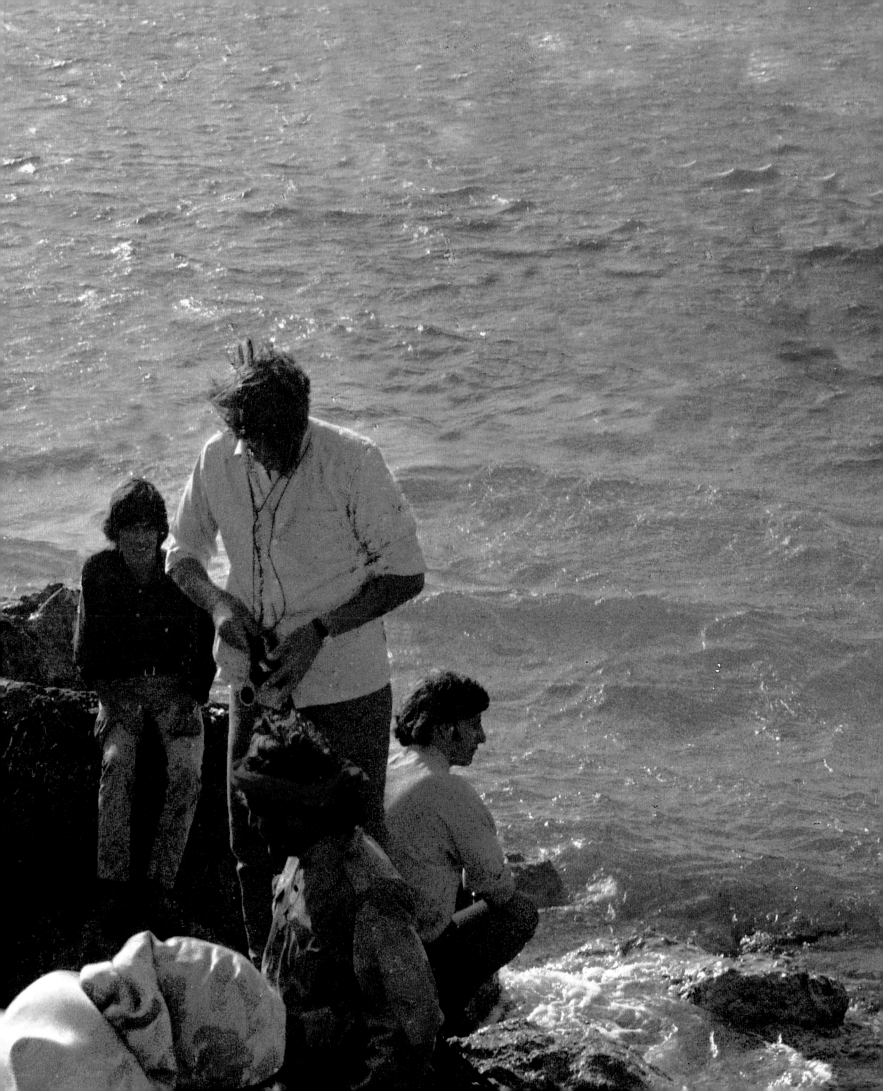

LOCATION FILMING FOR *HELP!*
OBERTAUERN, AUSTRIA
SUNDAY 20 MARCH 1965

THE FILMING OF *HELP!* TOOK THE BEATLES to extremes weatherwise – from the Bahamas to the wintry slopes of Obertauern in Austria, where their wives and girlfriends also joined them for a holiday. On Saturday 13 they flew from London at 11.00 am for Salzburg, where they were greeted by 4,000 people, then gave their almost obligatory press conference, at the Hotel Edelweiss.

On 14 March the filming began with a toboggan sequence, which was not included in the final edit of the movie. The following day was devoted to the ski lift sequence. The sequence shows just how dangerous life could be for a cameraman in the 1960s, without a health and safety expert in sight! The cameraman stood on the top of the lift's pulley system filming from above, and risking serious injury if he were to fall as the ski lift turned (see below).

On the evening of 17 March, after they had finished filming the curling rink sequence, it was announced that the movie was to be called *Eight Arms To Hold You*; a few weeks later it was changed to *Help!*, the Beatles explaining that writing a song called 'Eight Arms To Hold You' was easier said than done.

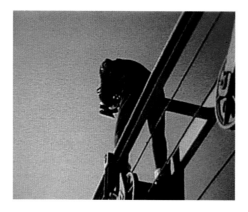

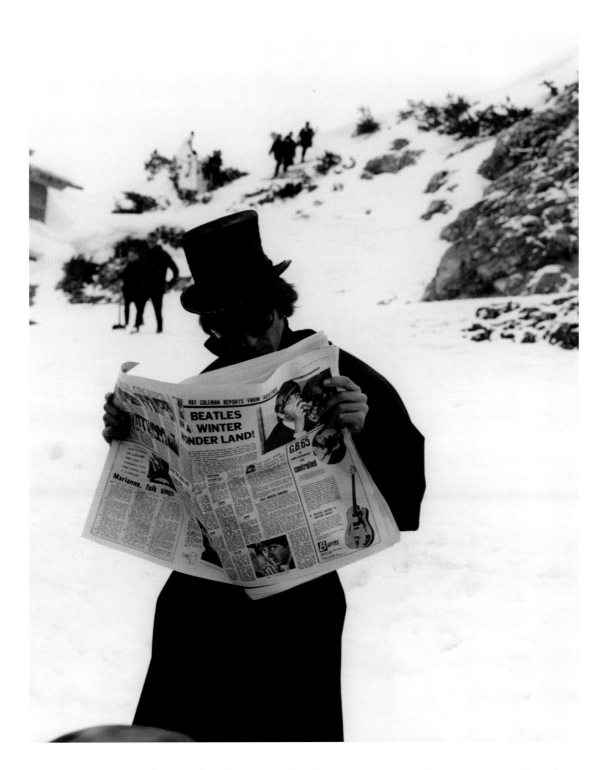

OPPOSITE: A screen grab from an 8mm home movie showing the precarious conditions cameramen undertook to get their shots of the skiing sequences in the movie.

ABOVE: George reads a copy of *Melody Maker*, which runs a story 'Beatles in a Winter Wonderland'.

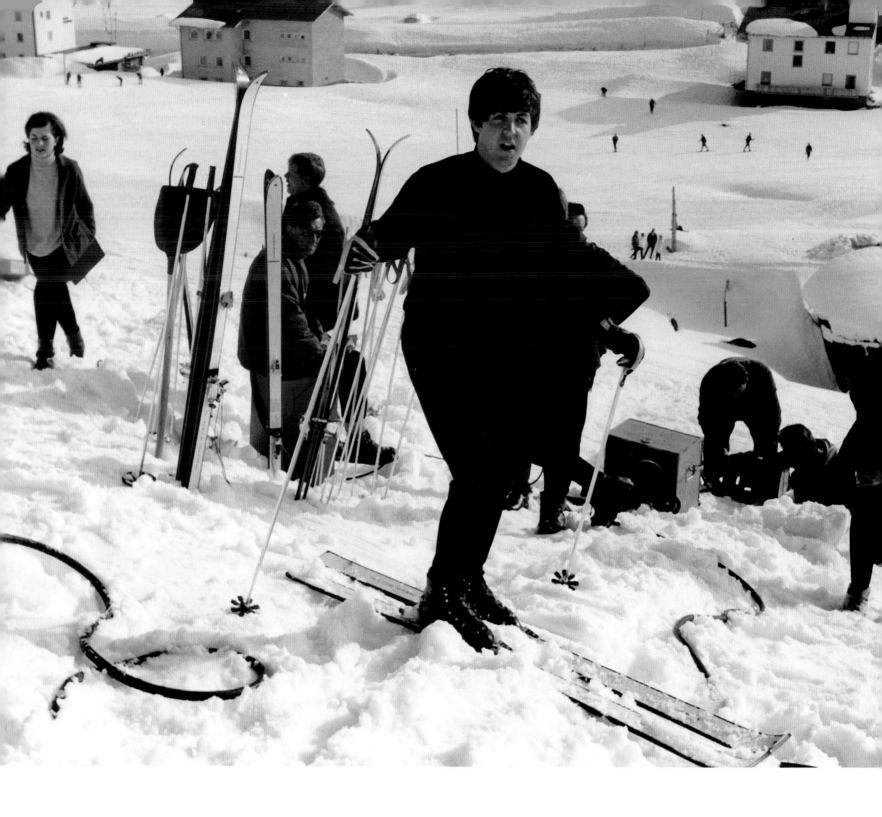

ABOVE: Paul McCartney, like the others, a novice skier. The Beatles were taught the rudiments of skiing by Gloria Mackh, an Austrian Ski-Master who was also Miss Austria in 1964.

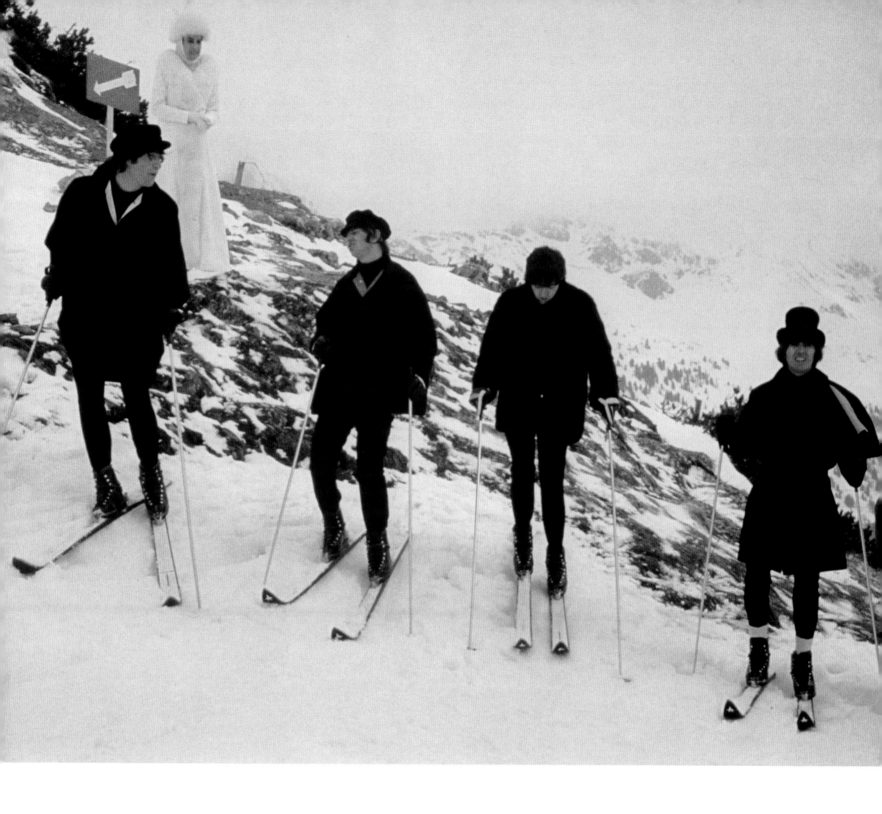

ABOVE: John, Ringo, Paul, and George take to the slopes, with co-star Eleanor Bron in the background.

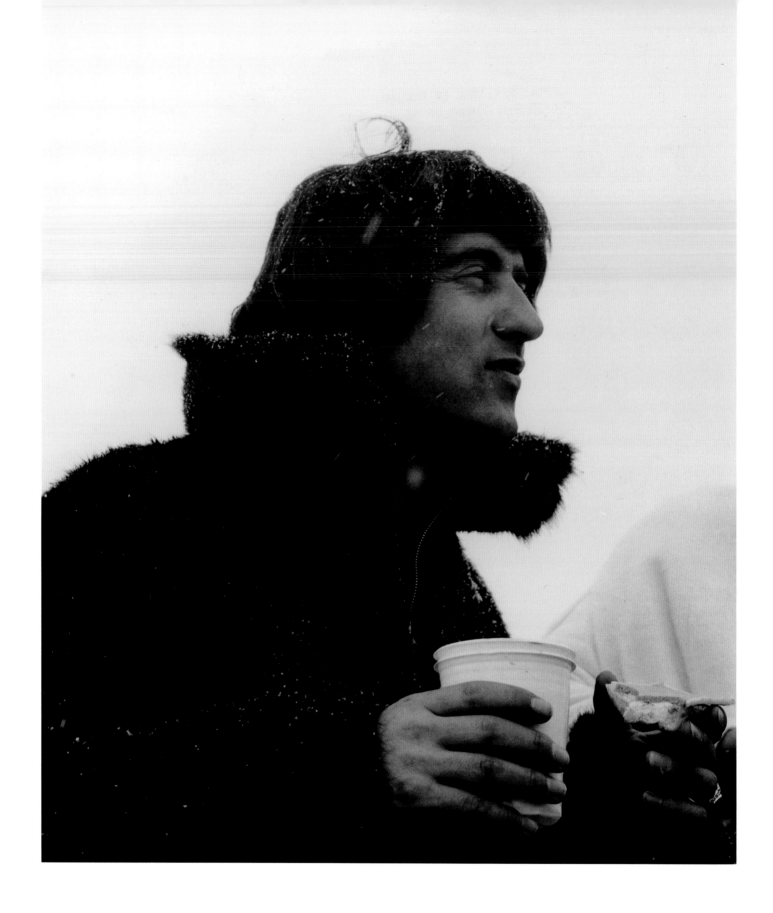

ABOVE: One of the doubles who stood in for the Beatles in some of the skiing sequences – they were paid 1,000 Austrian schillings a day.

THE BEATLES ON CAMERA
. .
146

ABOVE: Beatles with wives and girlfriends at the Hotel Edelweiss: From left, John Lennon, Cynthia Lennon, Ringo Starr, his wife Maureen Starkey, Paul McCartney (back to camera), Pattie Boyd, and George Harrison.

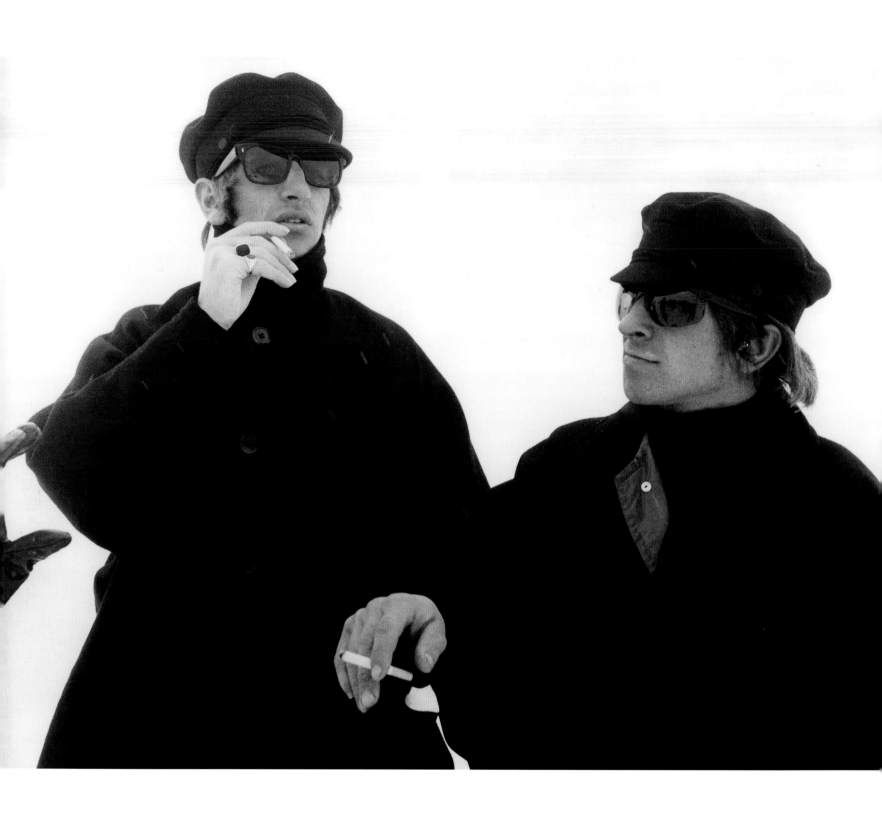

ABOVE: Ringo (left) with his *Help!* double.

OPPOSITE: John browses the latest issue of *Cashbox*, the US music trade magazine.

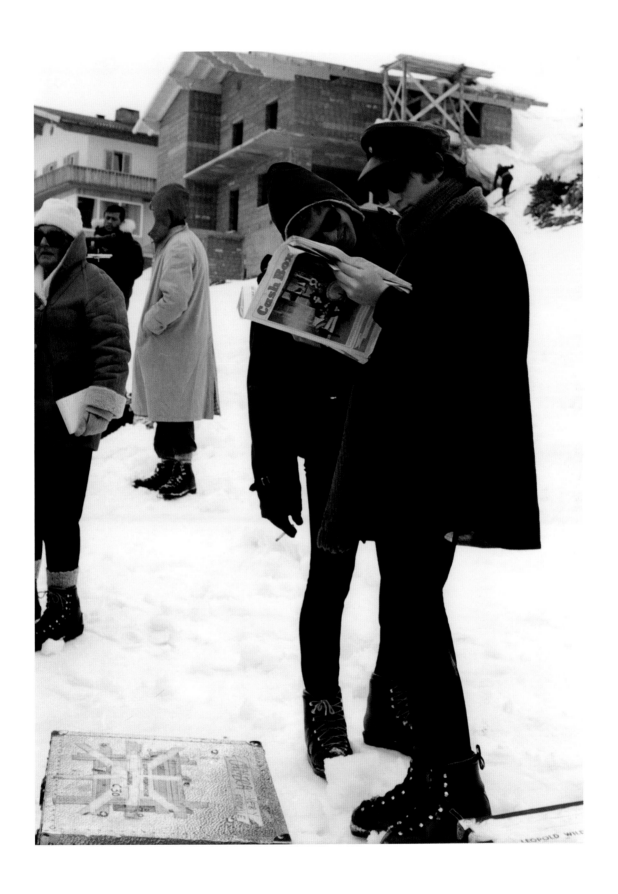

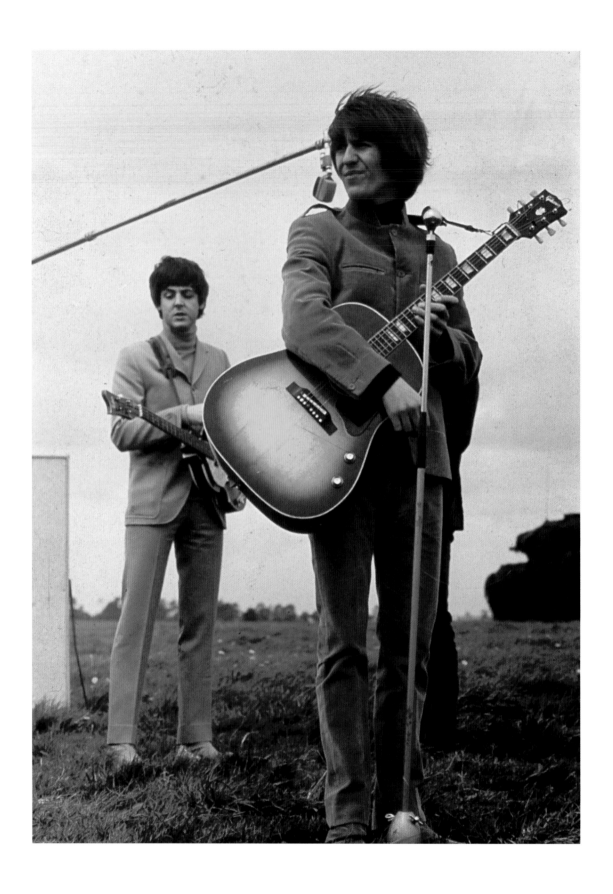

LOCATION FILMING FOR *HELP!* SALISBURY PLAIN AND TWICKENHAM, ENGLAND
MAY 1965

BETWEEN 3 AND 5 MAY 1965 THE BEATLES found themselves filming sequences for *Help!* on Salisbury Plain with the British Army 3rd Division. As can be seen from the screen grab below, a cameraman risked life and limb strapped to a helicopter landing board to film aerial sequences as the Beatles performed 'I Need You' in the company of units of the British Army.

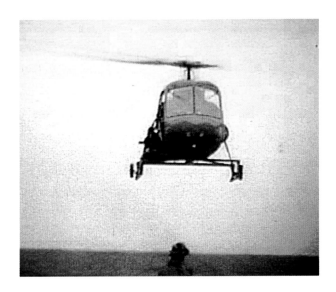

OPPOSITE: Paul and George during the Salisbury Plain shoot.

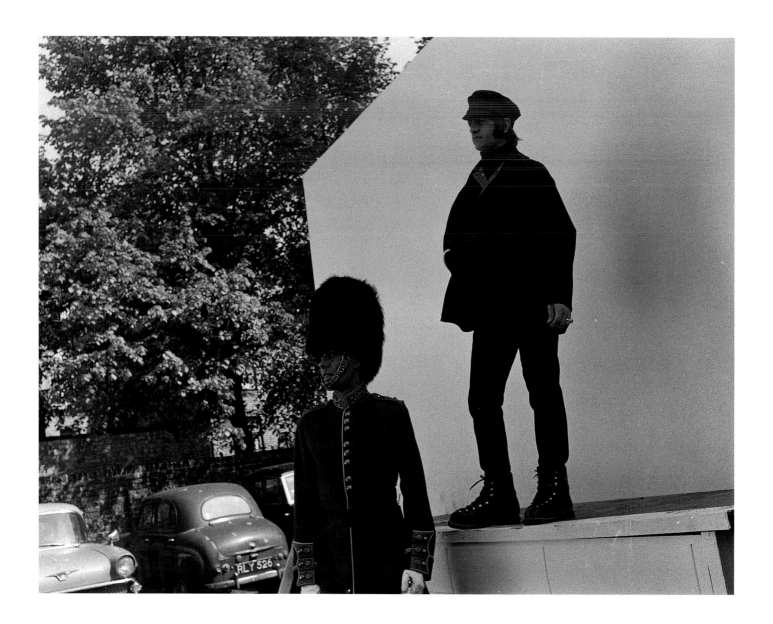

Robert Freeman had taken the photographs in Austria to use for the album cover of *Help!*, but Ringo's portrait had not turned out as desired. A hastily arranged photo shoot with photographer John Paignton had Ringo wearing the same cape against a white background – the picture was then dropped into the album photo to appear as if he was in the Alps rather than Twickenham Studios. Twelve existing negatives from this shoot were sold by John Paignton's widow Dorothy in 1998.

ABOVE AND OPPOSITE: Paul and John at the Twickenham *Help!* shoot, along with one of their co-stars from the film, Victor Spinetti.

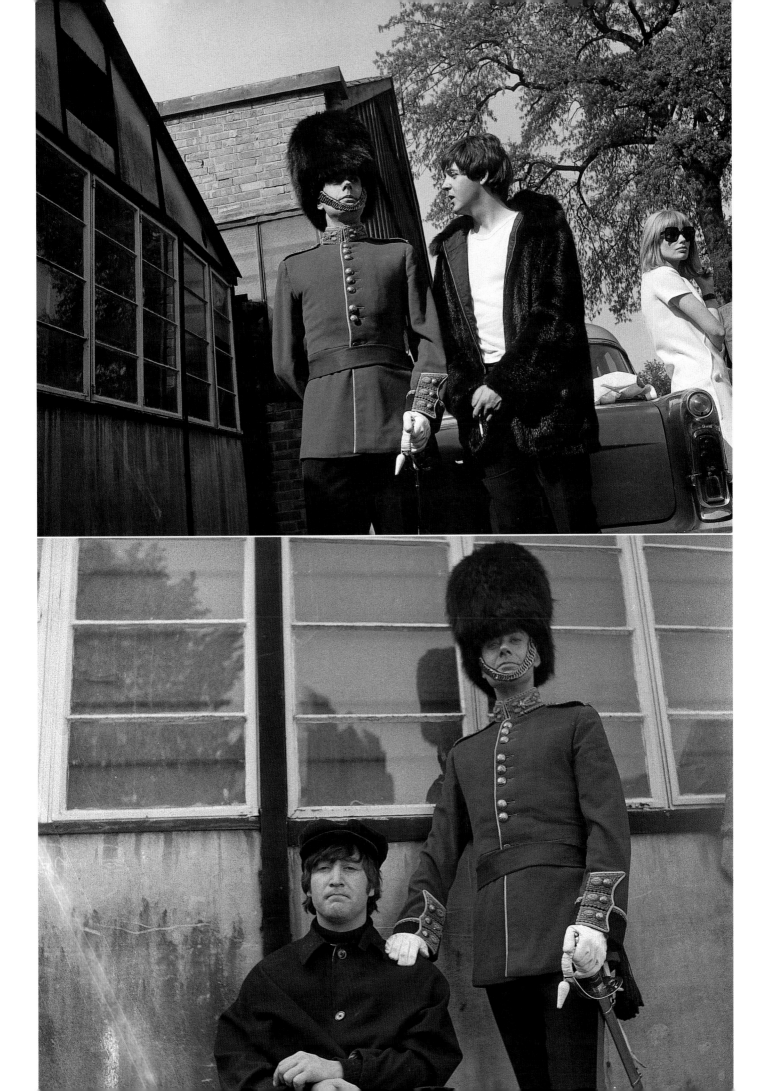

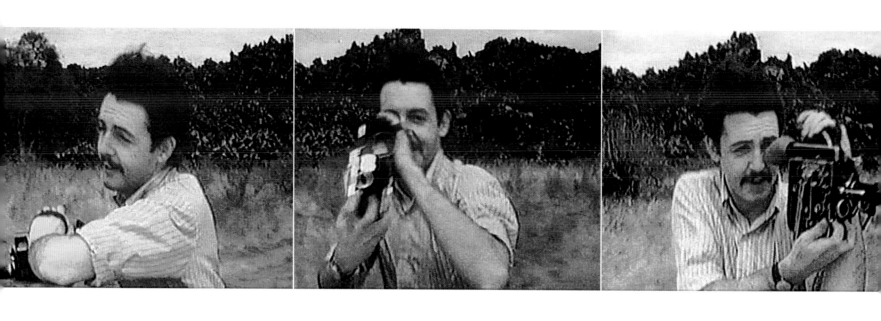

SAFARI, KENYA
SUNDAY 13–19 NOVEMBER 1966

ON 6 NOVEMBER 1966 PAUL MCCARTNEY set off on a car trip across Europe. He travelled to Bordeaux, where he met up with the Beatles' 'gentle giant' road manager, Mal Evans. Mal had his Canon Super 8 camera with him, which resulted in some very rare footage of a Beatle on holiday.

The plan was to hook up with John Lennon in Spain, where he was filming *How I Won the War*. Taking in the sights of the sea port San Sebastiàn, then on to Madrid, Cordoba, and Malaga, they hoped to meet John in Almeria, a beautiful part of Spain where many a spaghetti western was filmed. But when they finally arrived in Almeria on 12 November, they found that John had returned to the UK as filming had finished. With no mobile phones, communication in Spain in the 1960s was not easy at the best of times.

Paul decided to travel on to Kenya and go on a safari – something that he had always wanted to do. He called his girlfriend Jane Asher to say he would meet her there. He flew to Madrid with Mal, then on to Rome, catching the connecting flight to Nairobi. Mal Evans, Paul, and Jane Asher returned home on 19 November 1966.

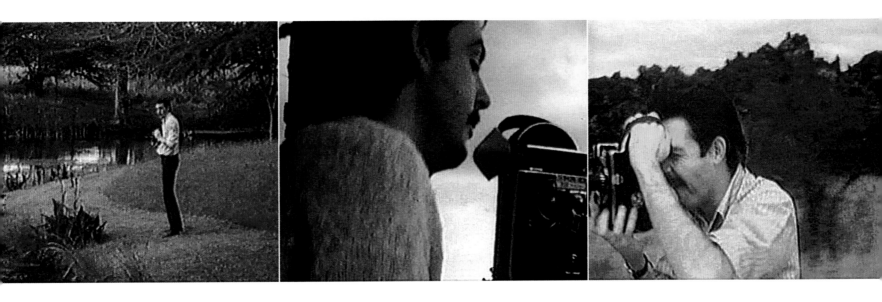

ABOVE: Paul was filmed on Mal's Canon Super 8 home movie camera, walking in the garden of the Tsavo Inn, in the Ambosali Park near Mount Kilimanjaro. They stayed at the Treetops Hotel, a favourite of the British Royal family, and were also caught on camera on safari, filming monkeys, giraffes, and elephants, alongside other tourists.

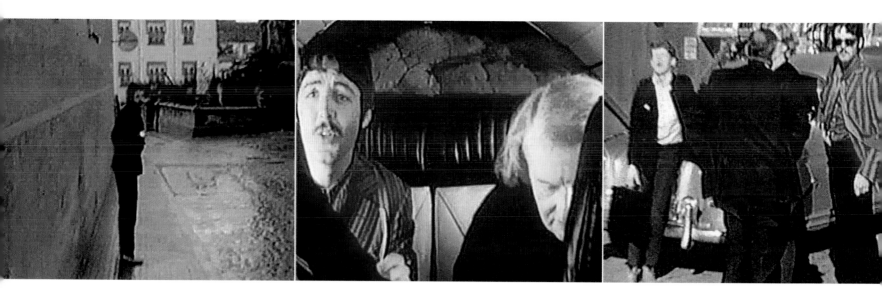

DENVER AND LOS ANGELES
TUESDAY 4–10 APRIL 1967

IN APRIL 1967 PAUL AND MAL EVANS HEADED FOR LOS ANGELES, changing planes at Paris-Orly airport. On 4 April they travelled on to San Francisco, changing planes in LA to a private Lear jet. In LA they spent the day hanging out and jamming with Jefferson Airplane. The next day they boarded the Lear again (said to belong to Frank Sinatra) to fly to Denver Colorado to meet Jane Asher, who was celebrating her 21st birthday while appearing on a theatre tour with the Bristol Old Vic. The screen grabs which Mal shot on his Canon Super 8 show Paul on board the jet, and Paul hand-in-hand with Jane Asher. They then flew to Los Angeles, visiting the Beatles' publicist Derek Taylor and his family, before going shopping in the Century Plaza Center, which is still one of LA's premier shopping malls. All was captured on the home movie, which – along with footage from the Kenya trip – was released as a limited-edition home video, *The Mystery Trip,* by VEX Films in 1992, after they had purchased the original footage at a Sotheby's auction.

MAGICAL MYSTERY TOUR

MONDAY 11–24 SEPTEMBER 1967

AT 12.45 PM ON 11 SEPTEMBER THE *MAGICAL MYSTERY TOUR* bus with Paul McCartney on board departed Allsop Place near Baker Street in London, picking up the other three Beatles en route in Virginia Water, Surrey; Freda Kelly, the Beatles' fan club secretary, sat behind Ringo. The first stop for the night was the Royal Hotel in Teignmouth, Devon.

Coach driver Alf Manders continued the next day with 33 people on board. On route to Widecombe, the bus got stuck trying to cross a small bridge, resulting in a line of cars forming in both directions – the passengers of the cars soon got excited once they realised it was the Beatles on board. After reversing off the bridge, the bus headed for Plymouth, stopping at the Grand Hotel for lunch. The plans for the *Mystery Tour* project were so vague that no one was sure if the lunch was for real or part of the film.

The bus then moved on to the Atlantic Hotel in Dane Road, Newquay, where they used the hotel as their base for the next three days. The Beatles were used to having rooms booked by Brian Epstein, who had passed away a few weeks before filming. So they had booked late, and rather than being placed in a part of the hotel that afforded good security and getaway routes, the group had to stay in the hotel annexe. Alan Russell, a local policeman whose leave was cancelled in order to fulfil crowd control duties around the hotel, was disciplined by his inspector two weeks later after he appeared smiling on a picture with the Beatles, which was posted in a local greengrocer's shop.

During the Beatles' stay, Ted O'Dell delivered his usual supply of eggs to the Atlantic Hotel. A slogan on his van read: 'Eggman Delivered Eggs', which the Beatles spotted and photographed. Subsequently 'I am the Eggman' became an integral lyric in 'I Am The Walrus'.

On the morning of 14 September, George was filmed in an oversized blue overcoat meditating, a sequence which was not used in the final film. After this, they filmed the 'disappearing into a tent' scene (where the Beatles would emerge in West Malling aircraft hanger). Everyone returned to the Atlantic Hotel for a late lunch at 4.00 pm

The team then went on to the Tywarnhayle Inn in nearby Perranporth. On entering the pub with Miranda Ward (a local journalist), Ringo and Neil Aspinall, Paul announced that he was the local piano player and they were all going to have a sing-song. 'Oh, We Do Like To Be Beside The Seaside' and other old favourites were banged out on the upright piano into the early hours.

The next day, the crew filmed in front of the Atlantic Hotel before heading back to London. On the way home they stopped at a fish and chip shop in Roman Road, Taunton, Somerset, owned by James and Amy Smedley – who would recall 'I still can't believe they actually ate my fish and chips!'

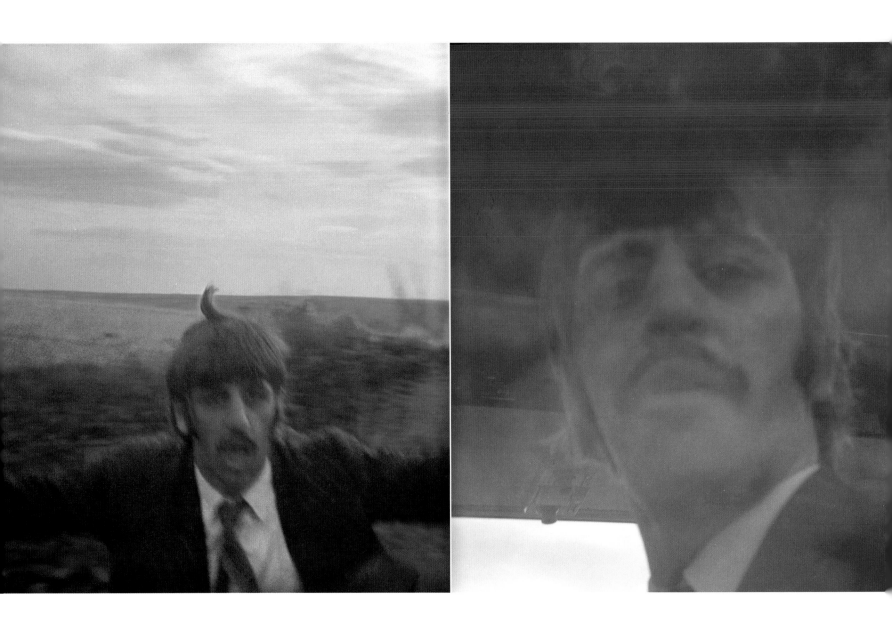

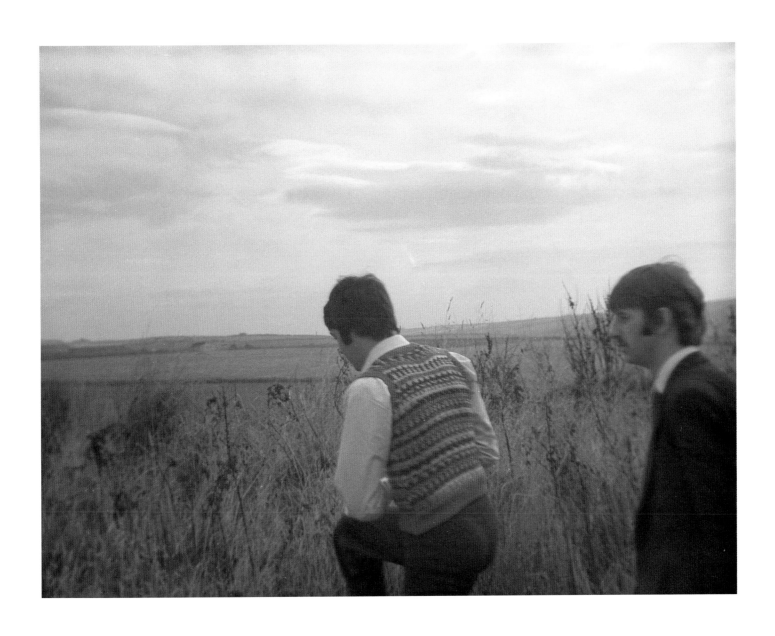

ABOVE AND OPPOSITE: Ringo and Paul take a break from the bus and stretch their legs in the countryside, during the long drive to Cornwall.

MAGICAL MYSTERY TOUR
WATERGATE BAY
WEDNESDAY 13 SEPTEMBER 1967

ON WEDNESDAY 13 SEPTEMBER THE BEATLES were filmed at Watergate Bay. John was in charge of filming a scene in which girls had to dress in bikinis, despite the cold Cornish air, but the sequence was not included in the movie. George, meanwhile, went to the Atlantic Hotel, recording a 13-minute interview with Miranda Ward, who worked for regional radio. Miranda had asked Tony Barrow, the Beatles publicist, if any of the Fab Four would do an interview on the bus on their way to Watergate Bay, but Barrow replied that they were fully booked until the following Easter, six months hence. She then encountered Mal Evans in the hotel lift, who said he'd ask the boys, after which George came up to Miranda and said he'd do the interview.

Miranda: Who had the original idea for the Magical Mystery Tour?

George: I think Paul had the idea, he wrote a song called 'Magical Mystery Tour', and so he decided to do it now so we could have it ready for a November or December release.

Miranda: Are there any plans for a full length film? What is the position there?

George: We signed a contract with United Artists for three films, thing is we can do it any time we want. We wanted to do a film that might mean something to either us, or the people who go to watch it. Got to have something good, and how we visualise the film it's got to be at least the difference between [the song] 'Help!' and 'Sgt. Pepper' — we'll probably end up by not having a big production team to film it all.

Miranda: Rather like you're doing this one?

George: More like this idea, where we'll help to direct the thing, and we'll probably edit it – the more people involved, the less of our movie it tends to be.

Miranda: How are the four of you going to incorporate your numbers in it ?

George: Well the 'Magical Mystery Tour' song could be played at the beginning, showing the people get on the coach and all that bit. The other songs, we'll be doing those next week in the studio. Because its called Magical Mystery Tour, and this isn't just a typical coach tour – anything can happen you see, that's the difference, it's magic and we can do anything.

The interview was broadcast on Saturday 30 September 1967, from 6.30 to 7.30 pm.

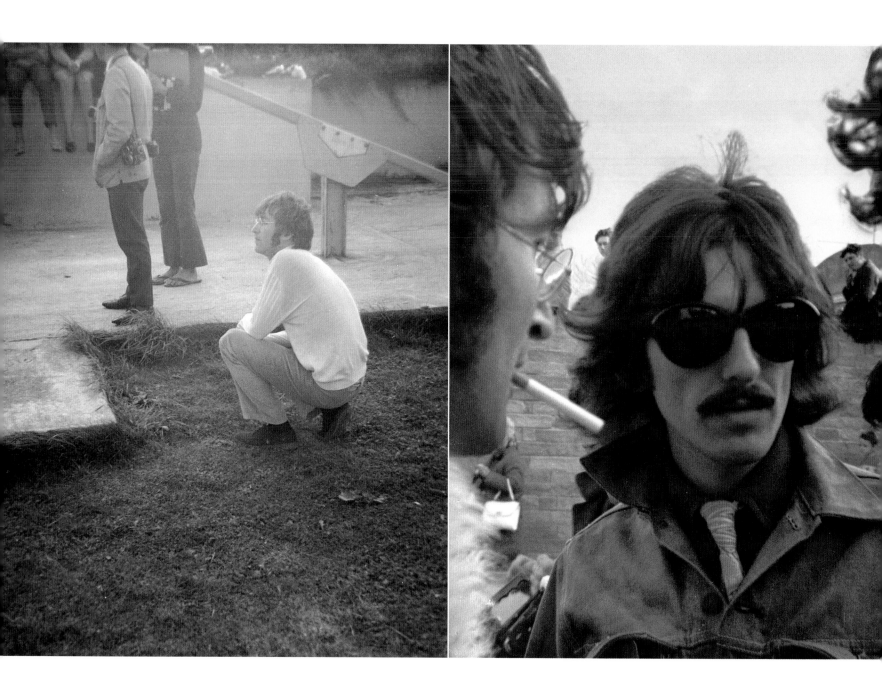

ABOVE: John as film director of the shoot at Watergate Bay, and with George (above right) on location.

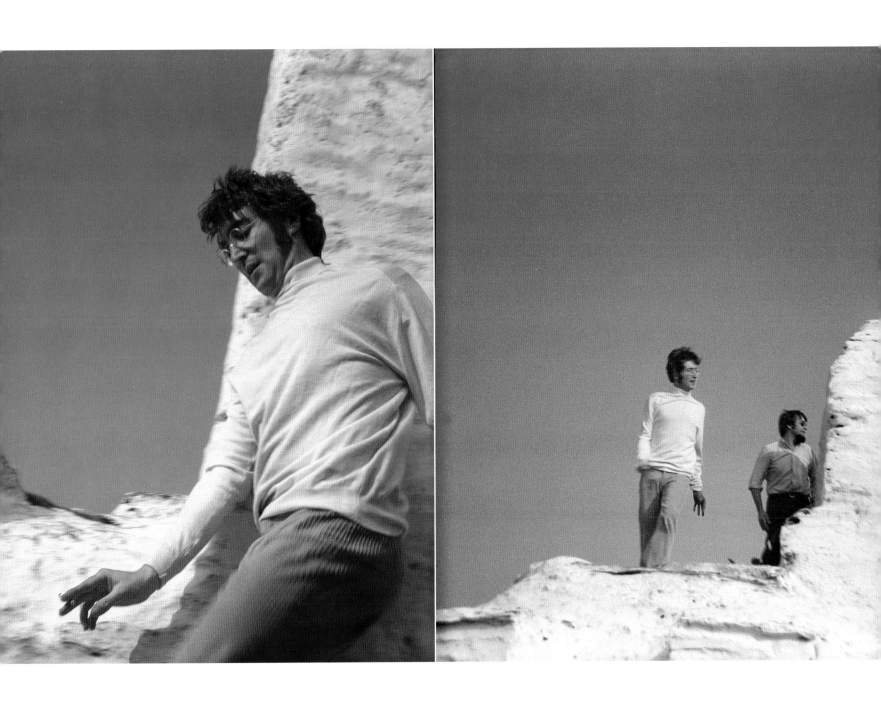

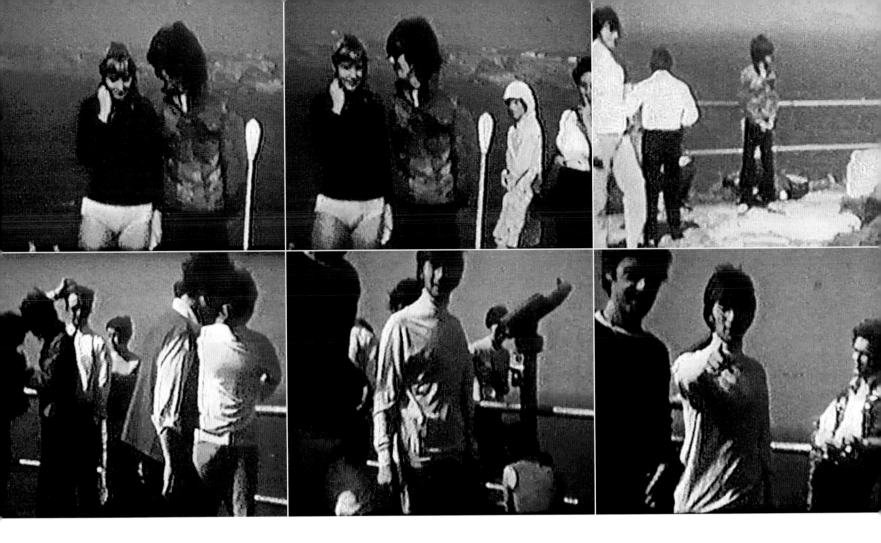

ABOVE: Screen grabs from an 8mm home movie made by one of the guests on the bus, showing John directing some very cold girls in bikinis on the seafront at Watergate Bay.

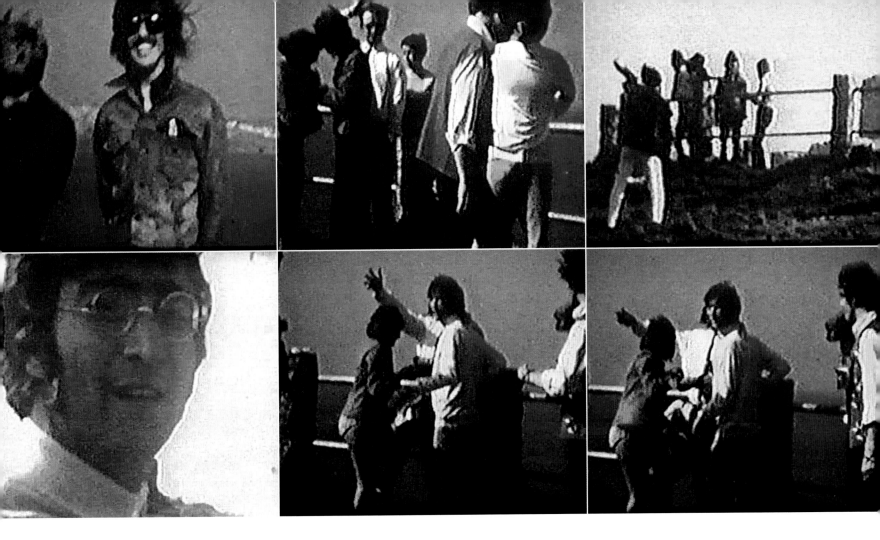

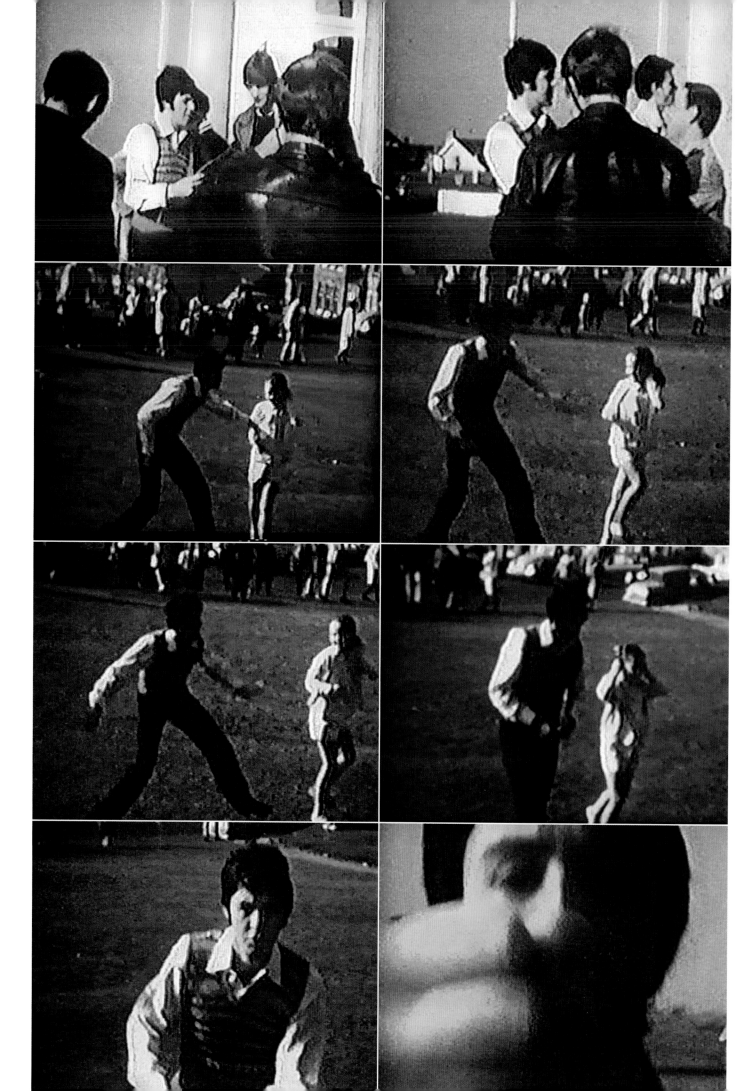

ABOVE: John Lennon through the window of the bus.

OPPOSITE: More 8mm screen grabs, Paul fooling around before the party makes its exit from the Atlantic Hotel.

MAGICAL MYSTERY TOUR
WEST MALLING AIRFIELD, KENT
TUESDAY 19–24 SEPTEMBER 1967

THE FINAL LOCATION FOR THE SHOOTING OF *MAGICAL MYSTERY TOUR* was a disused airfield in West Malling, Kent, where the Beatles would film the 'I Am The Walrus' sequence outside, and both the 'magician's laboratory' scene and the spectacular 'Your Mother Should Know' dance finale inside a huge aircraft hangar.

Among those hired to help with the props and sets was Paul Mackernan, who was working changing scenery and backdrops at Birmingham Repertory Theatre. He'd been told they were looking for workers on the shoot: 'On arrival at the airfield, I was interviewed for five minutes, then told I had the job for £95 per week plus £35 expenses, a lot of money in those days.'

Mackernan had the foresight to take his camera with him, hence these fascinating pictures from the film shoot. Perhaps surprisingly, he was allowed virtually free access to take pictures when he wished; when Mal Evans challenged him on one occasion, he merely replied they were for his 'portfolio'.

Now a property lawyer, Paul Mackernan eventually decided to sell his pictures, after talking to dealers at a Beatles convention in Wolverhampton. I ended up purchasing them from the collector he initially sold them to.

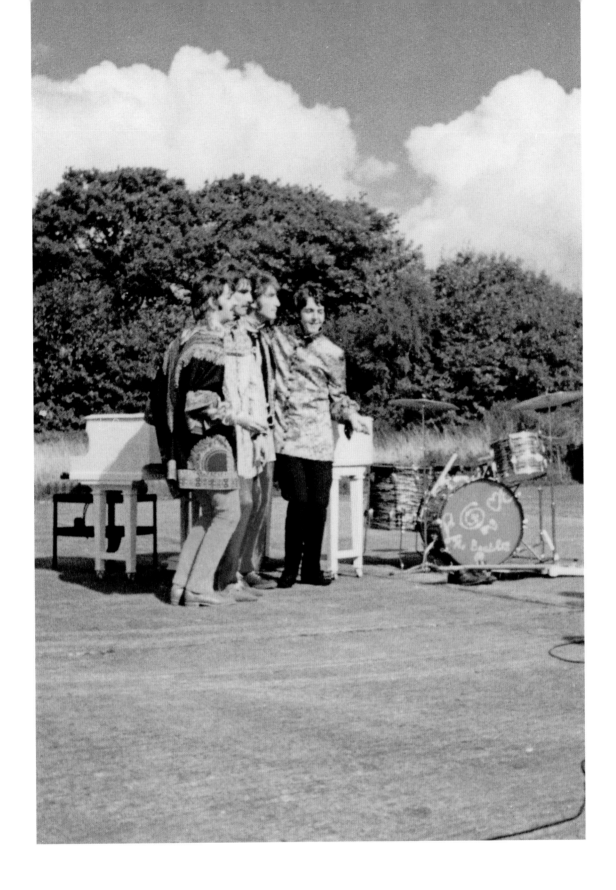

ABOVE AND OVERLEAF: For the famous 'I Am The Walrus' scene, the Beatles set up their instruments on the tarmac at the airfield, the 35-foot aircraft noise baffles forming the 'wall' on which a row of policemen stood.

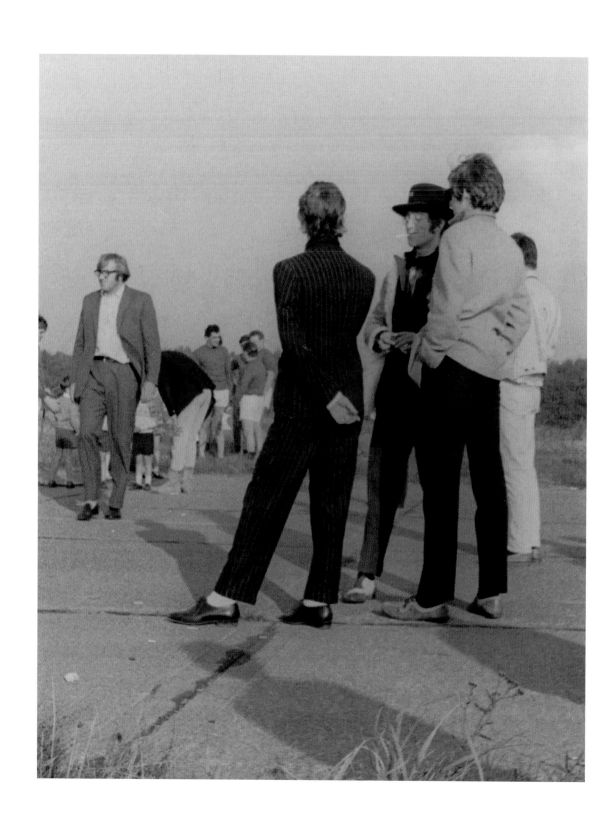

On 24 September, the last day of the shoot, the vast interior of the hangar – where the Beatles had already shot the 'four magicians' sequence – was prepared for 'Your Mother Should Know'.

A hundred and sixty dancers were recruited from Dame Peggy Spencer's formation dance team. Two of the dancers, Colin and Jean Eames, remember being asked to join the Beatles for a dance routine – they signed up immediately, along with 158 others. Valerie Underdown remembers being greeted by the Beatles on arrival at the hangar: 'The three coaches arrived one with boys, second with girls and the third had all the pom-pom frilly dresses and blue duster coats. The girls were directed to a separate part of a hangar where the Beatles enjoyed watching the girls getting changed.' Paul (who wrote the music) led the dancers down the rickety white staircase, but the scene was changed as they became aware that the staircase would not carry the weight of all the dancers.

Paul Mackernan's pictures of the dancing shoot were all taken in black and white because the local shops had no colour film in stock.

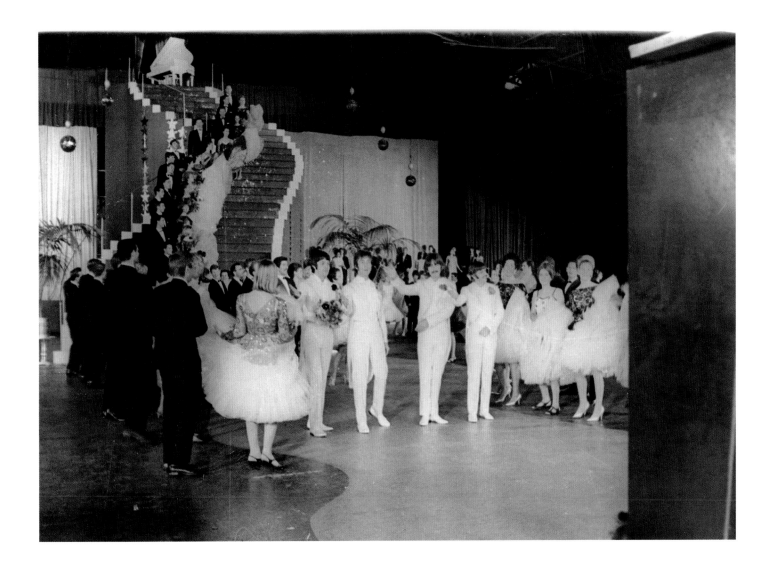

ABOVE: The Beatles saluting the dancers at the bottom of the Hollywood-style winding staircase.

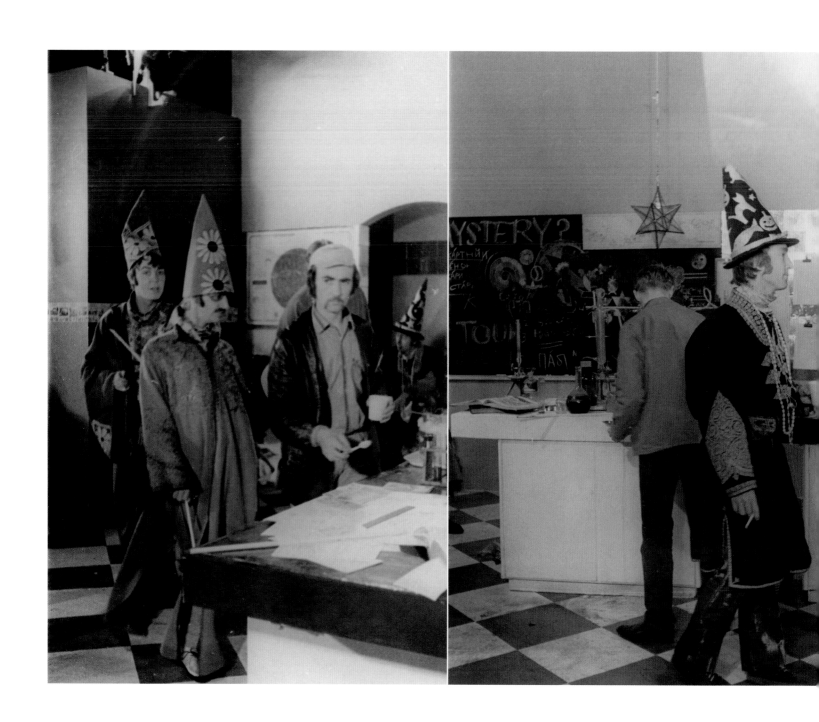

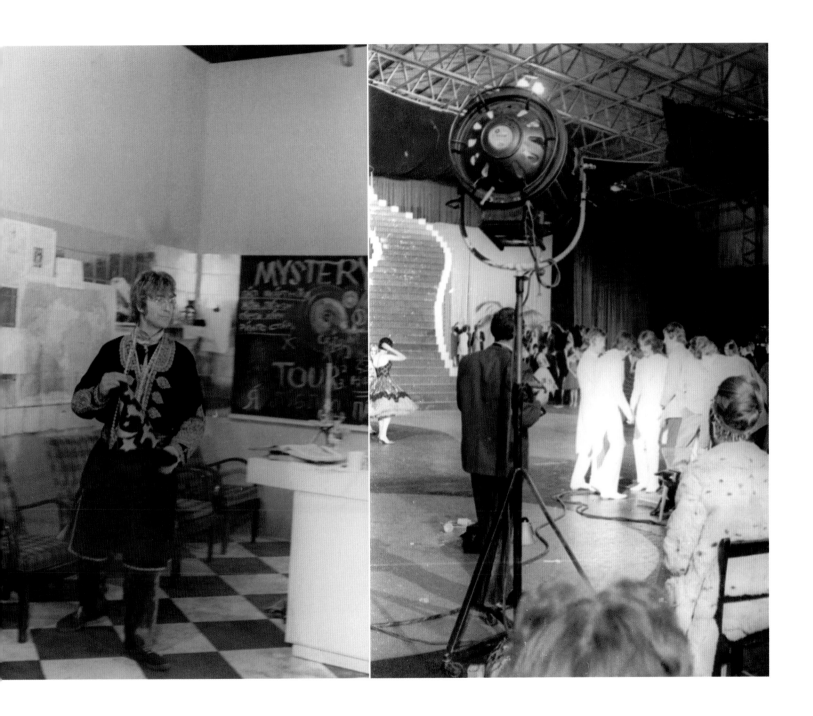

ABOVE AND OPPOSITE: Paul, Ringo, and John in their magicians attire.

ABOVE, RIGHT: The white-suited Beatles preparing for the dance routine.

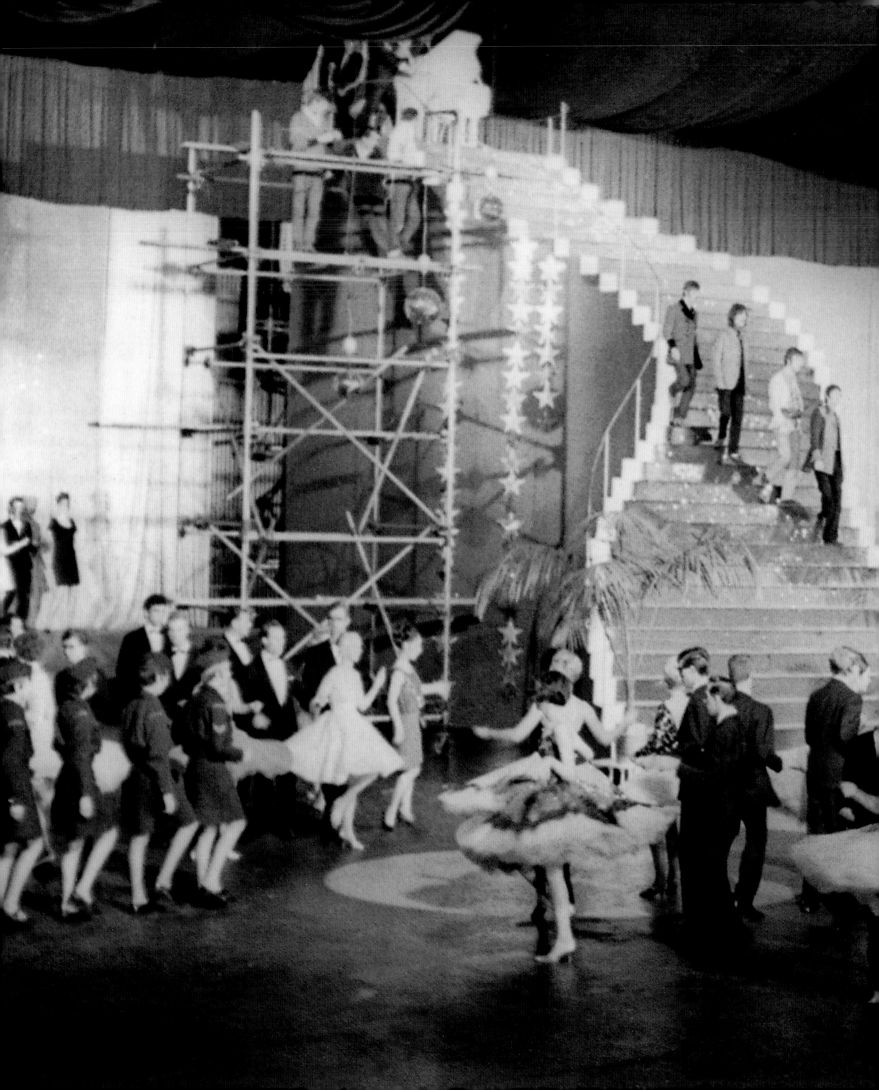

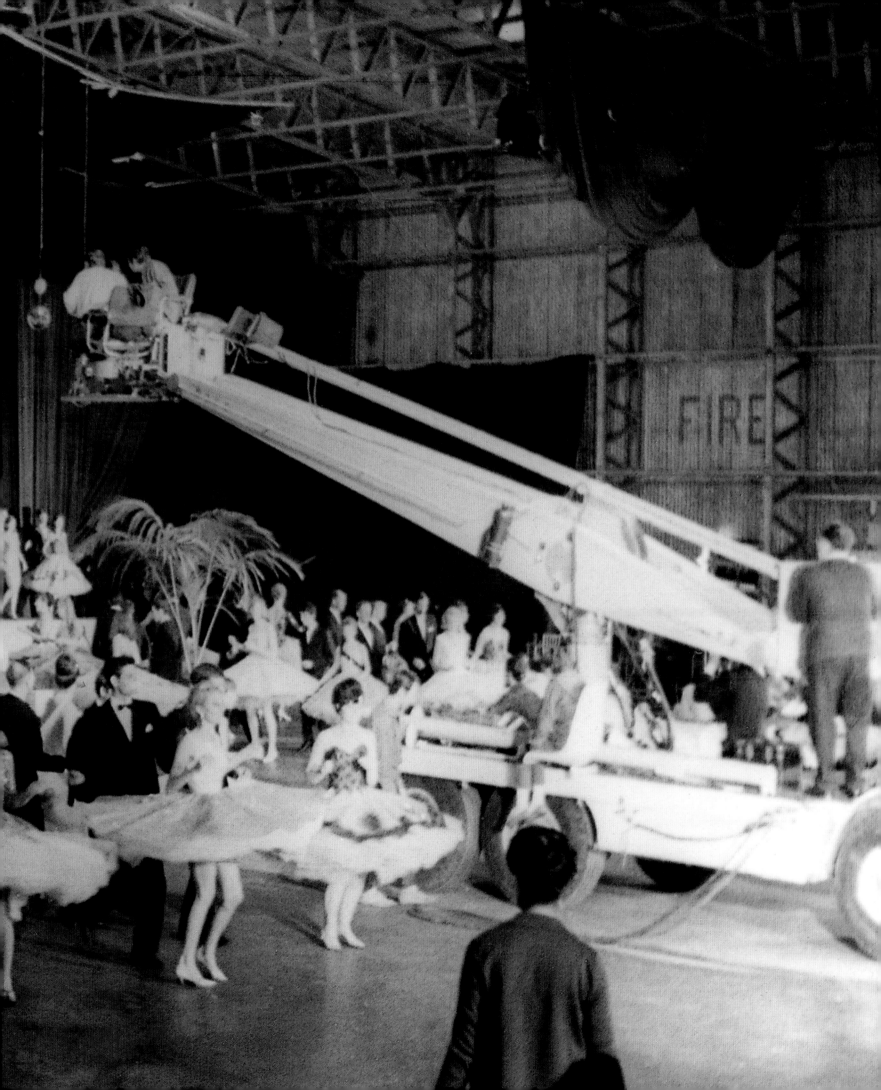

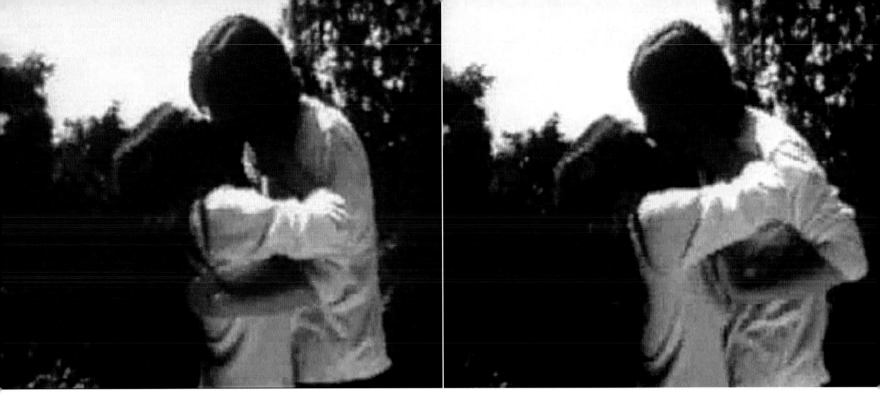

WEYBRIDGE

MAY 1968

THESE PICTURES OF JOHN AND YOKO EMBRACING and John playing his guitar were taken in May 1968 at John's house in Weybridge, Surrey, by the cameraman William Wareing. The 8mm home movie was filmed during breaks in the filming of what was to become *Smile*, also known as *Number 5*. The footage also includes John listening to an acetate of the 'White Album' in his house. They were experimenting with a high-speed Super 8 camera which shot 300 frames a second, the film being slowed down to show the movie in slow motion. The final film, cut down from a proposed five-hour movie, was screened at the Chicago Film Festival in 1968.

William came to my shop, Vinyl Experience, on several occasions to sell me the film. When I finally purchased it, William had already tried to sell the film at Sotheby's and later at Christie's, but it had failed to reach the reserve price. I was thrilled to buy the movie, which came on two spools in a yellow cardboard box.

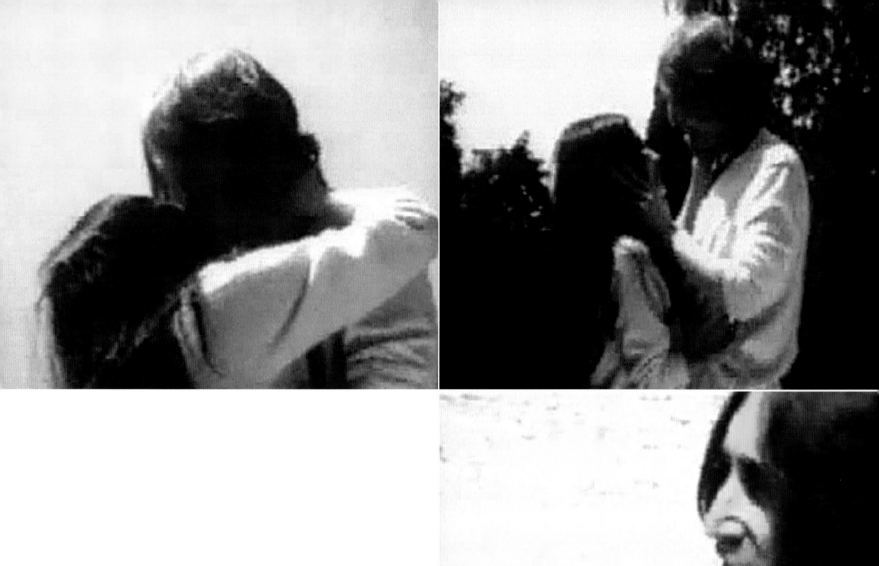

MIKE MCGEAR'S WEDDING
FRIDAY 7 JUNE 1968

BETTER KNOWN AT THE TIME AS MIKE MCGEAR, a member of the hit-making satire group the Scaffold (who would top the charts with 'Lily The Pink' later in the year), Paul's brother Mike McCartney was married to Angela Fishwick on 7 June 1968 at a small family wedding ceremony held in the village of Caerog in North Wales. Paul was best man, accompanied by his girlfriend Jane Asher. Mike McCartney was himself an accomplished photographer, and took many pictures of the Beatles at home, rehearsing and on gigs, particularly during the period when they were still based in Liverpool in the early 1960s.

The pictures, which were taken by Bob Hewitt, a freelance photographer from Rhyl, were from 61 negatives I purchased at an auction at Sotheby's.

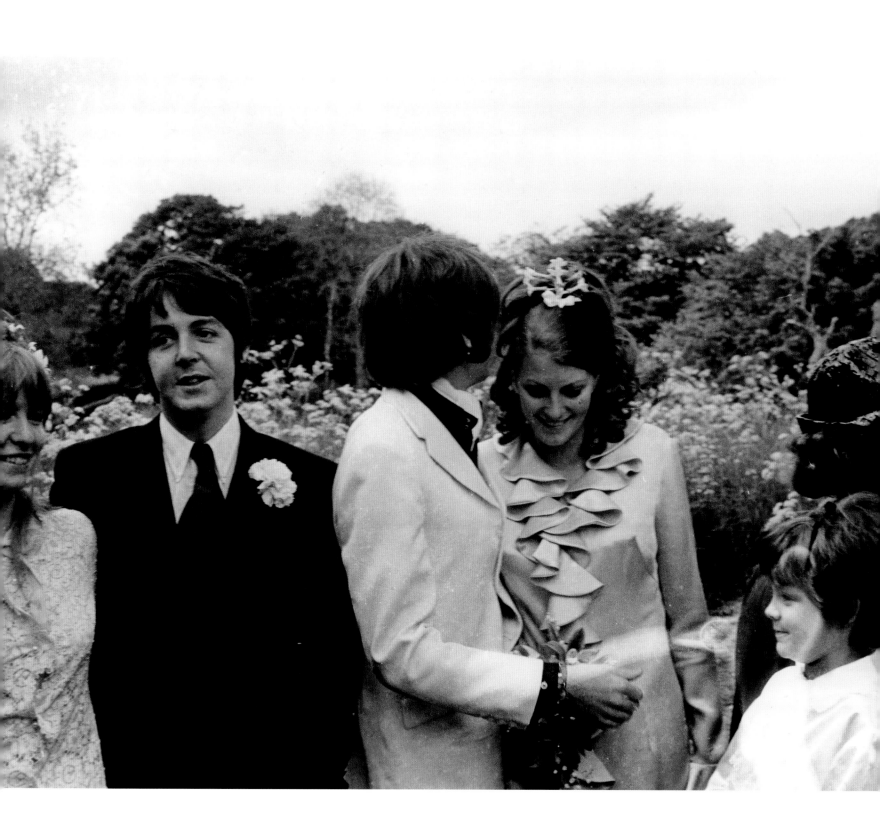

ABOVE: Left to right, Jane Asher, Paul McCartney, Mike McCartney and his bride Angela Fishwick.

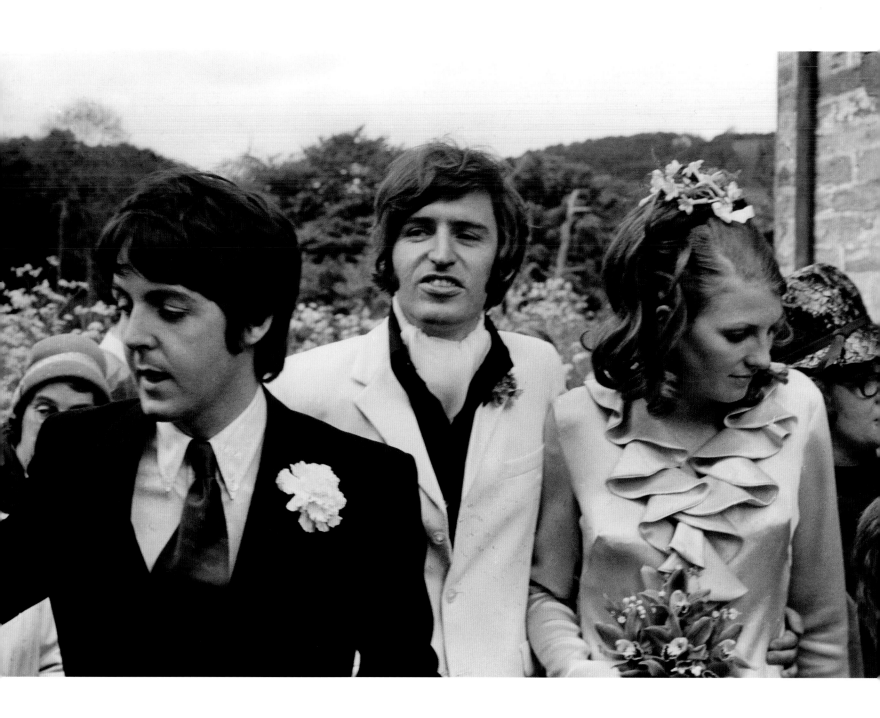

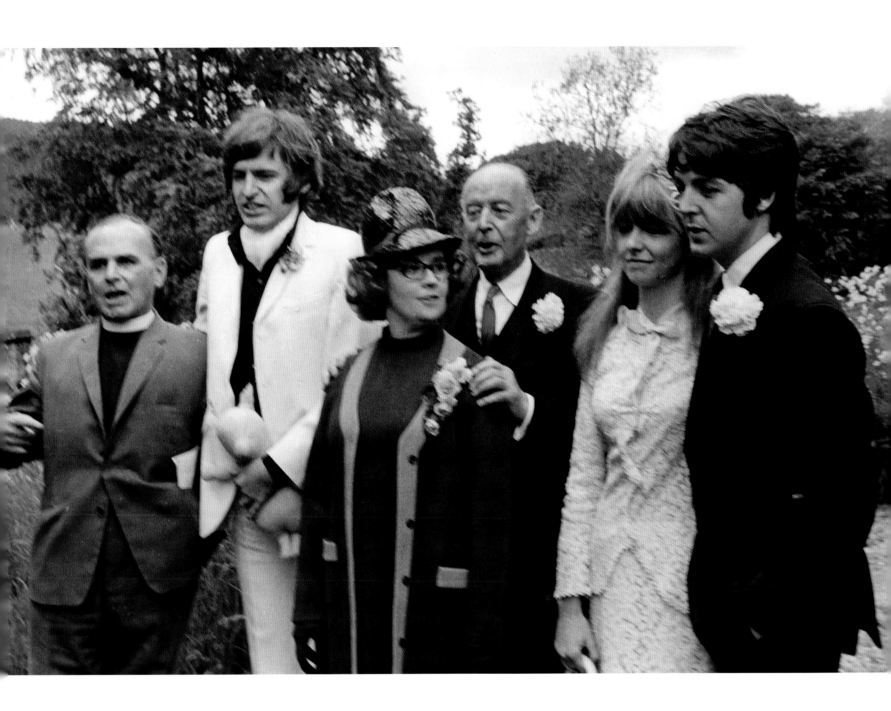

ABOVE: The wedding guests included Paul and Mike's father, Jim McCartney, seen here to the left of Jane Asher.

A MAD DAY OUT
SUNDAY 28 JULY 1968

BY THE SUMMER OF 1968, whenever the Beatles' activities were covered by the media, the pictures used were old images of them wearing psychedelic fashions from the year before, or pictures of them as the Fab Four mop-tops from their Beatlemania years. This was simply because the press no longer had the opportunity to photograph the group – the Beatles had not played in concert since 1966, and now rarely made public appearances together. Apart from a very brief photo session at the EMI recording studios on 8 February, the Beatles hadn't yet posed for any group photos in 1968.

In late July, however, in the midst of recording sessions for the so-called 'White Album', the Beatles decided to spend a 'Mad Day Out' being photographed at seemingly random locations all over London. Paul McCartney's then girlfriend, Francie Schwartz, was given the task of picking locations that would act as sites for the photo session, which was to take place on Sunday 28 July 1968.

Veteran war photographer Don McCullin was employed as the primary cameraman, but additional photographers Ronald Fitzgibbon, Stephen Goldblatt, Tom Murray, and Tony Bramwell (an ex-Beatle roadie) came along as well, as did the Beatles' assistant Mal Evans. Other spectators on the shoot included Mal's six-year-old son Gary Evans, Yoko Ono, and Francie Schwartz. McCullin said of the day: 'I was in awe of them, really... They were the most famous pop group in the world, and I was expected to take a total turn from the work I used to do or I did at the time. And then I suddenly had to find myself photographing celebrities.'

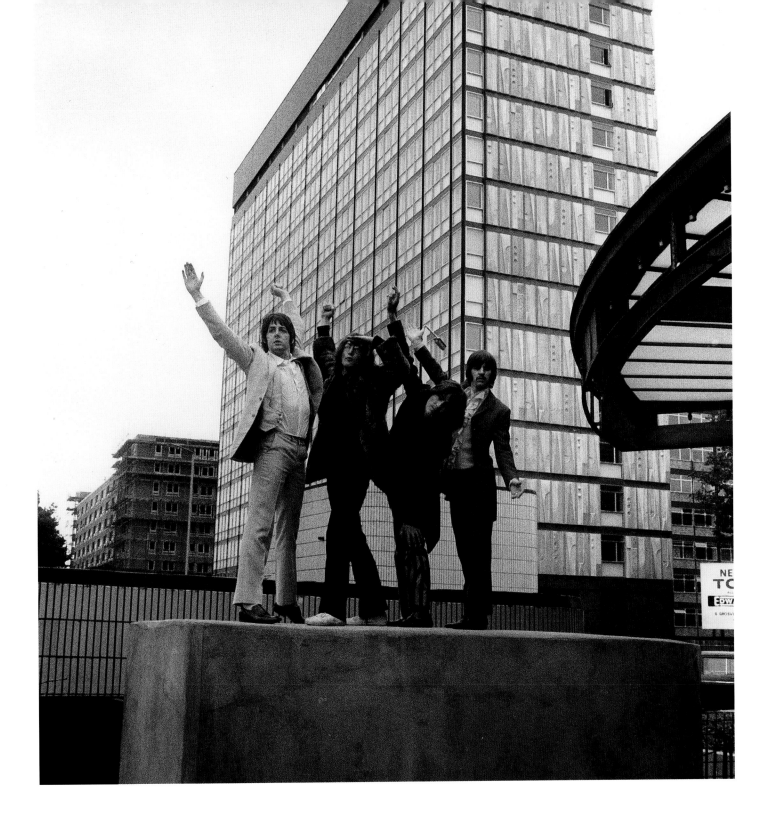

ABOVE: Trailing round London on a sleepy Sunday, the Beatles posed and joked for McCullin in a variety of locations – many in the East End. This image was taken at Old Street underground station.

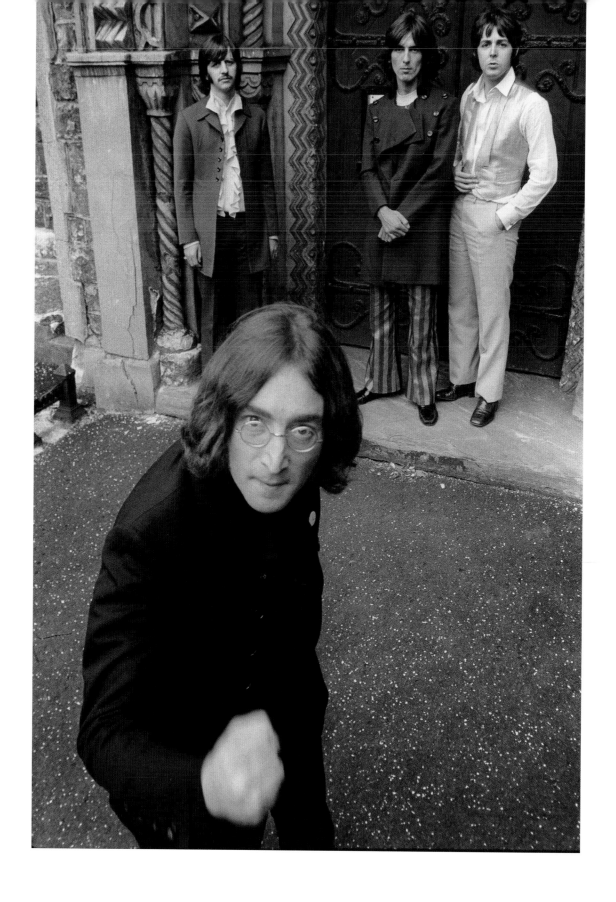

ABOVE AND OPPOSITE: John Lennon seems particularly animated in these pictures taken during the 'Mad Day Out' with the Beatles.

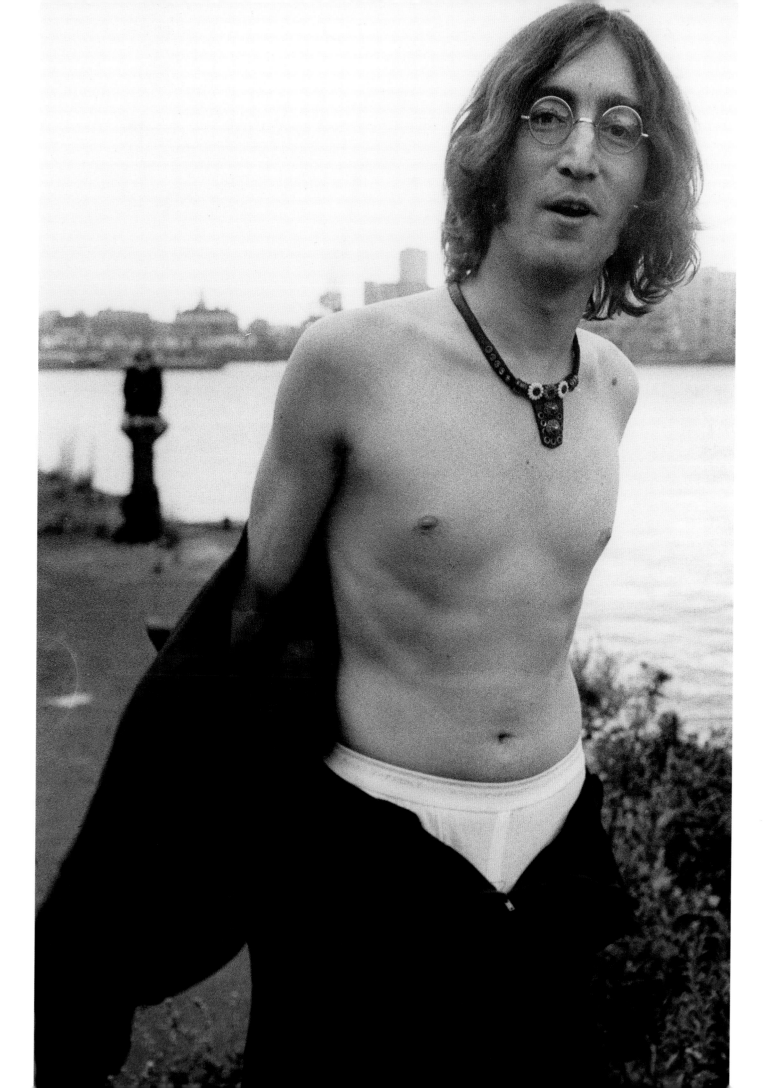

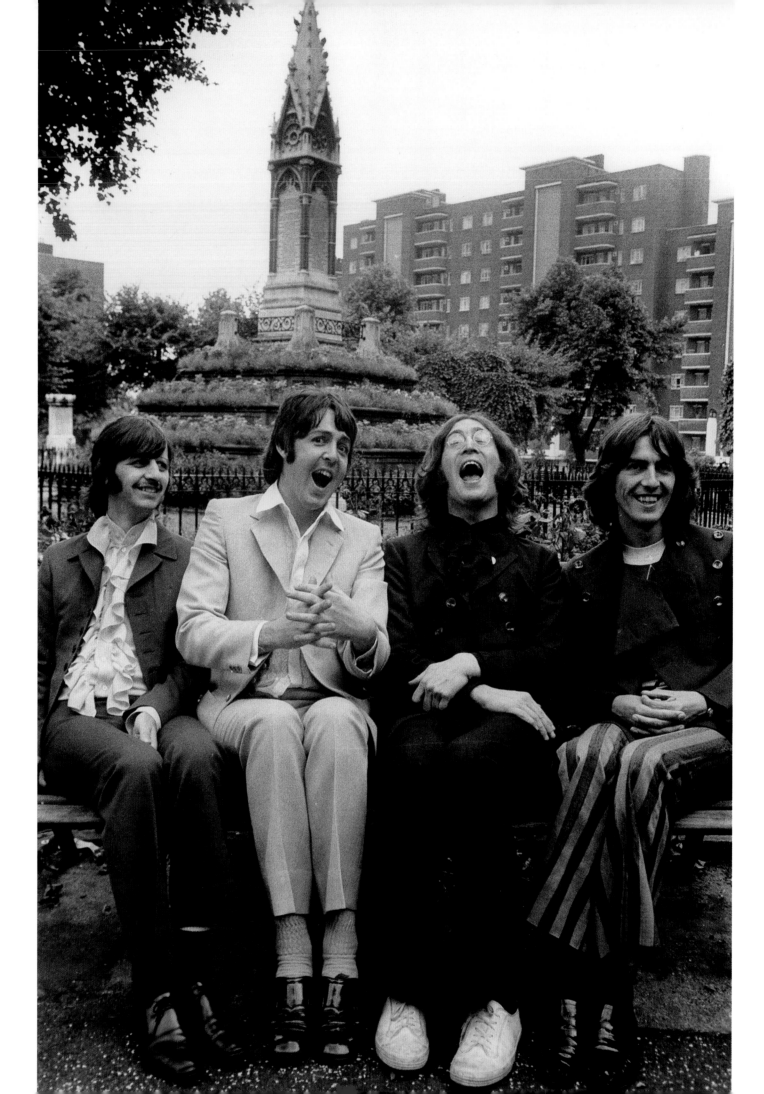

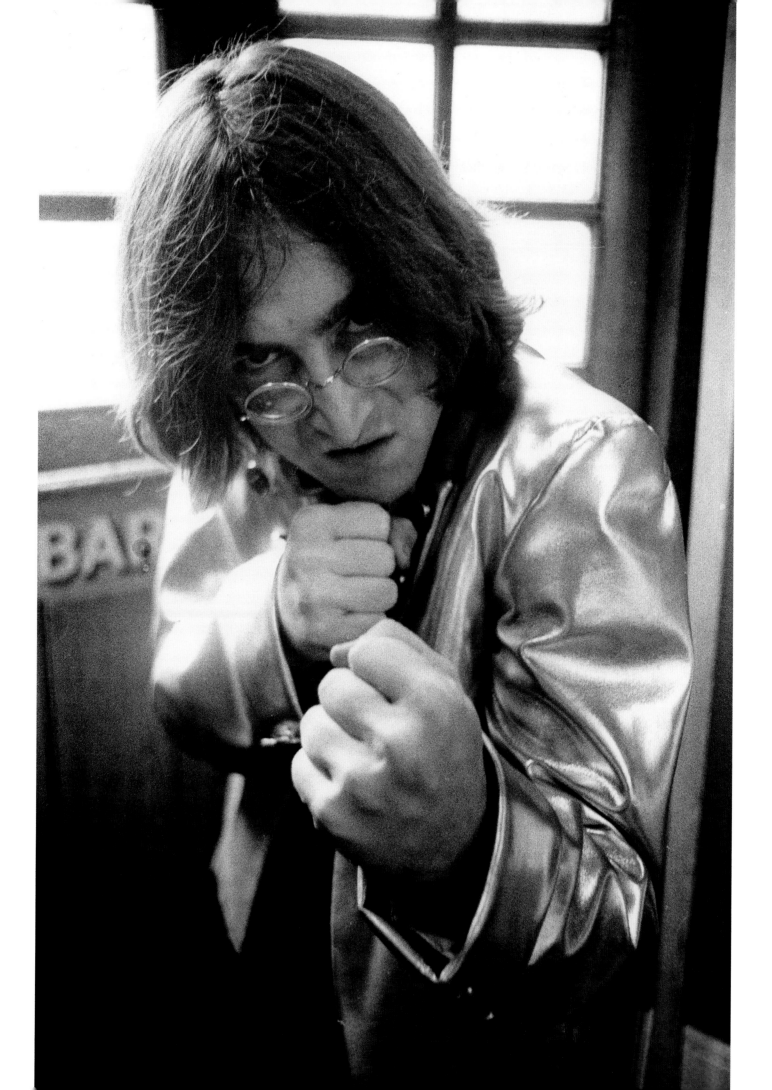

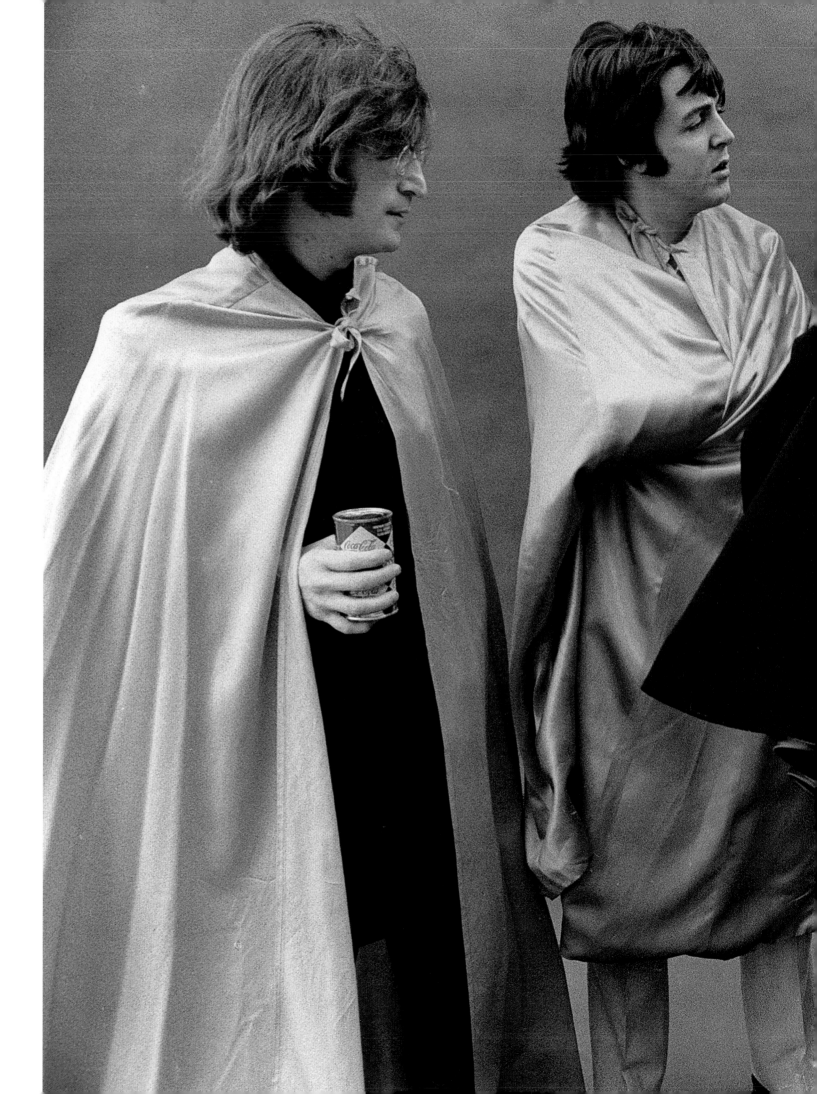

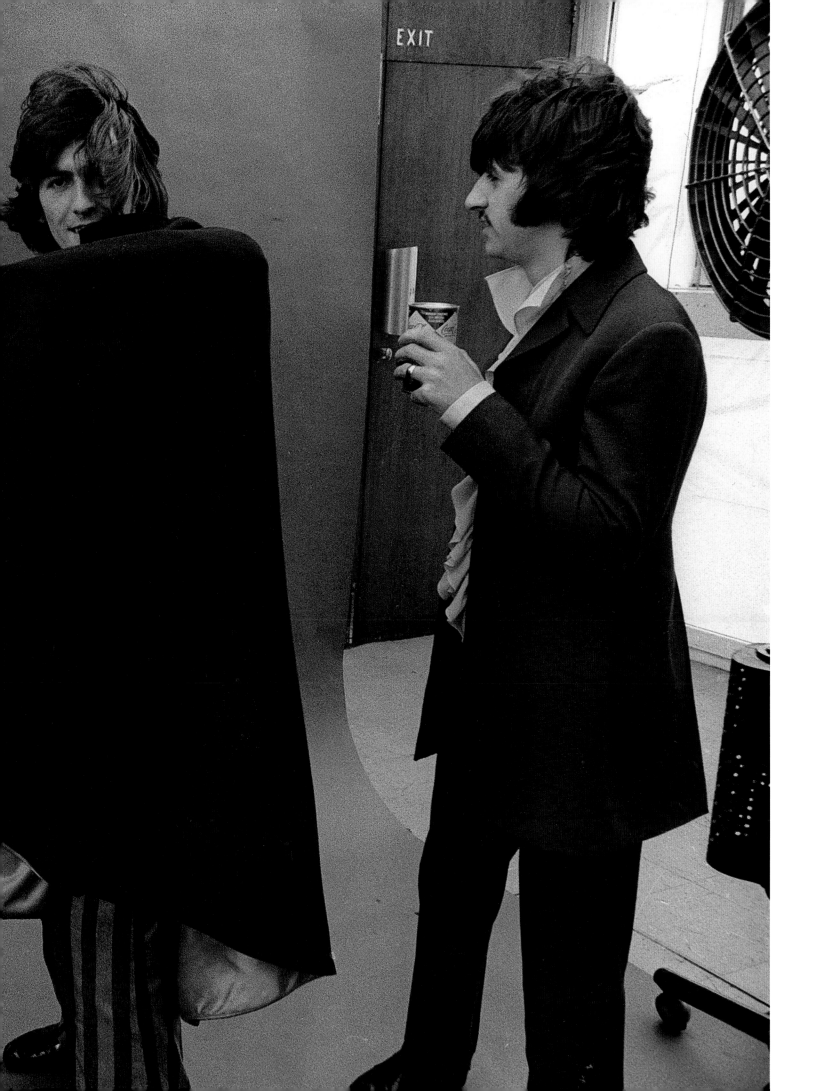

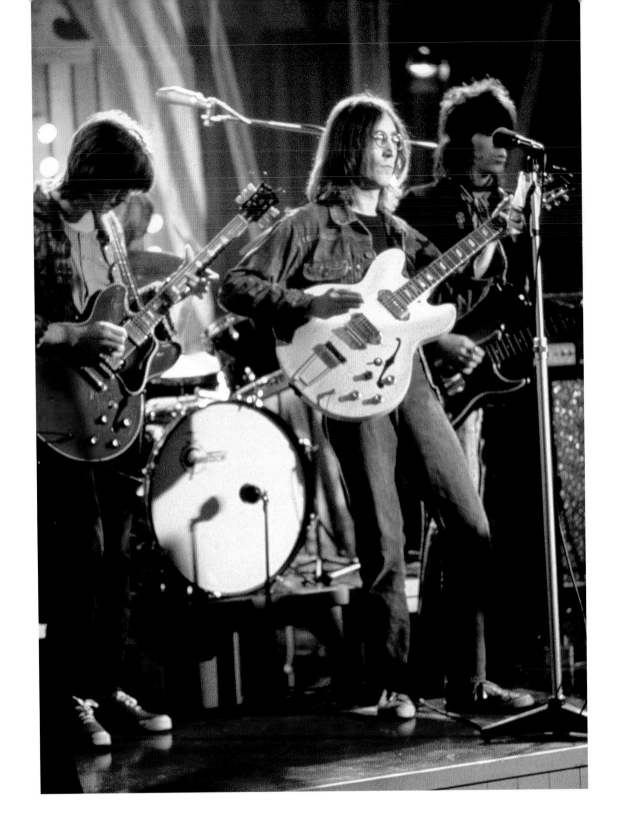

ABOVE: John Lennon flanked by (left) Eric Clapton, and the Rolling Stones' Keith Richards.
OVERLEAF: Watching a circus trapeze act: Back row, Bill Wyman, John Entwistle, Brian Jones, Mitch Mitchell.
Front row, Keith Moon, Charlie Watts, Yoko Ono, John Lennon's son Julian, John Lennon, and Eric Clapton.

ROCK 'N' ROLL CIRCUS
TUESDAY 10 DECEMBER 1968

DURING NOVEMBER 1968, MICK JAGGER and the Rolling Stones were booking acts for their planned TV show *Rock 'n' Roll Circus*, and had secured the services of The Who, Eric Clapton, Mitch Mitchell of the Hendrix Experience, Jethro Tull, Taj Mahal, and Marianne Faithfull. Brigitte Bardot was already contracted elsewhere, Johnny Cash declined his invite, but they did go on to get a confirmation from John Lennon and Yoko Ono. The director was Michael Lindsay-Hogg, who had also directed the Beatles' promotional film for 'Hey Jude' earlier in the year.

On 10 December, after hours of rehearsals and false starts, Dirty Mac took to the stage – a supergroup pieced together for the day and named by Lennon after the blues band Fleetwood Mac. Lennon fronted the outfit with Mitch Mitchell on drums, Eric Clapton on guitar, and Keith Richards on bass, playing 'Yer Blues' from *The Beatles*, their so-called 'White Album'. This was followed by Yoko Ono and Lennon playing 'Whole Lotta Yoko' with Ivry Gitlis on violin.

These stills were shot by photographer Dick Polak, who worked extensively in the music field, his commissions including publicity shoots and album cover photography for the Sutherland Brothers and Quiver, Luther Grosvenor, Rory Gallagher, and many more. He married the actress/ fashion designer Edina Ronay, which is how I came to meet him. When my wife was choosing her wedding dress, the name Edina Ronay came up, followed by a visit to Ronay's house in Putney. There I was introduced to her husband, Dick Polak, and I mentioned how I had seen some of his photographs of *Rock 'n' Roll Circus* (which at that time had not been released), his name appearing on the border of the transparencies.

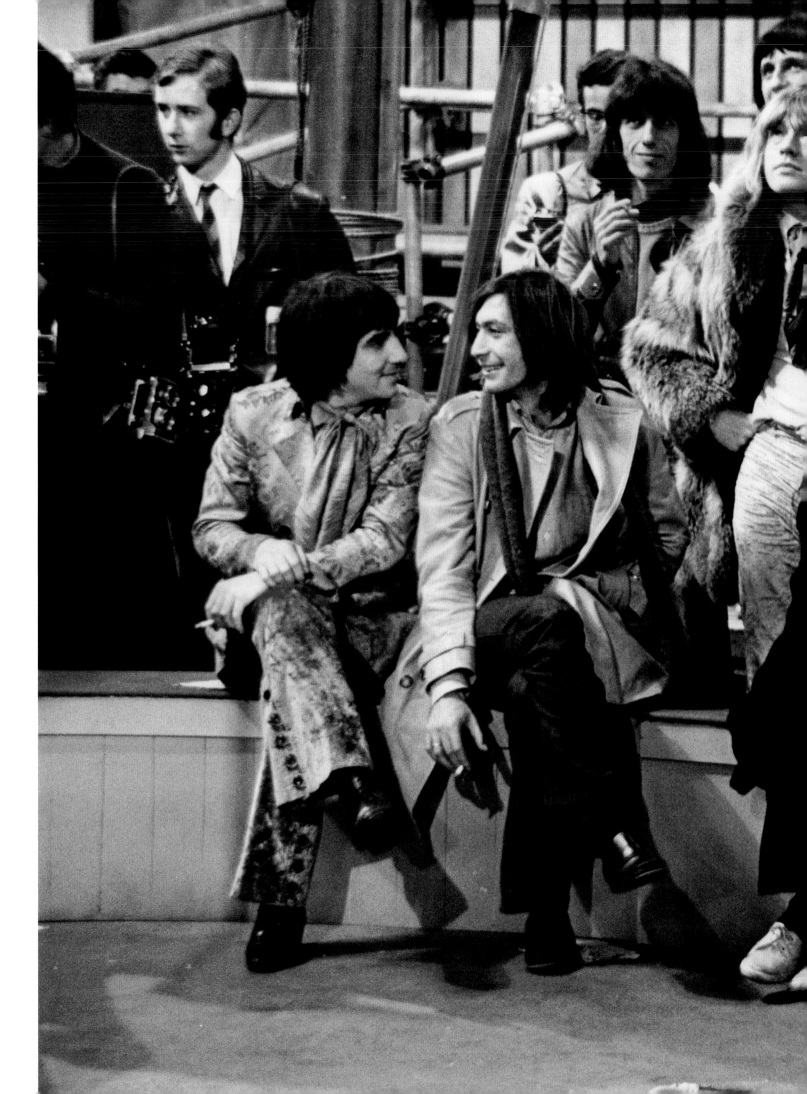

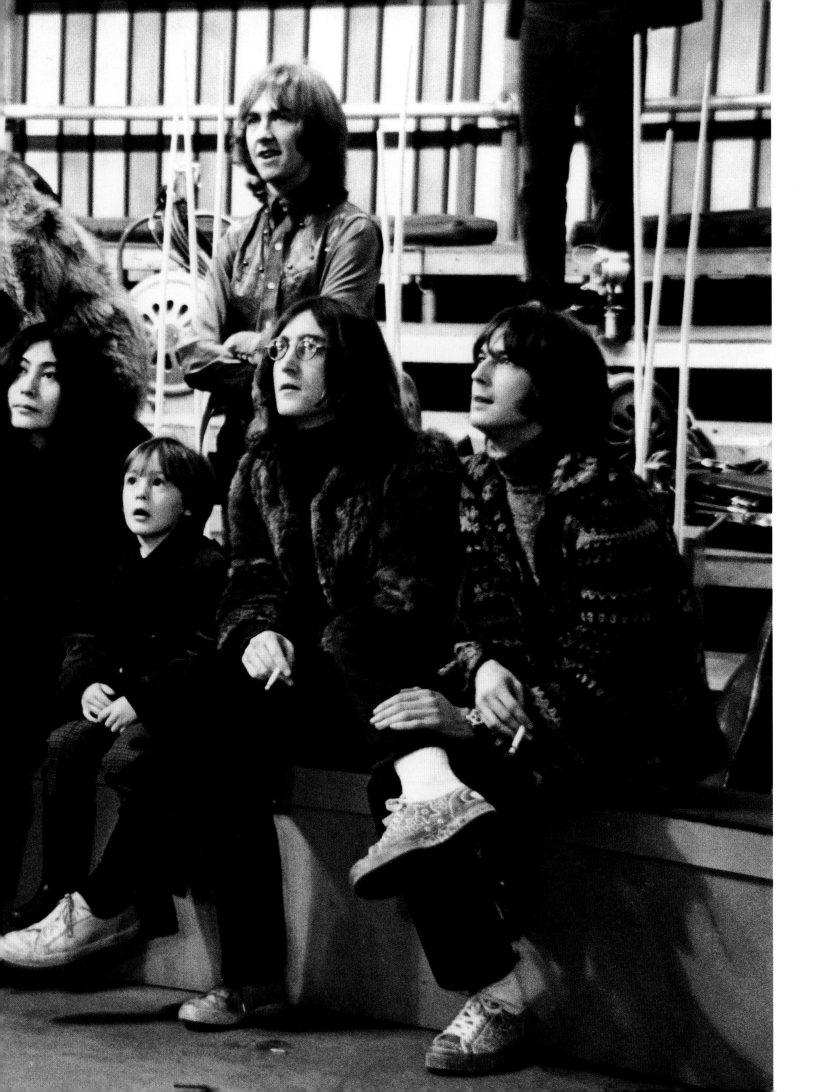

AMSTERDAM HILTON HOTEL
TUESDAY 25–31 MARCH 1969

REALISING THEIR MARRIAGE ON 20 MARCH 1969 would attract huge media attention, John and Yoko decided to use the publicity to promote world peace. They spent their honeymoon in the Presidential Suite, Room 702, at the Amsterdam Hilton Hotel for a week between 25 and 31 March, inviting the world's press into their hotel room every day between 9 am and 9 pm. After the near-scandal caused by the nude cover of the *Two Virgins* album, the press were expecting love-making of some degree, but instead the couple were sitting up in bed—in John's words, 'like angels'—talking about peace, with signs over their bed reading 'Hair Peace' and 'Bed Peace'.

John, of course, would famously refer to the bed event in the Beatles' single 'The Ballad of John and Yoko', released two months later, at the end of May 1969:

' Drove from Paris to the Amsterdam Hilton,

Talking in our beds for a week.

The newspaper said, "Say what you doing in bed?"

I said, "We're only trying to get us some peace." '

The pictures opposite and overleaf were taken by Laurens van Houten, the noted Dutch rock photographer whose extensive portfolio includes work with Led Zeppelin, the Clash, Rod Stewart, and, famously Elvis Presley's final concert in Las Vegas.

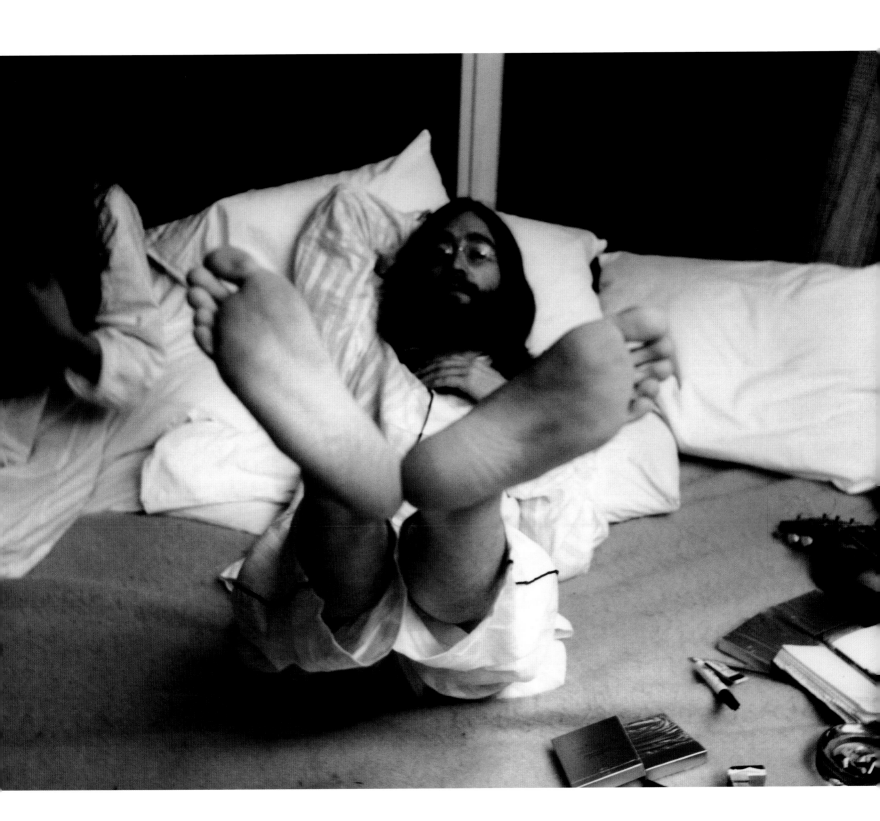

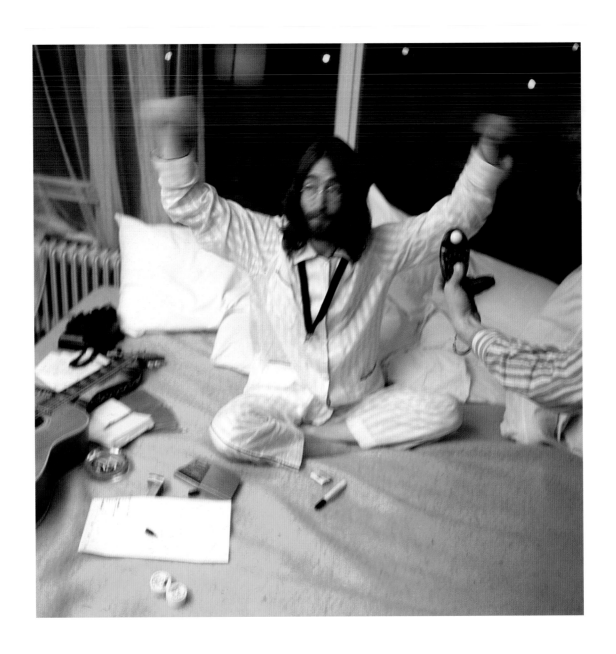

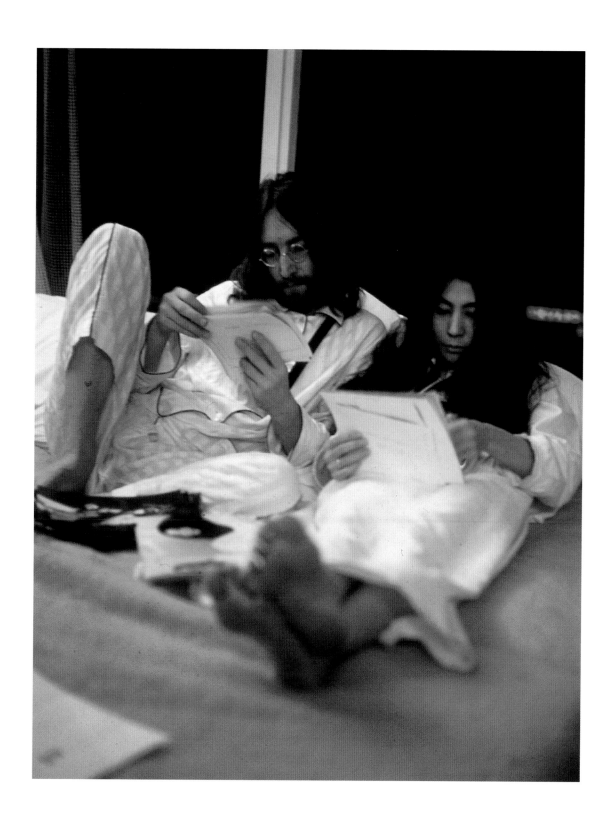

HIT FACTORY RECORDING STUDIO
NEW YORK CITY
SATURDAY 6 DECEMBER 1980

These photographs were taken, poignantly, just two days before John Lennon was shot dead on 8 December 1980. The location is the Hit Factory recording studio in New York City, and John was there with Yoko Ono to take part in an interview for the BBC with presenter Andy Peebles. Also present were BBC producer Paul Williams, executive producer Doreen Davies, and a representive from Warners Bros Records in London, Bill Fowler.

Although the Beatles had officially broken up as a group a decade earlier, in April 1970, there had been persistent rumours of a reunion of one kind or another, permanent or just temporary for a one-off event. But the four had their own projects to pursue, albums to make, concerts to perform, and personal lives to live. And, for the first time since 1963, they were often out of the ever-present gaze of the cameras that had been ubiquitous during their eight years as what Lennon would call 'just a rock 'n' roll band that got very, very big'. While they had not got together as a unit again, the possibility was always there – in the public's mind at least. The killing of John Lennon signalled the end of this possibility – the Beatles story had finally came to a tragic and irrevocable end.

OPPOSITE, TOP: Top row (l to r) BBC executive producer Doreen Davies, BBC producer Paul Williams and presenter Andy Peebles. Bottom row, Yoko and John.
OPPOSITE, BOTTOM: At New York's Hit Factory, Andy Peebles, Yoko Ono, and a gaunt-looking John Lennon.

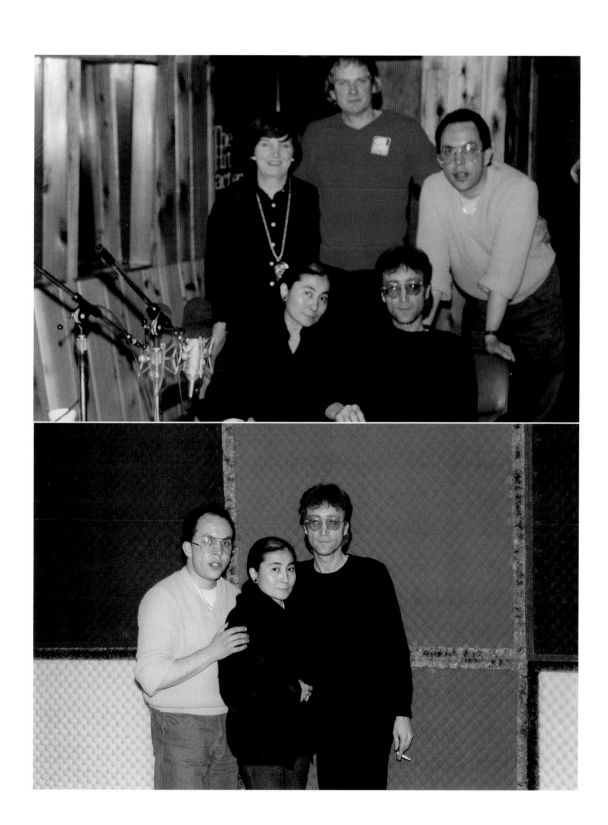

INDEX

BIBLIOGRAPHY AND SOURCES

The Beatles Anthology (Cassell), 2000

Betts, Graham, *Complete UK Hit Singles* (Collins), 2004

Clarke, Donald (Ed), *The Penguin Encyclopedia of Popular Music* (Viking), 1989

Evans, Mike, *The Art of the Beatles* (Anthony Blond), 1984

Evans, Mike, *Rock 'n' Roll's Strangest Moments,* (Robson Books), 2006

Rawlings, Terry, *Then, Now and Rare: British Beat 1960–1969* (Omnibus Press), 2002

Pieper, Jörg and Path, Volker, *The Beatles: Film & TV Chronicle 1961–1970* (Premium Forlag AB), 2005

Russell, Jeff, *The Beatles: Album File & Complete Discography* (Cassell Illustrated), 2005

Selected editions:

The Beatles Book Monthly, *Disc* magazine, *New Musical Express*

AUTHOR'S ACKNOWLEDGEMENTS

Number 1, thanks to my wife Colleen (the most drop–dead gorgeous lady in the universe, and I'm not just saying that), who has stuck with me and given me support and loving in everything I do. My children – Grace (winner of Windlesham school 'Have I got talent?'), Alice (the Audrey Hepburn lookalike and pianist, who always gives her undivided attention to everyone she meets), and Eve (the Diana Rigg lookalike and smiling drummer virtuoso) – without their combined joy and laughter it would not have been possible to finish this book. To my in-laws Frank and Phyliss Lees, who are always on hand to help, no home should be without them. I'd also like to thank my two brothers and their families: Anthony, Elizabeth, William (rock god at Nottingham University), Toby (the rock drummer), and Holly Hayward (the next Annie Leibowitz); and my newly found eldest brother's family in Vancouver – skipper Jonathan and devoted wife Jane, Jessica (at British Columbia), Juliette (the soon to be new Speaker for Canada), and Jeremy Levine (the best actor to come out of Canada for years); my late mother Eve, who loved her children and music – sorry that she is not here to see her daughter-in-law and grandchildren; and my father John who is finally back on the scene.

For their help in making this book possible, I would also like to thank: Anna Cheifetz for her enthusiasm, support and blast-from-the-past email which kick-started this project; the photographers Paul Mackernan and Richard Rosser; Chas McDevitt, Dorothy Paignton, and Martyn Fenwick for his day-to-day calls giving nothing but encouragement and words of wisdom; Jordi Tarda for his rock 'n' roll inspiration; Mike Evans for applying the glue and scissors to the text; and finally for their support and faith in difficult times, Anil and Enid Simi and Sierra Prassad.

Finally, we tried to locate many people in the course of researching these photos; anyone who has any information to add or wants to sell memorabilia or photos and film, please email mark@mpc–inc.co.uk

PHOTOGRAPHY CREDITS

First published in the United Kingdom in 2009 by PAVILION BOOKS
10 Southcombe Street, London, W14 0RA

An imprint of Anova Books Company Ltd

Editor: Mike Evans
Designer: Ros Holder
Cover Designer: Georgina Hewitt
Proofreader: Alyson Silverwood
Indexer: Patricia Hymans
Production: Rebekah Cheyne
Associate Publisher: Anna Cheifetz

ISBN 978–1–86205–867–5

A CIP catalogue record for this book is available
from the British Library.

10 9 8 7 6 5 4 3 2

Reproduction by Dot Gradations Ltd, UK
Printed by 1010 Printing International Ltd, China

www.anovabooks.com

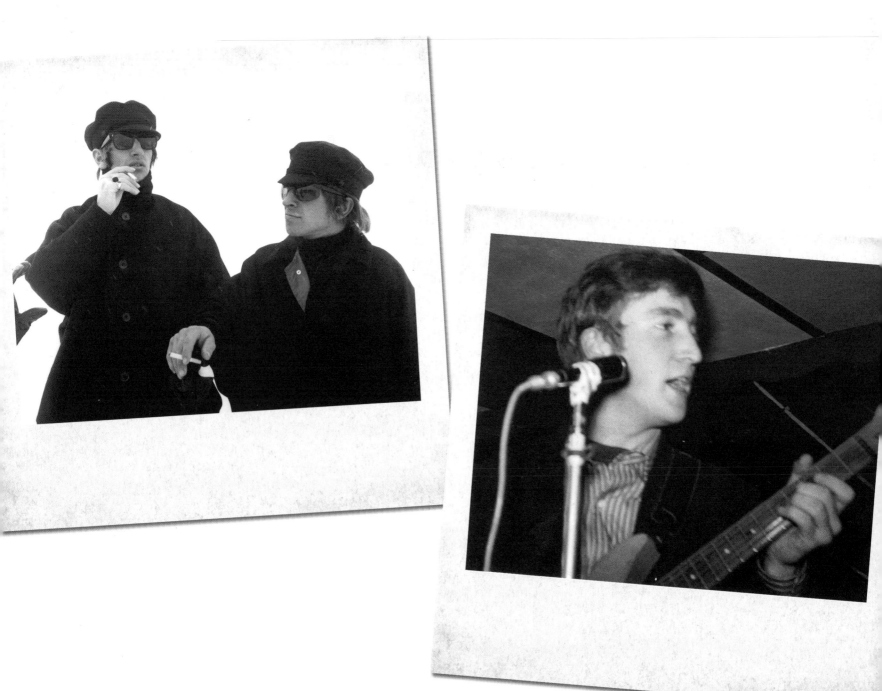